Image of the Risen Christ

Dr. Kenneth E. Stevenson

Frontier Research Publications, Inc.
P.O. Box 129, Station "U", Toronto, Ontario M8Z 5M4

Image of the Risen Christ
ISBN 0-921714-58-0
Copyright © 1999

Cover design: The Riordon Design Group
Printed in Canada: Harmony Printing Limited

Table of Contents

Dedication . 7

Acknowledgments . 9

Foreword . 11

Introduction . 15

Part 1: The Importance of the Shroud

1 What is the Shroud and Why Should We Study It? 21

2 History of the Shroud . 29
 Hints from Art History . 31
 The Mandylion . 33
 The Shroud and the Mandylion 36
 Scientific Studies . 43
 The Later History of the Shroud 45
 The D'Arcis Memorandum . 46
 The House of Savoy: New Shroud Owners 48
 Conclusion . 51

3 Fraud and the Shroud . 55
 The Scientific Evidence . 56
 Modern Attempts at Forgery . 59

Part 2: Looking Back

4 Back to the 80s . 67
 The State of the Question in the Late 1980s 69
 What Was Science Saying? . 70

STURP and the Shroud 71
Major Theories of the 80s 72
Science and the Shroud 80
Conclusion 89

5 The New Testament and The Shroud 93
Crucifixion 94
The Burial 96
Jewish Burial Customs 96
The Wrapping 98
The Grave Clothes 99
The Unwashed Body 102
Conclusion 104

6 Carbon 14 – Is the Shroud a Medieval Object? 107
Laboratory Selection 109
Methodology 111
Dates or Discrepancies? 116
Conclusion 123

7 Other Tests for Age: Their Reliability and
Their Results 125
Scientific Research 126
Pollen ... 127
Mites .. 129
Artifacts 130
Archeological Peculiarities 132
Textile Studies 133
History .. 133
Conclusion 139
Some Important Cautions 140
Conclusion 142

8 The Burial Cloth of Jesus? 145
Jesus and the Man in the Shroud 146
The Identification of the Man in the Shroud 150
Scholarly Opinions 159
Conclusion 163

9 Death by Crucifixion 165
The Discoveries and Disputes of Pathology 165
Current Shroud Pathology: An Overview 166

Further Debate . 168
Pre-Crucifixion Suffering . 170
The Positions of the Nails . 171
Cause of Death . 174
The Spear in the Side . 176
Signs of Death . 177
Washing the Body . 179
Marfan's Syndrome . 180
Conclusion . 182

10 Evidence for the Cause of the Image 185
Hypotheses Involving Fakery 186
Natural Hypotheses . 190
The Scorch Theory . 194
Questions about the Scorch Theory 195
Conclusion . 199

11 New Evidence for Jesus' Resurrection 201
Scientific Opinion in the 80s . 202
The Evidence . 205
A Brief Apologetic for the Resurrection 209
A Miracle? . 211
A Philosophical Case . 212
A Theological Case . 213
Conclusion . 213

Part 3: Into the Millennium

12 Shroud Studies in the 90s . 219
Conservation and Preservation 219
Archiving . 222
Image Formation: What's New? 222
Provenience Studies . 224
1994 Fire Simulating Laboratory Model 224
The Biological Fractionation Theory 224
Bio-Plastic Coating Theory . 225
Conclusion . 226

Part 4: Significance of the Shroud
13 The Image That Won't
Go Away . 229
A Historical Perspective . 230

Skeptical Antagonism.......................... 234
The Testimony of the New Testament.............. 238
A Scientist's Conviction 248
Decide for Yourself 249

Afterword 251

Appendix: Timetable for Recent Shroud Studies
 and Events (1988–2000).......................... 255

Notes ... 259
 Chapter 2: History of the Shroud 259
 Chapter 3: Fraud and the Shroud................. 260
 Chapter 4: Back to the 80s 260
 Chapter 5: The New Testament and the Shroud 263
 Chapter 6: Carbon 14: Is the Shroud a
 Medieval Object?............................. 264
 Chapter 7: Other Tests for Age:
 Their Reliability and Their Results 266
 Chapter 8: The Burial Cloth of Jesus? 267
 Chapter 9: Death by Crucifixion:
 The Discoveries and Disputes of Pathology 268
 Chapter 10: Evidence for the Cause of the Image 272
 Chapter 11: New Evidence for Jesus' Resurrection? .. 275
 Chapter 12: Shroud Studies in the 90s 277
 Chapter 13: The Image that Won't Go Away 277

Index ... 279

Dedication

I would like to dedicate this book, *Image of the Risen Christ*, to my son, Kenneth, whose budding mastery of Hebrew has encouraged me to deeply explore the deep truths found in the Word of God. Our Lord is truly restoring "a pure language" to His people as He promised thousands of years ago (Zephaniah 3:9). I encourage my son, as I do all readers, to always remember Jesus' charge to Peter (Luke 22:32) "I have prayed for you that your faith may not fail" and that you might "strengthen your brothers" of every tribe, nation, people, race, and tongue in the fulfillment of your prophetic destiny.

In His Love,
Your proud and loving Father.
Ken

Acknowledgments

I would like to first acknowledge my gratitude to my Lord and Savior Jesus Christ, whose "gifts and callings" in my life have truly proven to be lasting and "without repentance." Jesus has demonstrated His grace and love in my life and ministry. For many years I have wanted to produce a fair, in-depth study of evidence concerning the mysterious Shroud of Turin.

I would like to thank the many people who helped to make this book a reality. Without their generous help this book would never have been produced. Grant and Kaye Jeffrey saw the potential and believed in this project enough to commit to publish it. A special thanks to Michele Dalbo who labored intensely to synthesize my extensive research files into a "readable" project. Words cannot fully express my gratitude to my beloved wife, Mary, who continues to be my best friend, partner, and "cheerleader" through it all. Finally to all of the staff, designers, editors, and typesetters of Frontier Research Publications, Inc., who have taken the dream and produced it in a readable format for our readers. Thanks to all of you for a job well done. My heartfelt prayer is that God will use this material to awaken many people to the wonderful evidence about the reality of Christ's death and resurrection that is revealed through an examination of the mysterious Shroud of Turin.

Dr. Kenneth Stevenson

Image of the Risen Christ

Foreword

Ten years ago I had the privilege of meeting and becoming friends with Dr. Kenneth Stevenson, a fascinating and accomplished young man who shared with me the remarkable evidence about the mysterious Shroud of Turin. Previously, like many other Christians, I had ignored the claims that the Shroud of Turin could possibly be the actual burial garment of Jesus Christ on the basis that it appeared to be only a Catholic "relic." In addition, the well publicized claims that the 1988 radioactive carbon 14 dating tests suggested that the Shroud was woven approximately A.D. 1260 seemed to settle the matter once and for all. Why should I bother to investigate something that had already been discredited by leading scientists?

However, that evening I began a journey of scientific and historical discovery about this mysterious, ancient burial cloth that has continued for a decade and continues to fascinate me today. Far from repudiating the possibility that the Shroud of Turin is the genuine burial cloth of Christ, Dr. Kenneth Stevenson revealed that the evidence strongly suggests the real possibility that this mysterious linen cloth might have covered the actual body of Jesus of Nazareth almost two thousand years ago. It was fascinating to examine the reports that suggested the 1988 carbon 14 dating tests

were inaccurate and that all C-14 radioactive tests on antique objects needed to be redone after stripping the biological contamination that accumulates on these old objects such as fibers from the Shroud.

Incredibly, for over three decades the world's leading scientists from many diverse disciplines have discovered astonishing evidence that suggests that this ancient linen cloth bearing a mysterious and unexplained image of a crucified man is not a fraud. Furthermore, after more than 150,000 hours of intense scientific testing, greater than that applied to any other ancient artifact in history, no one has been able to present a credible explanation of how this strange image was formed on the cloth. Despite valiant efforts, various agnostic researchers have failed to come up with any plausible mechanism which would account for how a medieval artist could possibly have produced such a complex and medically accurate image of a crucified man.

Dr. Kenneth Stevenson is a remarkable young man who graduated from the U.S. Air Force Academy and became one of the youngest aircraft commanders in the Strategic Air Command to fly America's huge B-52 bombers. After leaving the Air Force, Ken joined the team of pilots who fly the top executives of IBM corporation around the world. Finally, the Lord led Ken to enter into full-time ministry as he began a ministry in New York State which is now known as Everlasting Covenant Church.

In 1978 Ken became the official spokesman for the Shroud of Turin Research Project (STURP), the major scientific project to evaluate the Shroud using the most comprehensive scientific techniques available. For a number of years this team of almost fifty American scientists examined the Shroud utilizing the most modern equipment and technologies available to probe its ancient secrets. He was the editor of the Proceedings of the U.S. Conference of Research on the Shroud of Turin. His personal participation on the STURP team and his familiarity with the technical data provides an excellent

background for an in-depth evaluation of the evidence about this burial cloth. Ken continues his in-depth studies about the Shroud of Turin, and remains in close contact with many of the scientists and researchers who are carrying out additional studies about the Shroud. He authored two great books about the Shroud of Turin, *The Verdict on the Shroud* (1981), and *The Shroud and the Controversy* (1991) with co-author Gary R. Habermas. Almost two years later a tremendous amount of new discoveries and additional scientific data provides new insights into this most amazing of ancient artifacts concerning the life, death, and resurrection of Jesus of Nazareth. Ken has presented the latest discoveries and theories that have been recently developed regarding the origin of the Shroud. This new book, *Image of the Risen Christ*, will answer your questions about the latest research on the Shroud and assist you in coming to your own determination of the true nature of this ancient burial cloth.

I am impressed with Ken's balanced and fair evaluation of the evidence both for and against the possibility that the Shroud may be the actual burial garment of Jesus. While rejecting the tendency of a few to elevate the Shroud to an object of faith, Ken understands that, in our increasingly skeptical generation, the latest remarkable scientific and historical evidence about the Shroud of Turin has the capacity to awaken a profound interest in the life, death, and resurrection of Jesus Christ on the part of normally indifferent citizens.

In this fascinating book, *Image of the Risen Christ*, Dr. Kenneth Stevenson provides the most balanced, comprehensive and in-depth analysis of the unfolding scientific and historical evidence that bears on the question of whether or not the Shroud of Turin could actually be the true burial garment of Jesus of Nazareth. This very readable book will provide easy access to the astonishing discoveries taking place in laboratories around the world that suggest this ancient burial cloth may have touched the body of Christ and

may actually contain an image of the remarkable moment when He was resurrected from death to live again. The Shroud of Turin is controversial. You owe it to yourself to become informed about the fascinating new research that suggests the Shroud may have originated in Israel and may actually date back to the time of Christ.

Some Christians may ask: "Why should I care about whether or not this Shroud is the genuine burial cloth that wrapped the body of Jesus Christ?" I believe that the Shroud is vitally important to investigate because, if it proves to be genuine, then God has imprinted a mysterious image of the moment of Christ's resurrection on this ancient cloth as a virtual photograph of the greatest miracle in history—Jesus Christ's conquest of death. Many people have become fascinated by the Shroud and have then examined the Gospel's evidence about Jesus to discover a personal relationship with the Son of God.

Dr. Kenneth Stevenson provides a remarkably balanced examination of this fascinating subject that will interest, thrill and provoke serious thought among all those who read this book. As a Christian author who shares Ken's passion for excellent material that supports the historical truth of our Christian faith, I strongly recommend this book, *Image of the Risen Christ*, as a study that will motivate all believers to contemplate the awesome price Jesus paid on the Cross to win our reconciliation to our Heavenly Father. My prayer is that *Image of the Risen Christ* may awaken our generation with the powerful evidence that Jesus Christ died for our sins and that He was resurrected from the dead as illustrated by the mysterious image on the Shroud of Turin.

Dr. Grant R. Jeffrey
Toronto, Ontario
January 2000

Introduction

Some may ask, "Why write another book about the Shroud of Turin when you have already written two others?" Good question—I thought it was time to take another look at this important subject as the new millennium begins and in light of the new research and theories developed in the last few years.

I begin by encouraging an open-minded look at both the old and new data on the Shroud. I want to avoid both the tendency to look at the Shroud as a relic on one side and a closed-minded unbelief on the other. I need to be cautious, carefully following the data wherever it leads. While I wish to arrive at carefully reasoned conclusions, I also need to be sensitive to alternative theses. Open-mindedness requires a critical but fair investigation of all worthwhile views.

How do I intend to promote this open-mindedness? I propose a careful re-evaluation of some of the major conclusions in my study of the Shroud. I will pay special attention to issues with direct bearing on the question of authenticity. For example, how authoritative are the results of the carbon dating? Can they be challenged in any valid way? Concerning the cause of the image, have any worth-while hypotheses surfaced since the late 80s? Or do any older theses of image development become more important in light of the doubts

cast by the carbon-14 dating results? The fundamental approach, and one of the most important features of this book, will be to set the data (both old and new) before you so that you can arrive at your own conclusion.

To be sure, one's own presuppositions play a crucial role in how one views and analyzes the Shroud and the evidence and theories surrounding it. I am likewise influenced by my own thoughts on this subject. Religious persons tend to accept the authenticity of the Shroud despite the objections, while critics and atheists usually reject its authenticity regardless of the evidence in its favor. But these radically opposed views are examples of bias, not of an honest wrestling with the data to arrive at an objective conclusion.

I ask you to reconsider your own biases and view the data as carefully as possible. I want to help by laying out the major options. Of course, after my own studies on the Shroud, I have reached my own conclusions, which I will share with you. But these are not necessarily the last words. I want no one to accept blindly my conclusions but rather to arrive at a personal evaluation through careful examination of the evidence.

The Approach of This Book

Part 1 of this book will take you back to the 1980s and to my books *Verdict on the Shroud* and *The Shroud and the Controversy* that I co-authored with Gary R. Habermas. We'll explore some of the basic facts about the Shroud, its amazing history, how science relates to the Shroud, and just who was really buried in the Shroud. Because an entire generation has grown up since the publication of my first books, I thought it was time to educate them and allow them to form their own opinions based on science, evidence, and faith. The generations who in the early 80s looked at all the Shroud evidence and findings will want to again revisit all the facts—past and present—to see if their original opinions are still valid or if they need to re-evaluate and form new opinions.

The Shroud and the Controversy was published in 1989. That book discussed updates and findings since the publication of my first book, *Verdict on the Shroud*. In particular, Carbon-14 (C-14) dating was discussed along with various other tests and theories. Some of this information will again be presented as background for new information.

Part 2 will present interesting new findings and theories of the 90s.

Part 3 will discuss the significance of the Shroud in the lives of believers and non-believers and will present my conclusions from the past and my conclusions now, over twenty years later, and how they have been influenced and changed by new evidence and by my faith.

PART 1

The Importance of the Shroud

1

What is the Shroud and Why Should We Study It?

On the face of it, the Shroud of Turin is an unlikely object for serious scientific study or religious edification. The Shroud is an old linen cloth thought by many Christians to be the burial shroud that Joseph of Arimathea and Nicodemus draped around the body of Jesus before they laid Him in the tomb. This seems hardly possible. Furthermore, the cloth is imprinted with an image. To the naked eye, the details of this image are hard to discern. It is ghostly, dim, and it fades into a hazy blur as the viewer approaches the cloth. How plausible is the claim that this is a highly detailed image of Jesus Himself as He lay in the tomb?

Yet the Shroud of Turin will not be consigned to the category of colorful but bogus relics such as the crown of thorns, the crucifixion nails, and the rod of Moses. Some medieval bishops were sure that the Shroud was a painting, but a painting is one thing that scientists of the twentieth century who have studied the Shroud are sure that it is not.

The irony of the situation is that the mystery of the Shroud has deepened as scientists have inspected it with

ever-more sophisticated instruments. In 1898, when the Shroud was first photographed, the image was found to be a negative—its light and dark values were reversed when it was "printed" on a piece of photographic film. This "print" was far more detailed and life-like than the original. Then in the mid-1970s, microscopic examination of the cloth failed to turn up any sign of pigment, dye, ink, powder, or any other substance that an artist could have used to paint the image. Also in the mid-1970s, an image analyzer connected to a computer found that the Shroud image contains three-dimensional information, a wholly astounding and unexpected discovery, and one which still has no convincing explanation.

Millions of Christians became intensely interested in the Shroud when the photographs of the negative image were published in books, magazines, and newspapers throughout the world. These photos revealed a crucified body in extraordinary detail. Believers and unbelievers alike could count the scourge wounds, observe a bloody wound in the man's side, see his pierced wrists and feet, and note the signs of a beating in the face. The man of the Shroud, it seemed, suffered and died very much the way the Gospels say Jesus of Nazareth suffered and died.

Thus began the phenomenon of the Shroud. It is very much a twentieth-century phenomenon in need of more study as we begin the twenty-first century. The Shroud of Turin was an unexceptional relic until people began to examine it with modern scientific instruments. The result of the many scientific tests has been a remarkable possibility: the more we learn about the Shroud, the more likely it seems that the cloth is what it appears to be—the burial garment of Jesus Christ.

The phenomenon of the Shroud consists largely of intense reactions to the possibility that it is genuine. If archeologists digging in a ruin somewhere in the Mediterranean world had unearthed a cloth imprinted with a mysterious image of

some unknown person, the discovery would probably be greeted with a moderate amount of excitement and curiosity. But the Shroud of Turin is said to bear an image of Jesus Christ. Thus people's opinion of the Shroud often reflects what they think about Jesus, rather than calm reflection on the possibility that an object with religious value may have survived since the first century A.D. We should take a closer look at some of these reactions.

A common response to the Shroud is instant disbelief: it *can't* be genuine. At the beginning of the twentieth century, Yves Delage, an eminent professor of anatomy and a well-known agnostic, read a paper to his colleagues in the French Academy in which he concluded that the man of the Shroud was Jesus Christ. He was greeted with derision and outrage. Every scientist who has seriously studied the Shroud has met with some version of this response. Instinctive disbelief is a common reaction.

The disbelieving view—the assumption that the Shroud *cannot possibly* be genuine—has its source in something other than scientific reasoning. It *is* hard to believe that the actual burial garment of Jesus Christ, imprinted with a detailed image of his body, possibly reposes today in a cathedral chapel in Turin, Italy. Yet archeological artifacts, including burial clothes, survive from times earlier than the first century A.D. and there are things in the universe more curious than a mysterious image on a linen cloth. The likely reason for instant disbelief is that the Shroud may have something to do with Jesus Christ, along with the suggestion, seldom entirely absent in a discussion of the Shroud, that something miraculous is involved in its preservation and its image. In short, the Shroud seems to offend something in the modern temperament. It touches a nerve. Yet, mere disbelief does not deal realistically with the question of the Shroud's possible authenticity.

Some people's response is one of hostility. Madalyn Murray O'Hair, the noted American atheist, labeled the

Shroud a fraud in a speech at Easter 1981. (Her speech was an attack on Jesus Christ and the church.) People who become hostile about the Shroud are often hostile to Christianity and to the man who is at the center of the Christian faith. Some single out the Shroud as an object of their emotional unbelief. The atheists' unbelief mimics Christian faith, just as organized atheism mimics organized religion.

Many Christians view the Shroud with suspicion and are wary to talk about its possible significance. Many of these people are Protestants—both conservative and liberal—but others are Catholics. Their complaint is that the Shroud distracts Christians from more important elements in the Christian life—the Bible, fervent faith in God, and service to others. These Christians have a point. Relics have not always strengthened Christian faith. Relics have distracted Christians from more important things, and they have been abused. However, the remedy is not to dispense with all relics, but to investigate their authenticity. The Shroud of Turin, if authentic, can build faith. It could possibly reveal details of Jesus' crucifixion and death—and Atonement, the sacrificial act that Christians believe brought about man's salvation.

At the other extreme are Christians who revere the Shroud. For a few, it is more important than the Bible, correct doctrine, loving service, or any other aspect of Christian life. These Christians, like those who are suspicious of the Shroud, need to take a more balanced approach. The intensity of many of these reactions is in a sense understandable. The Shroud may be important. The stakes are high. The fact that the Shroud relates to Jesus Christ elicits emotional responses, but also makes it imperative that we not reach conclusions swiftly or lightly. Any conclusion that the Shroud is genuine must be based on a convincing body of facts. Caution is also in order if it seems likely that the Shroud is authentic. If the Shroud really is the burial garment of Jesus, we must carefully

consider how to fit it into the scheme of our Christian faith and life.

Yet these real scientific and pastoral problems do not fully explain the phenomenon of the Shroud. It also has spiritual roots. The claim about the Shroud involves Jesus Christ, and His claims on us are great as well. The Shroud seems to suggest that He died the way the Scriptures say He did. If so, he may have risen from the dead the way the Scriptures say He did.

Until this century, the Shroud of Turin has been almost exclusively an object of interest to Roman Catholics. Catholics have viewed it, written about it, studied it, venerated it, and protected it. In recent years, however, the Shroud has become an object of intense interest to many others as well, including evangelical Protestants and secular scientists. In fact, many of the scientists who have studied the Shroud have been agnostics, and there is a great deal of general public interest in the Shroud among unbelievers as well as believers. Why has this burgeoning interest arisen in an object traditionally associated with the Catholic Church?

One reason has been changes in Roman Catholic piety. The old-style Catholic piety which sometimes led to the attribution of miraculous and wonder-working powers of the Shroud and other relics, is becoming a less prominent feature of daily Catholic life. At the same time, evangelical Protestants have realized that the Shroud, if authentic, contains valuable information about Jesus Christ, and that its implications could potentially help the cause of evangelism in the modern world. Viewed properly, the Shroud can build faith, not misdirect it.

However, the main reason for the new interest in the Shroud is, ironically, the advancement of science. Science may have shaken the beliefs of many Christians, but it has only deepened the mystery surrounding the Shroud of Turin. Instead of debunking the Shroud, the intensive scientific investigations during the 1970s made it even more

intriguing. Public interest has increased as chemists, physicists, engineers, and technicians admit their bewilderment with the image and the process that formed it.

The skeptical world-view which often accompanies modern science has ironically created a climate conducive to serious interest among Christians. The question of authenticity has become more important than ever before. In the Middle Ages, the Shroud of Turin was of value primarily for personal piety. The church encouraged Catholics to use it as a way of meditating on the passion and death of Jesus Christ, but it did not make official claims that the Shroud was really the burial garment of Jesus. By contrast, the Shroud today begins to look as if it could challenge unbelief by offering physical evidence for the death and resurrection of Jesus Christ. The skeptical modern mind is receptive to such evidence precisely because it is skeptical. For some, perhaps, it is the only type of evidence that would be convincing.

This is why the Shroud is potentially so important. This is an age characterized by widespread rejection of the supernatural and the miraculous. This skepticism has invaded even the church. Many modern persons—even theologians, Bible scholars, and pastors—have a skeptical view of the literal, physical resurrection of Jesus Christ. "Scientific reasoning" compels them to doubt that Jesus actually rose from the dead. Many of them understand the resurrection as a "spiritual" phenomenon—Jesus "rose" in the minds of His disciples, and He lives on today in the "memory" of His followers.

It is hard to imagine a more effective challenge to this "scientific" view than the Shroud. In an age when science is making faith in the Gospel difficult, science may yet support evidence for the Gospel's validity.

However, I cannot reflect on the possible significance of the Shroud until I assess the evidence for its authenticity. This I will do in the following chapters. I will adopt a cautious, even skeptical, posture; where facts are incomplete

or hard to interpret, I will say so. Yet I will try to assess the facts about the Shroud and make judgments about their significance. A major goal will be to reach a verdict. Science and historical evidence cannot prove that the Shroud of Turin is the burial garment of Jesus Christ, but it may be possible to reach a likely conclusion—"beyond a reasonable doubt," to borrow the American legal term. Most scientific conclusions about complex phenomena are actually judgments of probability. Scientists gather facts, and then create theories to explain those facts. The theories themselves are not facts. When scientists say they have reached a conclusion, they usually mean that a certain theory is the most likely explanation for the observed facts. My goal will be to reach a conclusion of this type to account for the known facts about the Shroud of Turin.

Like many who have studied the Shroud, I was initially skeptical of it. I first heard about it while I was a cadet at the U.S. Air Force Academy. I later returned to the Academy to join its faculty as a teacher. Studies of the Shroud by my friends at the Academy persuaded me to examine the facts carefully and eventually drew me into the Shroud of Turin Research Project (STURP). I co-authored *Verdict on the Shroud* to provide a serious but popular presentation of the scientific data about the Shroud, as well as a presentation of a carefully reasoned conclusion about its possible significance.

Because the Shroud is an unusual object for scientific study, you must clearly understand the framework within which I will present and assess the facts. We will not assume that the Shroud is genuine, or in any way favor a miraculous explanation of its image. At the same time, I cannot prejudice my study by rejecting the miraculous a priori, assuming that supernatural events cannot occur. In other words, my treatment of this subject will be balanced. I will avoid both a pious approach, which interprets every fact as proof of the validity of the Shroud, and a skeptical approach, which refuses to view the evidence objectively. I intend to treat the

available data fairly so that my conclusions rest firmly on the known facts.

To this end I would caution the reader to read carefully and to weigh the evidence accordingly. Do not allow skepticism about miracles or a distaste for relics to mislead you. View the evidence as impartially as possible so that you can reach whichever conclusion is best supported by the facts.

2

History of the Shroud

The complex history of the Shroud poses a problem for historians. If Christ's burial cloth, imprinted with an image of His crucified body, had survived throughout the centuries, it would have been famous. The Shroud would be the most awesome relic in all of Christian history; one would expect its existence to be well documented.

This is not the case. There is little historic record of the existence of Jesus' burial shroud before the mid-fourteenth century except for a reference to his burial garments in the Gospel according to the Hebrews dated approximately 125 A.D. In fact, such a shroud is scarcely even mentioned in any ancient source before the sixth century. The Gospels are relatively silent about it, and the few scattered references to Jesus' burial garment in church liturgies do not constitute absolute proof that the Shroud actually existed during those years. Moreover, very few of the early references that do exist mention the most astounding fact—the image on the Shroud. Why, skeptics understandably ask, would no one have reported such a significant detail? Those who question the Shroud's authenticity have long regarded this lack of a solid historical record as the weakest link in the argument.

The problem is compounded by the fact that the circumstances surrounding the Shroud's emergence as a historical object appear suspicious. The Shroud first became widely known around 1357 when it was exhibited in a small wooden church in the sleepy French provincial town of Lirey, a village about one hundred miles southeast of Paris. The Shroud's owner, Geoffrey de Charny, had been killed the year before by the English at the Battle of Poitiers. Impoverished by her husband's death, his widow, Jeanne de Vergy, hoped to attract pilgrims—and their monetary offerings—by exhibiting Jesus' burial garment in the local church. Crowds did gather—but only for a time. Bishop Henri of Poitiers, the local ordinary, quickly ordered the exhibition stopped, apparently doubting that a French noble family of modest means could have come into the possession of the true Shroud of Christ.

Jeanne de Vergy and other members of the de Charny family never explained how Geoffrey de Charny managed to come into possession of so fabulous a relic. Indeed, the question remains unanswered to this day (although, as we shall see, there is a plausible explanation). When exhibition of the Shroud resumed twenty-five years later, it is reported that Bishop Pierre D'Arcis, Bishop Henri's successor, branded the Shroud a forgery and insisted that Pope Clement VII stop the display. However, the pope did not respond. Only later, when the Shroud came into the possession of the powerful House of Savoy, was it finally accepted as the true Shroud of Christ. But even then, acceptance came slowly. The Roman Catholic Church, in fact, has never claimed that the Shroud is genuine. Now, in the twentieth century and the approaching twenty-first century, some scientists accept the Shroud's authenticity more readily than medieval Christians did.

Can the silence of the historical record be explained? Is there any evidence for the Shroud's existence prior to its appearance in Lirey? There is, in fact, a case to be made for the historical authenticity of the Shroud. It is partly a circumstantial case, one relying on probabilities and

likelihood, and it still contains a few gaps. Nevertheless, it is a plausible theory. In addition, scientific investigation has revealed other strong evidence for a first-century origin for the Shroud of Turin.

Hints from Art History

Our historical inquiry can begin with the image of the face of the man buried in the Shroud. The face—bearded, long-haired, with Semitic features—closely resembles the standard artistic rendition of the face of Christ. I have often traveled with a three-dimensional representation of the face of the man in the Shroud, created with the assistance of computer-aided image analysis. People immediately recognize this as the face of Christ—precisely because it *is* the standard face of Jesus in art. It seems that everyone has seen it before. The Shroud face either reflects or has influenced the way most artists have portrayed Jesus for centuries.

Why is this so? Skeptics argue that the similarity betrays forgery: the forger, presumably working in the fourteenth century, painted the face according to the standard artists' rendition of the face of Christ at the time. But if the Shroud is more than 700 years old, the same similarity would then argue for its authenticity. If it existed before the fourteenth century, the Shroud may have influenced or even determined the standard portrayal of Christ in art.

A French biologist and artist named Paul Vignon was probably the first person to note the similarities between the Shroud face and artistic renderings of the face of Jesus. Later researchers, most notably Edward Wuenschel, Maurus Green, and most recently, the British historian Ian Wilson, have done an exhaustive comparison of the Shroud face with ancient images, particularly Byzantine icons.[1] They have developed evidence for what has become known as the "iconographic theory," the theory that the Shroud was known to artists as early as the sixth century, and that it inspired the conventional likeness of Christ.

These art detectives have been diligent. Vignon and Wuenschel thought they could find twenty "oddities" in Byzantine frescos, paintings, and mosaics which resemble peculiarities of the Shroud image. Wilson decided that fifteen of these are substantial enough to offer evidence in support of the theory.[2] A close study of the face of the Shroud image, for example, reveals a transverse streak across the forehead, a three-sided "square" between the brows, a "V" shape at the bridge of the nose, a raised right eyebrow, an enlarged left nostril, a transverse line across the throat, and two strands of hair at the top of the forehead. These appear in Byzantine icons. The most unusual of the markings, a combination rectangle and "V" at the bridge of the nose, was found in eighty percent of all the icons examined. Wilson found almost equally high percentages for all of the markings over a representative group of icons. This high frequency of similarities suggests a relationship between the Shroud face and Byzantine depictions of Jesus.

Why would a competent artist include these peculiarities in his art? The obvious answer is that, for some reason, he believed they belonged there. Wilson and others suggest that artists were copying one image, a holy likeness of Jesus that was revered as genuine, and hence definitive.

This image, if it existed, seems to have begun to influence Christian art around the sixth century A.D. The appearance of Christ in portraits shifted dramatically around this time. Before the sixth century, there was little similarity among pictures of Christ; the earliest portraits show Him as a beardless, short-haired youth.[3] The Gospels give no information about His appearance, and Jews, the earliest Christians, probably shunned portraits of Jesus because Jewish law prohibited religious images.

Around the sixth century, however, a conventional likeness of Jesus began to emerge. The majority of these paintings display at least some of the telltale peculiarities, which are also visible in the mysterious image of the face of

the dead man on the Shroud of Turin. Christ is bearded, even fork-bearded like the man in the Shroud. Often His right eyebrow is raised, sometimes His left, as if the artist understood that an image produced by contact with His body would be reversed when viewed. Many of the Byzantine icons show a streak across the forehead and another across the throat, corresponding to fold marks on the Shroud face. Most of these icons have a peculiar box and "V" feature at the bridge of the nose.

How can this be explained? Did the Shroud image influence Christian art from the sixth century onward? If so, why doesn't history say more about the existence of Jesus' burial garment? The answer to this puzzle can help establish the existence of the Shroud of Turin before the mid-thirteenth century if there is a record of a holy image that was revered as the true likeness of Christ from the sixth century onward, and if that image was actually the Shroud in another guise.

The Mandylion

The reason for the shift in the artistic representation of Christ in the sixth century is no mystery. The image that changed Christian art is known to history. It was a representation of Christ's face known variously as the "image of Edessa," the "Edessan image," and the "Holy Mandylion." This was a cloth found in 525 A.D. in a niche above the west gate of the walls of the city of Edessa, now Urfa, in south central Turkey. In 944, the Mandylion was taken to Constantinople, the capital of the Eastern Empire, where it was revered as the true likeness of Christ. It was seldom exhibited publicly; an ancient Byzantine hymn suggests that it was regarded as too holy to be viewed. Yet monk-artists almost certainly saw it privately and used it as the model for the representation of Jesus on icons. Then in 1204, the Mandylion disappeared during the sack of Constantinople by a marauding mob of crusaders from Western Europe. Robert de Clari, a Crusader

historian, inquired after the fate of the image and concluded that "neither Greek nor Frenchman knew what became of it."

The story of the origin of the holy image of Edessa is legendary; perhaps it contains a kernel of fact. It is said that Abgar V, first-century ruler of Edessa, was stricken with leprosy. He wrote to the healer-teacher Jesus of Nazareth in Palestine, asking Him to come to Edessa to cure him. Jesus is said to have sent a letter declining to come, but promising to send a disciple instead. A disciple did eventually come after Jesus' death and resurrection, bearing with him a holy cloth imprinted with the Savior's image. At the sight of the cloth, Abgar was cured and the Christian faith was established in the city.[4] Some accounts suggest that the disciple who brought the cloth to Edessa was Jude Thaddeus. If so, then the bearer of the Mandylion may have been close to the Lord, perhaps even a relative. Other scholars dispute the identification of Jude Thaddeus with the apostle Jude and identify the messenger to Edessa only as one of the seventy disciples.

There are some reliable historical facts behind this account. Abgar V really existed, and the Edessa area was evangelized soon after Jesus' departure from this world. There was a tradition in Edessa that a holy image of the Lord was associated with this evangelization.

The Holy Image of Edessa quickly disappeared from history. Abgar Vs son, Mannu, reverted to paganism and persecuted Edessa's Christians. The cloth vanished, but its memory was preserved, especially after Christianity was re-established in Edessa around the end of the second century A.D.

The Edessan Christians may have hidden the holy image in the city walls when Mannu began to persecute them in the mid-first century. They may have done this very quickly, perhaps under conditions of desperate danger, as Mannu and his men hunted them down. Perhaps all those who knew

the precise location of the holy cloth were killed, while the survivors preserved its memory.

If Christians hid the holy cloth, they could not have chosen a better hiding place. The niche in the wall was dark and protected from the elements, especially the severe floods which, periodically, devastated Edessa. It was rediscovered only because the walls themselves were being repaired. After its reappearance, the holy image was again revered and its discernible influence on art began at this time. The Emperor Justinian built a shrine and a cathedral for the cloth, and it somehow survived the frequent outbursts of iconoclasm in the eighth and ninth centuries during which many religious icons and paintings were destroyed.[5]

The holy image came to Constantinople in 944 as a result of what Wilson calls "one of the most bizarre military missions in all history." The aged and superstitious Byzantine Emperor, Romanus Lecapenus, decided to bring the Mandylion to Constantinople, the center of Eastern Orthodoxy. Romanus thought that this famous relic would provide divine protection for his city, and he was probably motivated by a desire to procure it from a city in Moslem territory. Romanus sent his most able general on a campaign across Asia Minor to retrieve the cloth. When the army reached Edessa, its commander offered the city's emir a strange but attractive deal. In return for the image, the army would spare Edessa, release 200 Moslem prisoners, pay a ransom, and guarantee Edessa's perpetual immunity from attack. The emir eventually agreed to these demands, but then Romanus' army had to contend with Edessa's outraged Christian minority, which, of course, revered the image and refused to surrender it. The Christians twice tried to pass off copies of the original, but eventually Romanus' men secured the real cloth and returned it in honor to Constantinople.[6]

In Constantinople, the cloth became known as the Mandylion, a name derived from an Arabic word meaning veil or handkerchief. There it remained, one of the holiest and

most revered of Orthodoxy's relics, until its disappearance in 1204. During these centuries, the Mandylion exerted its influence on the typical Byzantine portrait of Jesus.

The Mandylion vanished in an orgy of pillage and looting. A European army, gathered in Constantinople to prepare for the Fourth Crusade, decided to attack fellow Christians instead of infidels. It was one of the most shameful episodes in Western history. The crusaders looted houses, palaces, and Orthodox churches. A Christian army, supposedly marching for the glory of God, had struck a mortal blow at one of the world's great Christian cities.

The Shroud and the Mandylion

Were the Shroud and the Holy Mandylion the same cloth? Although the evidence from art history suggests a close connection, the link is not obvious and many questions must be answered. The very first question is why the disciples of Jesus would have allowed their Lord's burial shroud to leave their possession.

We cannot know for sure, but it is likely that the disciples regarded Jesus' burial garment somewhat differently than we might today. For Jewish Christians, the most important feature of such a garment would have been the fact that it was a burial cloth—an unclean thing according to Jewish law. Anyone who touched it was rendered ritually impure. In addition, Jewish law prohibited religious images: this image would have revealed the details of a grisly scourging, beating, and crucifixion—the punishment of a criminal. In short, Jesus' disciples had good reason not to talk much about His burial shroud; they could have hidden it away carefully.

It is also necessary to bridge the gap between the Mandylion's disappearance in 1204 and the mysterious appearance of the Shroud in France in 1357. Nothing definite is known of the Mandylion after the sack of Constantinople. Some historians of the Edessa image surmise that the cloth was taken to Europe along with other looted relics and was

destroyed in the French Revolution. One crusader thought that the Venetian doge sent it to Venice, but the ship sank with all on board. Robert de Clari, the chronicler of the Fourth Crusade, says that no one knows what became of the Holy Mandylion.

Ian Wilson proposes an intriguing theory to link the Mandylion with the Shroud. He suggests that from 1204 to the early 1300s, the Mandylion-Shroud was in the possession of one of the most exotic and mysterious groups in the medieval church—the Knights Templars.[7]

The Knights Templars were a religious order of knights founded about eighty years before the sack of Constantinople for the purpose of defending the crusader territories in the Holy Land. The Templars attracted powerful friends and noble members because they combined the two great passions of the Middle Ages—religious fervor and martial prowess. The members of the order took vows of poverty, chastity, and absolute obedience, and their courage in battle was legendary. They vowed never to retreat under attack, and they defended crusader territories in the Holy Land with resourcefulness and great bravery. By the time of the sack of Constantinople, the Templars had grown very powerful. They built impregnable fortresses in the Holy Land and in Europe. Princes and nobles in those unsettled times often entrusted their valuables to the Templars for safekeeping. Among these valuables were many relics.

The Templars surely had the strength and motive to safeguard a relic as fabulous as the Mandylion-Shroud. As one of the principal traders of relics from the Fourth Crusade, the Templars would have been in a position to acquire it, and their wealth would have protected them from the common temptation to sell relics for much needed cash. They would have been able to keep its location secret in their network of fortresses and castles. As pious and noble knights, they would also have honored it. Did the Knights Templars in fact acquire the Mandylion-Shroud and keep it hidden for 150

years? There is some suggestion that they did. The evidence is circumstantial, even fragmentary. It is, in large part, an argument from historical silence—the weakest of all historical arguments. If the Shroud and the Mandylion are the same, and if the cloth lay hidden for 150 years in Europe or the Near East, the secretive Knights Templars were one group that could have hidden it.

One suggestive piece of evidence emerges from the rumors during the thirteenth century about the Knights' secret initiation rites and worship services. Scholarly debates continue to this day about what actually went on at these secret gatherings. The Templars' enemies, of which there were many, accused them of such offenses as spitting on the cross, denying Christ, sodomy, and idol worship. Most scholars find these charges unjustified. The Templars were orthodox Christians who gave admirable service to the church. Nevertheless there may have been some customs in their initiation and worship services that others may have interpreted as idol worship.

The Templars were said to worship a mysterious "head" at their secret ceremonies. During their initiation, which usually took place near a model of the tomb of Christ, each new Templar was given a white mantle imprinted with a red cross symbolizing Christ's crucified body. According to Wilson, "a special ceremony" was devised for initiated members of the order, whereby they were given a momentary glimpse of the supreme vision of God obtainable on earth, before which they prostrated themselves in adoration.[8]

Could this vision have been a glimpse of the Mandylion-Shroud? The strongest indication that it could have been comes from a painting discovered in 1951 in a Templar ruin in the village of Templecombe, England. The painting resembles Byzantine copies of the Mandylion and also conforms to some of the vague Templar descriptions of the

"head" that played such an important role in their initiation and worship ceremonies.

This possible link between the Templars and the Mandylion is paralleled by a possible connection between the Templars and the Shroud. On October 13, 1307, King Philip the Fair of France, the most powerful enemy of the Templars, suppressed the Order. He imprisoned its members and subjected them to inquisition and torture. On March 19, 1314, the leaders of the French Templars were led to a public scaffold before the Cathedral of Notre Dame in Paris and ordered to repeat their "confessions," which, of course, had already been extracted under torture. The grand master of the French Templars, Jacques de Molay, and one of his fellow leaders, refused to recant. Instead, they defended the Order and repented for confessing to lies about it under threat of torture and execution. King Philip promptly spirited these men to a small island in the River Seine and had them slowly burned to death. It is said that de Molay, as he died, called down God's judgment on King Philip and the pope, who had acquiesced in the persecution of the Templars. As it happened, both men died within the year.

De Molay's companion at the stake was the master of the Knights Templars in Normandy. His name was Geoffrey de Charnay. His name, of course, is virtually the same as that of the first known owner of the Shroud—Geoffrey de Charny of Lirey. Spelling of proper names in medieval times was inexact. Although it is not firmly established, it is quite possible that Geoffrey de Charnay, the Templar, was of the same family as Geoffrey de Charny, the man who mysteriously turned up with the Shroud in the mid-1350s.

Artists who modeled their paintings of Jesus on the Mandylion image produced icons that uncannily resemble the face of the man in the Shroud. Are the Shroud and the Mandylion the same?

There is one strong objection to the Mandylion-Shroud connection. The Shroud is fourteen feet long, three-and-a-

half feet wide, and bears an image of both the front and the back of a dead man. The Holy Image of Edessa, the Mandylion, was only a face. Indeed, as noted earlier, the word *mandylion* is derived from an Arabic word which meant a veil or a handkerchief. If the Mandylion was the Shroud, its true nature must have been disguised for many centuries.

Wilson suggests that the nature of the Mandylion was indeed disguised. Early in its history, he says, the Shroud was folded up in a "doubled-in-four" fashion so that only the face was displayed. Artisans then surrounded the face with an ornamental trellis and placed the cloth in a frame. Indeed, traces of trellis-work decoration are found in some Byzantine copies of the Mandylion. The folding and decoration could have disguised the true nature of the Shroud for a millennium, perhaps until some Templar knight in the early thirteenth century closely examined the holy relic from Constantinople and discovered to his astonishment what it really was.

Why would the Shroud have been disguised in this way? It has already been noted that most first-century Jews, even Christian Jews, would have regarded burial garments as unclean objects. Many would have been embarrassed, even horrified, at a bloodstained burial garment containing the signs of a brutal beating and grisly crucifixion. They may well have decided at an early stage to disguise the true nature of the cloth.

The Byzantine Christians seem to have shared some of this early Christian abhorrence toward Christ's suffering and crucifixion. Edward Wuenschel, one of the early Shroud historians, points out that realistic depictions of the crucifixion did not become common until the thirteenth century, and even they remained a feature of the Christian West. By contrast, the Byzantine Greek artists either depicted Christ reigning in glory, or used a symbol such as a lamb to suggest His sacrificial atonement.[9] Wilson cites several historical references indicating that the Byzantines knew the

true nature of the Mandylion—that it was a full-length burial shroud and not simply a face cloth.[10] If so, perhaps simple prudence dictated that they keep silent about this fact.

Physical inspection of the Shroud indicates that Wilson's "double-in-four" theory is likely. John Jackson, an Air Force physicist who was one of the organizers of the Shroud of Turin Research Project (STURP), reconstructed the pattern of the folds. Using Shroud photographs and a life-size mock-up of the cloth, he found that doubling the cloth in four did indeed expose the face area. Furthermore, Jackson found an eight-fold pattern of folds, visible in a new series of photographs of the Shroud, which is exactly consistent with Wilson's doubling in four. Jackson pointed out that these folds are rather inconspicuous when the Shroud is viewed. They may have escaped notice before because the human eye has trouble sorting out the faint, blurry body-image from other more prominent features of the cloth. Some of these other images are quite prominent and disconcerting, such as the fire damage and water marks. For many, viewing the image on the Shroud is similar to deciphering Rorschach diagrams or those business cards which cleverly disguise the face of Jesus in patterns of black and white. Among the images the eye rejects are the signs of the doubled-in-four folds. However, this configuration appears in photographs.

If only the face of the Shroud image was exposed for so many centuries, why are signs of this not more visible now that the cloth is stretched out? If the Shroud spent more than half its life as the Mandylion, there should be a circular area around the face of Christ which is more yellowed than the rest of the cloth. But perhaps the Mandylion was not exposed to the open air and sunlight often enough to become visibly discolored. If the Shroud and the Mandylion are indeed the same, then the Shroud was hermetically sealed in the Edessa city wall for 500 years, and later kept in a reliquary where it was removed only twice a year in Edessa and only once a year in Constantinople. Private showings of the Mandylion

for dignitaries and artists would have been conducted indoors. So in the course of twelve centuries the cloth's actual exposure to heat, air, and sunlight may have amounted to only a few hundred days.[11]

There is also other evidence suggesting that the Mandylion and the Shroud are the same. As already noted, the Shroud image appears blurred and dim, especially when viewed closely. Descriptions of the Mandylion are similar. One Byzantine writer in the tenth century described the image as "a moist secretion without coloring or painter's art."[12] When the Mandylion first arrived in Constantinople, the sons of the Emperor Romanus were disappointed because they were unable to distinguish Christ's features clearly. Stories were told to explain how this holy but indistinct image was formed. The Byzantine Greeks thought that Christ had miraculously formed the image by drying His face with a cloth or by wiping His sweat-soaked face in the Garden of Gethsemane.

These stories are the source of the legend of Veronica's Veil. It is said that Veronica, a pious woman of Jerusalem, rushed into the street as Jesus was being led to Calvary. She offered Jesus her veil to wipe His sweat- and blood-soaked face. He did, and when He returned it she found that His image had been miraculously impressed on the cloth.[13] The very word "Veronica" suggests the source of the story: *Vera* means "true," and icon means "likeness." This was how the image of Edessa was described: It was "a true likeness," an image "not made by human hands."

The history of the Shroud is incomplete. It may never be known for certain whether the Shroud of Turin and the Holy Mandylion of Edessa and Constantinople are the same object. Yet the historical case that the two cloths are the same is a convincing one. Much of the data is subject to different interpretations in detail, but, taken together, the connection between the two is highly plausible—even probable.

Scientific Studies

Apart from the historical case, modern scientific inquiry has produced independent evidence that the Shroud dates from the first century A.D. Several scientific studies conducted in the 70s suggest that the Shroud was already an ancient object when it emerged into history in 1357.

In 1973, Max Frei, a Swiss criminologist, was asked to authenticate the photographs taken of the Shroud in 1969. Frei, a botanist by training, noticed pollen spores on the cloth and received permission to sample them. Over the next few months, Frei laboriously separated the different spores, photographed them, and matched them to their plants by reference to botanical texts and catalogs.

Frei identified spores from forty-nine different plants.[14] Some of these plants grow in Europe, hardly a surprise since the Shroud has often been exposed to the open air in France and Italy, and would have picked up local air-borne pollen spores. But thirty-three of these plants grow only in Palestine, the southern steppes of Turkey, or the area of Istanbul. The Shroud has never left Europe since its appearance in Lirey in 1357. Frei's meticulous work strongly indicates that the Shroud was exposed to the open air in Palestine and Turkey at some point in its history—just as Wilson's Mandylion-Shroud theory suggests. Frei indicated that the overlay of the pollen grains convinced him that the Shroud has a first-century origin, although this cannot be absolutely proven by the pollen analysis.

Two other studies also bear on the Shroud's pre-1357 existence. Gilbert Raes, a professor at the Ghent Institute of Textile Technology in Belgium, inspected some threads removed from the cloth by a scientific team in 1973. He concluded that the weave of the linen was a type common in the Middle East in the first century A.D. Raes also observed something very interesting: traces of cotton among the linen fibers. He thought the cloth had been woven on a loom also used for cotton. Cotton, of course, is grown throughout the

Middle East, but not in Europe.[15] Raes' finding was supported by Silvio Curto, associate professor of Egyptology at the University of Turin and a member of the commission of Italian scientists who examined the Shroud in 1973. "The fabric of the Shroud," Curto said, "can date back to the time of Christ."[16] If the Shroud is a fraud, a European forger would have had to have gone to the enormous trouble of procuring a cloth from the Middle East for his work, one which contained microscopic traces of cotton in the weave and pollen spores from non-European plants. He would have had no motive to do this because the science of his age could not have determined the place of origin of the cloth. In addition, such an act would have ignored the age of the cloth.

The final study bearing on the Shroud's age is a result of the 1976 experiments showing that the Shroud has three-dimensional data encoded within it.

John Jackson and Eric Jumper, the physicists who discovered the three-dimensional image, noted objects placed over the eyes of the man buried in the Shroud. They suggested that these objects might be coins. If so, they said that the ancient coin which was of the same size as the "buttonlike" images was the lepton of Pontius Pilate, minted between 14 and 37 A.D.[17] Francis Filas, professor at Loyola University in Chicago, says that the images are indeed coins, and that the coins are leptons. He says that computer enhancement and analysis of the images reveals that the objects have twenty-four coincidences of dimensions, location, selection, order, and angles "fitting only a coin issued by Pontius Pilate between 29 and 32 A.D."[18] This lepton is decorated with an astrologer's staff and four Greek letters. Some Shroud experts are taking a wait-and-see attitude on this point, but Filas' evidence strongly indicates a first-century origin for the Shroud. Studies of remains in first-century Jewish cemeteries confirm that the Jews placed coins over the eyes of the dead.[19]

The Later History of the Shroud

The history of the Shroud since 1357 is well documented. As we have already noted, it was first exhibited by Jeanne de Vergy in an obvious attempt to keep her family from financial destitution. Geoffrey de Charny, her husband and the Shroud's owner, was killed in the Battle of Poitiers. Pilgrims streamed to Lirey to see the cloth, but Bishop Henri of Poitiers ordered the exhibition stopped. None of the de Charny family ever explained how the Shroud came into its possession. The Templar connection could explain much of this mystery that surrounded the first historical appearance of the Shroud. Geoffrey de Charny may well have been a member of the family of the executed Templar leader Geoffrey de Charnay. Could de Charnay have whisked the Shroud into his family's safekeeping while Knights at the Order's Paris headquarters resisted Philip the Fair's suppression of the order in 1307? If de Charny of Lirey came into possession of the Shroud this way, he had good reason to be quiet about it. The Knights Templars had been accused of idol worship; was the Shroud the idol? As a devoted and courageous servant of the French king, de Charny would not have wanted to embroil himself in any revival of the king-Templar tragedy.

Bishop Pierre D'Arcis of Troyes, Henri's successor, was also skeptical of the Shroud when it was exhibited again in 1389. Jeanne de Vergy and her son, Geoffrey II de Charny, had carefully obtained permission to exhibit the Shroud directly from Pope Clement VII, bypassing Bishop D'Arcis. In his indignation, the bishop wrote a bitter letter to the pope, in the course of which he claimed that the Lirey Shroud was a known forgery (see Chapter 3). Pope Clement rejected D'Arcis' protests and ordered him to keep perpetual silence on the matter under pain of excommunication. However, the pope also ratified an earlier decision that Jeanne and Geoffrey describe their cloth only as a "representation" of the true shroud.

The D'Arcis Memorandum

Bishop D'Arcis did not fall silent. He complained to King Charles VI of France, who had also assented to the exhibition. The king withdrew his permission and sent a bailiff to Lirey to seize the Shroud in the name of the crown. The clergy and townspeople refused to surrender the relic. At this point, Bishop D'Arcis wrote his famous memorandum to the pope, including the charge that Bishop Henri had determined that the Shroud was a forgery. He made the charge in the following passage:

> The Lord Henri of Poitiers, of pious memory, then Bishop of Troyes, becoming aware of this, and urged by many prudent persons to take action, as indeed was his duty in the exercise of his ordinary jurisdiction, set himself earnestly to work to fathom the truth of this matter. For many theologians and other wise persons declared that this could not be the real shroud of our Lord, having the Saviour's likeness thus imprinted upon it, since the Holy Gospel made no mention of any such imprint while, if it had been true, it was quite unlikely that the holy Evangelists would have omitted to record it, or that the fact should have remained hidden until the present time. Eventually, after diligent inquiry and examination, he discovered the fraud and how said cloth had been cunningly painted, the truth being attested by the artist who had painted it; to wit, that it was a work of human skill and not miraculously wrought or bestowed. Accordingly, after taking mature counsel with wise theologians and men of the law, seeing that he neither ought nor could allow the matter to pass, he began to institute formal proceedings against the said Dean and his accomplices in order to root out this false persuasion. They, seeing their wickedness discovered, hid away the said cloth so that the

Ordinary could not find it, and they kept it hidden afterwards for thirty-four years or thereabouts down to the present year [1389].[20]

Bishop D'Arcis' charge that the Shroud had been "cunningly painted" should be taken seriously, but there is good reason to be skeptical about it. The bishop was outraged when he wrote his letter to the pope. The de Charny family and the Lirey clergy had challenged his authority in the diocese. Worse, their challenge had succeeded. They had obtained permission for the exhibition directly from the pope, had defied Bishop D'Arcis' order to stop it, and had even successfully defied the king of France. There may well have been abuses connected with the relic's exposition. After all, the Shroud was officially called only a "representation" of the true burial garment of Jesus, but the peasant faithful were revering it as the authentic Shroud. Bishop D'Arcis had good reason to be angry.

In addition, there are weaknesses in D'Arcis' charges. The most serious is that he produced no evidence that the Shroud was a painting. There is no record that Bishop Henri de Poitiers conducted an investigation into the authenticity of the Shroud. D'Arcis himself produces no such evidence in his letter to the pope. He does not specify when such an investigation was conducted, who conducted it, or the name of the forger who painted the cloth. D'Arcis' successor at Troyes, Bishop Louis Raguier, maintained that the Shroud was genuine. Furthermore, Henri de Poitiers, the man who was supposed to have determined that the Shroud was a fake, seems to have been on friendly terms with the de Charny family. Pope Clement's response to D'Arcis' letter also casts doubt on the forgery charge. One would expect that the pope would have quickly investigated such an accusation made by a respected bishop. Yet the pope told D'Arcis to keep silent on the subject of the Shroud under

penalty of excommunication, and he allowed the exposition at Lirey to continue.[21] Curiously, D'Arcis' letter is unsigned.

In his rage, D'Arcis may have abandoned literal facts. The forgery charge was very possibly a fiction, but something caused the bishop to reject the Shroud. He passed it on to the pope. But there is no evidence that Bishop Henri of Poitiers had ever conducted the investigation as D'Arcis said.

Ian Wilson suggests a more charitable explanation. D'Arcis, he says, could have been referring to a copy of the de Charny Shroud. Many fake shrouds were floating around Europe at the time. Historians count more than forty "true shrouds" in existence during the Middle Ages. Some of them still exist and they are obviously copies of the Lirey cloth. Artists unquestionably did copy it. Questions of authenticity did not occur to the unsophisticated popular religious mind of that time as often as they do to us. Simple believers in the fourteenth century would not have been inclined to question the authenticity of a relic whose exposition bore the sanction of the pope. Indeed, this is the substance of Bishop D'Arcis' charges. He told the pope that venal and unscrupulous men had tricked him into sanctioning the exposition of a fraudulent relic. It is thus highly significant that Pope Clement did not investigate, but rather silenced D'Arcis and allowed the expositions of the Shroud to continue.

On the surface, the D'Arcis Memorandum seems impressive. Under the weight of the facts, it begins to collapse. The decisive refutation of D'Arcis' accusations comes from modern science. If the Shroud was painted, the forger's work cannot be detected by skeptics using the most sophisticated analytical technology of the twentieth century.

The House of Savoy: New Shroud Owners

In subsequent years, the de Charny family fell on hard times. Geoffrey II de Charny died in 1398, and his daughter and heir, Margaret de Charny, failed to produce an heir of her own. The wooden church at Lirey where the Shroud was

kept began to fall into a state of disrepair. Toward the end of her life, Margaret de Charny, apparently convinced that the Shroud faced an uncertain future after her death, began to look for a suitable family to take possession of it. She settled on the House of Savoy, a pious and powerful noble family which was expanding its domains in the area of northern Italy, Switzerland, and southeastern France. She deeded the Shroud to Louis of Savoy in 1453, and the House of Savoy has owned it ever since.

Margaret de Charny made a wise choice. The House of Savoy was successful in war and politics, and the head of the family eventually became the king of Italy. The legal owner of the Shroud is now the Roman Catholic Church since it was given to the Vatican by the late king of Italy, Umberto II, who lived in exile in Portugal. All recent exhibition and testing of the Shroud required the permission of both King Umberto and the Archbishop of Turin, its custodian.

Under Savoy patronage, the Shroud gradually gained a reputation as the true burial garment of Jesus. Around the year 1464, Pope Sixtus IV let it be known that he regarded it as an authentic relic, and the dukes of Savoy built a special chapel for it in the Savoy capital of Chambery, France. On December 4, 1532, fire broke out in the chapel and raged around the silver-lined reliquary where the Shroud lay folded. The fire melted part of the silver lining of the reliquary, and a piece of molten silver fell on the folded cloth and burned it through. One of the duke of Savoy's counselors and two Franciscan priests carried the burning casket out of the building and doused it with water, extinguishing the blaze. Happily the image was virtually untouched, but the marks of the fire and water disfigure the Shroud to this day. However, as we shall see later, the fire in the Chambery chapel provides scientists with a built-in experiment to test various theories for how the Shroud image was formed.

In 1578, the Savoys moved the Shroud to their new capital in Turin, Italy. The Shroud has remained there ever

since, except for a six-year period during World War II when it was safe-guarded in a remote abbey in the mountains of southern Italy.

The last phase of the Shroud's history began to unfold in Turin in 1898 when an Italian photographer named Secondo Pia was permitted to photograph it during a rare public exhibition. To his astonishment, Pia discovered that the image on the Shroud is actually a negative, with dark areas appearing light and light areas as dark. Its dim and blurred features sprang to life when "printed" on the film in Pia's camera. Scientists immediately recognized the significance of Pia's photographs. Many of them had assumed that the Shroud was a forgery like numerous relics of the Middle Ages. But why would a fourteenth-century forger have painted the image on the Shroud in a *negative* form? The concept of negativity was unknown until the invention of photography in the nineteenth century.

Secondo Pia's photographs initiated the series of increasingly detailed scientific studies which culminated in the 1978 investigation by the Shroud of Turin Research Project. Medical experts studied Pia's photographs and discovered that the image on the Shroud contains a degree of anatomical detail that far surpasses the medical knowledge of the fourteenth century. Scholars pointed out the remarkable consistency between what is known about Jesus' crucifixion and burial and what happened to the crucified and buried man in the Shroud. In 1976, a team of U.S. Air Force scientists made the remarkable discovery that the image on the Shroud has three-dimensional data encoded within it. With computer analysis, a three-dimensional replica of the image can be constructed.

It almost seems that the Shroud's deepest secrets lay hidden for 2,000 years until men invented scientific instruments sophisticated enough to detect them. Perhaps the age of sophisticated science is also the age which most needs to confront the man in the Shroud.

Conclusion

All of the historical references considered together on an object of less significance would normally be sufficient in identifying that object. After all, many entirely new archeological discoveries have been located based on a mere mention in the Bible. Often whole towns for which we have absolutely no external historical record are found. Even the possibility that some of the early internal documentation (such as the letter of Christ to Abgar) is apocryphal, should not in itself affect our acceptance of the data. After all, traditions and even history itself began in oral repetition handed down from generation to generation. We are all familiar with the success of Roots in which Alex Haley traced his family back to the very village of his heritage with a few poorly remembered words that had been handed down for over two hundred years. To put stock in multiple source references to an image independently confirmed by other means seems to me not at all unreasonable.

The very mention of the early existence of an article nearly identical to what we now know as the Shroud, if it came from a reliable source, would be grounds at least to question any radiocarbon date that was too far removed from those early dates. We have, in fact, a variety of reliable sources that match a reasonable history of the Shroud's missing years. Once again, we have a knowable, traceable, testable theory for the Shroud's presence and influence prior to the Middle Ages. The theory goes beyond speculation when point after point is independently documented by separate researchers. We have then, in short, one more crucial support for the Shroud's longevity and at the same time an equally important reason to reject the initial round of C-14 testing. What is most significant about this evidence is that it comes from the very field once thought to be most devastating to the Shroud's authenticity.

Knowing that the Shroud's whereabouts are heavily documented from 1357 onward, I am left to postulate how so

many things—history, art, legend, pollen, and religious tradition—can possibly line up by coincidence alone. Since much of what I now know was only uncovered in Wilson's research, it seems ludicrous to suspect that someone could have contrived it all. How, indeed, could an unknown, medieval forger contrive to order a cloth woven in the Middle East and taken through Turkey so it would match the pollen, legend, and scattered history of the Shroud of Turin? Nor would anyone have had the detailed knowledge of the art, religious traditions, and legends of countries and cultures half a world and at least a thousand years removed from the Shroud's European debut.

Don't forget that the lack of an unbroken historical tradition was the main target of early Shroud opponents. It seems obvious that, like the scientific testing itself, the history of the Shroud of Turin could only begin to be pieced together at a time such as the twentieth century when the technology exists to trace so many tenuous threads back to their original source. I might add that if the Shroud is a medieval forgery, then even the great art masters will pale by comparison to this forger's work. For not only did the forger create a masterpiece, but he did it in such a way that it would match a history and an artistic tradition that would require years of super-sleuthing, an army of translators, and a team of researchers even to begin to put it all together. Furthermore, he had to convince countless historians that they at last had a reasonable explanation for the problematic similarities between the Shroud and some "lost" miraculous image. Finally, he did all of this with assuredly almost no access to or knowledge of the majority of the data. Nor does any of the data include the tremendous knowledge of ancient Jewish burial customs and pathology which I will discuss in Chapter 5.

Besides, even if I postulate against all this evidence that the Shroud is a man-made copy of an earlier lost image, I am still left with the scientific data which clearly demonstrates

that the Shroud is not the creation of human hands. Therefore, the most logical and evidentially satisfying conclusion is that the Shroud was the inspiration for all the image imitations, not one of those imitations.

3

Fraud and the Shroud

Since the beginning of the Shroud's documented historical existence, many people have doubted that it is genuine. Because the image on the cloth is so remarkable, the question of fraud inevitably arises. Herbert Thurston, the British Jesuit who doubted the authenticity of the Shroud at the turn of the century, put the issue plainly. "If this is not the impression of Christ" he said of the Shroud image, "it was designed as the counterfeit of that impression. In no other person since the world began could these details be verified."[1]

Could this remarkable image be a forgery? Many churchmen in the fourteenth century thought it was. It simply seemed too implausible to believe that Jesus' burial garment had survived, not to speak of the incredible idea that it had been miraculously imprinted with an image of His dead and crucified body. It was only in the twentieth century, with the invention of modern scientific instruments and analytic techniques, that thoughtful people began to seriously entertain the notion that the Shroud might really be authentic.

As we have seen so far in this book, it is extremely difficult to imagine that some clever artist, no matter how

skilled, painted the Shroud in the fourteenth century. If the Shroud image is a painting, it departs in dramatic ways from the traditions of medieval Christian art. More importantly, it reveals a degree of anatomical and medical knowledge that no one in the fourteenth century possessed.

Additionally, the New Testament argues for the Shroud's authenticity: the Shroud image is consistent with the Gospel accounts of Jesus' death and burial. It is also consistent with what is known about Roman crucifixion practices and Jewish burial customs. Then there is the remarkable nature of the image itself. The image is unique. It is a negative, best seen "printed" on a piece of photographic film in the back of a camera, and it also contains three-dimensional and other unusual scientific properties.

The Shroud image seems so remarkable that one might say that the burden of proof rests on those who think it is a forgery. Yet the fact that the astonishing qualities of this linen cloth have no complete scientific explanation demands that we explicitly consider the question of fraud.

The fraud charges come from three sources. First, history records a serious accusation of fraud made to the pope in 1389. A bishop claimed that the image was a painting (see Chapter 2). Second, one scientist has gained some publicity for his charge that the Shroud may have been artificially created, a charge that scientists on the Shroud of Turin Research Project (STURP) dismiss. Third, some have made claims that they can reproduce the Shroud image. We will deal with the last two issues in this chapter. A fourth issue —the question of spiritual fraud—will be dealt with in Chapter 8.

The Scientific Evidence

When considering the possibility of a forgery in the classic sense of the word, science can investigate several areas. First, are there signs of pigments, dyes, stains, powders, acids, or other artificial or natural colorants on the cloth? Second, is

there evidence for the presence of a medium to apply said pigment? Third, are there any signs of an artist's hand at work—brush strokes, block prints, or finger rubbings? Finally, can a duplicate be made of the Shroud image that demonstrates all of the known characteristics of the image and still fall within the technological ability of a forger who lived between the first and fourteenth centuries?

Let us review STURP's conclusions about forgery.

The answers to the first two questions above—the presence of pigment and medium—are negative. Meticulous testing failed to find any evidence of pigment, powder, dyes, acids or any known colorant or medium to apply it. The image is composed of yellowed linen fibrils. No colorant known in the fourteenth century or today can account for the fibrils. The amount of yellow does not increase in the darker image areas, as would be expected if the image had been painted. Instead, the density of the image increases: there are simply more yellowed fibrils present in the darker areas. This characteristic explains why the image is so faint and diffused, especially at close range.

Scientists have considered—and rejected—other painting theories as well. If a pigment had been applied to the cloth and later cracked off, its residue would be detectable. No residue was found. Neither is there evidence of a medium to apply such a pigment. In fact, it is difficult to see how any kind of medium could have been applied. The image is on the surface fibrils only (to a depth of microns) and in no way soaks through the fibers. This would eliminate any pigment medium applied as a fluid; a fluid would have penetrated and traveled along the fibers, and its presence would have been detected.

Walter McCrone, a microscopist who did not examine the Shroud in 1978, but who obtained some "sticky tape" samples of cloth material from a member of STURP, detected the presence of iron oxide on the cloth. He speculates that an artist could have applied a small amount of this material to

the linen in order to enhance an already existing image, or perhaps to create the entire image. Members of STURP regard McCrone's speculations as virtually impossible. They point out that the amount of iron oxide on the Shroud is very minute. The 1978 examination of the cloth did not discover a concentration of iron anywhere near large enough to account for the image. Also, the iron oxide is the wrong color—the image fibrils are yellow, while iron oxide is red.

The most likely explanation for the presence of iron oxide on the cloth is that it originally resided in the red bloodstain areas. The iron was originally abraded blood matter that was transferred to other areas of the cloth as it was folded and unfolded throughout the centuries. The build-up of iron oxide on certain threads could be caused by ceremonial washing and brushing of the Shroud when it was removed from and replaced in its reliquary. Even so, those threads which show a larger than normal concentration of iron are not all in the image areas and are not characteristic of threads in the image areas.

Briefly stated, the investigating scientists specifically tested McCrone's thesis with sophisticated microchemical tests and found that iron oxide cannot account for the Shroud image. Also, submicron iron oxide has been available only within the last two hundred years, thereby meaning that it could not have been used on the Shroud image. Thus, it is not surprising that McCrone's research has not been independently verified.

A computer analysis at the Jet Propulsion Laboratory in Pasadena, California adds another piece of evidence against the painting theory. This analysis of the cloth found no directionality in image areas other than the vertical and horizontal patterns of the threads themselves. That meant there was no sign of brush strokes, finger strokes or other methods of artificial application. Even when the computer removed the vertical and horizontal patterns of the fabric weave from the photograph, the image was in essence

untouched. In short, there is no evidence of a forger's methods, mediums, or pigments.

Even the Shroud's history belies any painting. The fire of 1532 would have discolored a painting by burning the pigment in some places. The water which extinguished the fire would have caused the image to "run." Neither happened.

However, the facts which best refute hypotheses of fraud (including McCrone's) are the three-dimensional and superficial nature of the image, as well as the absence of any plateaus or saturation points on the image. In short, the scientific analysis has disproved the thesis that the Shroud's image is a painting of any sort.

Modern Attempts at Forgery

It remains then for the skeptic to demonstrate how the cloth could possibly have been forged. The best-known effort to do this has been made by a magician and self-professed amateur detective named Joe Nickell. Nickell has gained some publicity with his theory of how the Shroud was forged.[2] But does the theory match the facts?

Nickell says the Shroud image was created by a dry powdered form of myrrh and aloes brushed onto a cloth stretched over a bas-relief sculpture. As evidence he submits photographs of a rubbing obtained from a bas-relief of Bing Crosby which reflects a negative and positive image, but severely degraded in appearance.

The 1973 Italian Commission reported the presence of "granules and globules" of material on the Shroud; the Italians did not identify this material. Nickell says they are the myrrh and aloes his theory requires. However, the Italians denied that these granules and globules are myrrh and aloes and more importantly, reported that they have *nothing whatever to do with the image itself* and are merely particulate matter. Since Nickell's technique requires the build-up of particles in the image area, and since microscopic

inspection finds no evidence for this, Nickell's theory seems impossible.

Nickell's images of faces on cloth also fails on aesthetic grounds. They show none of the clarity and resolution of the image on the Turin cloth. Nickell's *Popular Photography* article in which he proposed his theory also contained a lengthy and inaccurate attack on previous research and the work of the Shroud of Turin Research Project. He misquotes or quotes out of context from the *1977 Proceedings* no fewer than eight times, contradicts himself, and reports incorrectly that there is no evidence of blood. Nickell also incorrectly states that the scientists and their predecessors had no direct access to the cloth. This, he claims, is why the investigators found no pigment on the cloth.

The Nickell theory fails for other reasons as well. The fire and water of the 1532 fire would have affected an image formed with organic substances. Photomicrographs reveal that there is no way for an image created by Nickell's method to be superficial in nature. Nickell's "myrrh and aloes" would penetrate as any particulate would, thereby meaning that his image would not be superficial. Nickell's application of powders would also have a directional nature, but the Shroud image is nondirectional. Additionally, Nickell's theory has difficult problems when aligned against historical facts. What sculptor could have created the masterful bas-relief needed to forge the Shroud according to his method? There is no record or tradition of sculpture to this degree of stark anatomical realism in mid-fourteenth-century France. Moreover, Nickell's technique is not known to have been used before the nineteenth century.

Most devastating to Nickell's hypothesis are the results of testing his image for three-dimensionality on the VP-8 image analyzer. It was found that his image was not three-dimensional. He thus failed to match this crucial feature of the Shroud.

Nickell's attempt to copy the Shroud image is only one of

many unsuccessful attempts to reproduce it. Painters copied the Shroud in the Middle Ages, but none of these painted shrouds even approach the quality of the original. All were recognized as copies at the time.

This raises an interesting point which further bolsters the case against forgery. Relics were an important part of the popular spirituality of the Middle Ages. Those who flocked to see them were not as troubled by questions of authenticity as we are today. This situation invited the creation of obvious fakes, although the word used at the time was "copies," and this artistic activity did not necessarily carry the connotation of fraudulent intent. An artist who was good enough to create an image as impressive as the Shroud's would surely have made many copies of it. Shroud copies of this level of artistry would have demanded a king's ransom. Where is the statue or the bas-relief that the artist used? It would have graced the finest cathedral and become a famous image in its own right. And, to repeat a point made before, this artist would have had to have forged an image that would not have been fully appreciated for hundreds of years after his death, until the invention of photography and other modern analytical techniques.

The basic fact remains: neither Joe Nickell nor any other artist or forger has ever created an image showing all the characteristics of the image of the man of the Shroud. For example, none of them are three-dimensional, superficial, or non-directional.

Photographers claim that it is impossible to fake such a delicate image photographically. One, cited by author Robert Wilcox, wrote, "I've been involved in the invention of many complicated processes, and I can tell you that no one could have faked that image. No one could do it today with all the technology we have. It's a perfect negative. It has a photographic quality that is extremely precise."[3] In recent years a skeptical artist and photographer from Great Britain set out to deliberately duplicate the Shroud image using modern

photographic techniques. He was convinced at the outset that the Turin cloth was a hoax. In the end, although his results were good enough to be used in the movie "The Silent Witness," his image is vastly inferior to the original. He concluded that it was virtually impossible for a human to have forged the Shroud image. In fact, the Shroud has never been successfully duplicated even with the aid of modern technology, despite some valiant attempts.

In summary, it is virtually impossible that the Shroud image can be a forgery. The only piece of evidence for fraud is the D'Arcis Memorandum. However, this letter is only an accusation; it contains no evidence, and it may even refer to a copy of the Shroud of Turin. The scientific testing of the Shroud uncovered no evidence for forgery. The technical demands of such a forgery appear far beyond the capabilities of a medieval artist, and modern-day attempts to duplicate the Shroud image have all failed.

We are thus left with three possible conclusions about the origin of the image of the man buried in the Shroud of Turin. Let us review them:

1. It is a freak occurrence of human genius. Someone forged the image in the fourteenth century or earlier. Twentieth-century science can find no trace of how he did it. He worked in an unknown way, with unknown materials, without the ability to check his work or know his results.

2. It is a freak occurrence of nature. An unknown but natural chemical process formed the image of a crucifixion victim in a tomb. The way the material was applied to the cloth is also unknown.

3. The image is a record of a known man—Jesus of Nazareth—at a known moment in history. The image is probably a scorch. How this happened is not known now and may never be known in scientific terms—because it involved an action of God outside the laws of nature.

We can rule out the first possible conclusion. We can have

confidence that modern science could detect the work of a forger. The report of the Shroud of Turin Research Project did not seriously consider the possibility that the third possible conclusion is the most likely, since science is not equipped to deal with such issues. Nevertheless, it does seem to be the most logical, and it is not good science to refuse it on the grounds that a "mechanism" for a scorch is not "technologically credible."

Nevertheless, even the second conclusion points inescapably to the probability that the Shroud is authentic.

PART 2

Looking Back

4

Back to the 80s

Contemporary interest in the Shroud of Turin is a multi-faceted phenomenon. During the 1980s the controversy over the nature of this cloth was fueled dramatically due to the results of carbon dating. In response to these results, some concluded that the matter of the Shroud's authenticity was forever cleared up and that the Shroud could not be the burial garment of Jesus. However, some decided to challenge those results on several counts, postulating that the Shroud could still be authentic. The debate presented two crucial issues: *the age of the cloth and the cause of the image on it.*

Measuring 14 ft. 3 in. long by 3 ft. 7 in. wide and known to exist since at least 1354 A.D., the Shroud might at first appear to be an odd object for the serious studies and debates which have characterized its most recent history. Caught in a fire in 1532 and almost destroyed by dripping molten silver, the Shroud survived with a twin series of burn marks down its entire length. Almost every destructive burn is mirrored by a similar one across from it, reminiscent of paper doll cutouts.

But most compellingly, this cloth reveals the frontal and

dorsal images of a man, the whole body of an apparent crucifixion victim. The double image, arranged head to head with the feet at opposite ends of the cloth, appears to have been created after being wrapped lengthwise around the dead body. The person apparently suffered wounds popularly associated with the crucifixion of Jesus: pierced scalp; serious beatings in the face and down the length of the body, both front and back; pierced wrists and feet; and a larger wound in the side of the chest.

The Shroud of Turin is certainly a complex and multifaceted subject. As in any scientific enterprise, new data can provoke a reconsideration of certain issues. After relevant data is gathered and organized, a hypothesis is formulated and tested. Scientific investigation then confirms or discredits the temporary thesis. After careful consideration, I have rethought several topics in light of the new data found in the 80s.

Another issue I re-evaluated in the late 80s was the use of statistical probabilities to argue that the Shroud was very likely Jesus'. In *Verdict on the Shroud*, I asked how likely it was that another victim was crucified in the same manner that Jesus was, including all of the abnormal features that marked His death (as the New Testament accounts relate). I judged that this would be a highly improbable occurrence. In the absence of enough detailed historical reports on which to predicate such analysis, my effort did not carry as much weight as I might have hoped. I should have been content to examine the evidence that the man buried in the Shroud might have been Jesus, leaving the *strength* of the conclusion to the readers.

With regard to the nature of the death and burial of the man in the Shroud, other issues arise. Can I know the specific cause of death? Was the man's body washed before burial? Challenges have been offered to the more traditional answers and I explain and evaluate them in detail in Chapter 8.

Other questions about the burial concern the nature of

the face band (and other cloths) or whether there is sufficient data about the actual condition of the bloodstains to decide whether the cloth was removed from the body. On the crucial issue of the cause of the image, should I be more open to the alternative theses? Chapter 10 deals with this important concern.

Other questions could be raised, but these are some of the more crucial topics for re-evaluation. At the same time, other conclusions need not have changed even though a great deal of new data has emerged in the past ten years. So I wish to be cautious in my conclusions, realizing that I need to be open-minded about some new considerations. One of my chief purposes in this book is to explore the new data and determine if any reconsiderations of my previously published conclusions are appropriate. Chapter 12 presents old and new conclusions.

The State of the Question in the Late 1980s

In the late 1980s, numerous books and articles appeared on the subject of the Shroud from a wide variety of sources and viewpoints, both scientific and otherwise. While even a brief review of these writings could itself be the subject of a book, I would like to make some general observations. Besides the subject of carbon dating, what were those researchers most concerned with studying?

Among the more popular topics for discussion were such medical issues as the nature of the blood stains, burial procedures, the washing of the body, and, perhaps most important, the nature of the Shroud image. On the last topic, a primary concern is the continued testing of alternative theses to discover a possible image mechanism.

It is fair to say that most scholarly publications on the subject have favored the authenticity of the Shroud, at least as an actual archeological artifact. Alternative hypotheses had been proposed, carefully tested by various scholars, and

generally rejected. Popular treatments, in general, have been even more outspoken in their support of the Shroud.

And what about the public as a whole? As I just mentioned, most popular works on the Shroud had favored the authenticity of the artifact. Though these publications have sometimes been too uncritical in their evaluations, it would appear that many had been convinced that the Shroud was the actual burial garment of Jesus. But even within this viewpoint, many opinions exist. Some have wondered if the Shroud is a sign from God to persons living in the last days as a witness to skeptics. Whether this is or is not the case, science cannot decide.

What Was Science Saying?

The one question that everyone wanted answered—Is the Shroud the burial garment of Jesus?—can never be answered by science, for it is by definition outside the realm of science alone. Science, advanced as it may be, has no tools at its disposal to identify positively any garment of Jesus. Even the identification of the mummies of known Egyptian rulers requires the interfacing of multiple interdisciplinary fields to achieve widespread acceptance. Moreover, everyone has expected all along that modern science would somehow be able to at least address the issue of identity (which I cover in Chapter 8). Certainly many Shroud enthusiasts felt as though scientific fields such as pathology, archeology, microbiology, anthropology, and pollen analysis would provide enough corroboration with the historian to enable at least an educated guess. Finally, the public had expected the Shroud of Turin Research Project (STURP) to render personal opinions on the identity issue if for no other reason than that they are the only human beings in our generation to have had enough exposure to the Shroud and the attendant data to give a reasonably educated conclusion.

Despite the fact that science alone can't address this major issue, science can and does address many areas that

contribute dramatically to our ability to answer the question of identity. Unfortunately, in the Shroud story, personalities, politics, and other nonscientific issues have severely muddied the waters of objectivity on authenticity and identity issues.

Let's take a quick look back at the major scientific research of the 8os before we go forward and examine the latest research and theories.

STURP and the Shroud

STURP failed to provide the public with updated reports on their research. Reports and periodic updates were necessary to satisfy the demands of a public whose curiosity was at a fever pitch by October 1981. In fact, STURP was largely responsible for the high public interest by virtue of the caliber of its members, their dedication to the research of the Shroud, and the media coverage of STURP's investigation. In addition, the appetite of the public was whetted by articles in print on STURP and its work, from the superficial coverage in *Time-Life* to the in-depth report in *National Geographic.* Unfortunately, STURP consciously limited its final publications to arcane journals like *Applied Optics, Archaeology, Analytica Chemica Acta (ACA),* and the *Proceedings of IEEE.* While these are excellent avenues for establishing scientific credibility and peer review, they're hardly normal public fare. The average person would require a translator even to begin to wade through the technical jargon in some of these articles. Consequently, the only true final report of STURP's findings has remained widely unknown to the vast majority of the public because of its publication in just such a journal (namely, *ACA*).

When *Verdict on the Shroud* appeared in print, some of STURP's team members declared that I had grossly misunderstood the scientific method and findings and therefore misrepresented the state of the Shroud question. Assuming that I, an engineer who worked with STURP from

its inception, could have been far enough off to warrant that comment, what hope did the average reader have of understanding what the quarrel was all about? In my humble estimation, most of the concern over *Verdict on the Shroud* was a matter of semantics.

Major Theories of the 80s

Articles by Shroud skeptics have appeared in numerous popular journals, such as *Discover, Geo, Popular Photography, Christian Century* and *Biblical Archaeology Review* have led to widespread confusion and misinformation. Some of these articles contain some pseudo-scientific statements, poorly researched (if researched at all) conclusions, and much ad hominem argument.

Most articles purporting to disprove the authenticity of the Shroud are partly based on Dr. Walter McCrone's work, which was touted far and wide in the popular press. Even many Christian writers had cited his work favorably, including Josh McDowell, Father Robert Wild, and Ralph Blodgett. However, STURP's work clearly disproves McCrone's theories. Let's examine McCrone theories of the 80s and then the work of those who followed him.

McCrone reported that in his opinion the Shroud image was a human artist's creation painted with a gelatin-based paint pigmented by iron oxide and mercuric sulfide[1] (iron earth and vermillion). However, McCrone contradicted even himself, for in *Chemical and Engineering News* he apparently agreed with STURP that the Shroud's yellow fibrils (image threads) are dehydrated cellulose.[2] The article reported, "McCrone, who was once a member of STURP himself, generally agrees with the group's explanation of the yellow color on the cloth."[3] Yet, in a rebuttal of William Meacham, a world-renowned archeologist, McCrone stated, "All of the image on the shroud fibers consists of common and well-known pigments and a stain on the fibers due to aging [sic] of the paint medium."[4] Furthermore, according to Natalie

Angier, he claimed the yellow in the Shroud's fibrils is caused by the threads being dried up because they had been coated with *collagen tempera* (an egg-based medium for applying a pigment or dye).[5] During one STURP meeting, he even suggested hematite or jewelers rouge as the cause of the yellowing until someone gently reminded him that it wasn't even available until the twentieth century, long after the image was known to exist. Without batting an eye, McCrone declared that certainly it was because an earlier image was being enhanced in anticipation of the 1898 photography.[6]

Equally bizarre is the number of McCrone supporters who glibly repeat his internal contradictions, without even being aware of how far they stray from the documented facts. For example, Marvin M. Mueller, of the Los Angeles Alamo Laboratory, made a glaring error in stating, "[samples] showed significant amounts of pigment . . . identified . . . as micron-size hydrous and anhydrous iron-oxide. . . . These particles . . . coat the individual fibrils."[7] Less than three paragraphs earlier, he concluded that the paint "medium" had "virtually disappeared leaving behind only cellulose fibrils."[8] Is there pigment on the Shroud or not? Apparently, Mueller isn't sure. Yet STURP and peers insist there is absolutely none.

Perhaps McCrone's most incredible claim is that STURP believed that the image is blood. As reported by Meacham, McCrone incorrectly contended that STURP's members "prefer to believe the image is blood."[9]

Also McCrone implied in *Discover* that STURP declares the Shroud to be a miracle.[10] Once again, McCrone misrepresents the facts. The single major statement to which STURP publicly agreed concerning the image is this: ". . . it is concluded that the image is the result of some cellulose oxidation-dehydration reaction rather than an applied pigment. The application or transfer mechanism of the image onto the cloth is still not known. . . . Available data from the 'blood' areas are considered and the results show these to be

blood stains."[11] STURP's assertion is clear and backed up by every aspect of their nondestructive tests on the Shroud in Turin, Italy. Furthermore, their work has been subjected to the most rigorous peer review imaginable. McCrone has, on the other hand, by his own admission been a "dissenter in the ranks."[12] Not only that, but he was a dissenter who insisted that he alone knew the truth about the cloth. STURP presented no hooplah, no mysterious miracle statements, no confusion—merely clear demonstrable statements of fact reviewed by peers and experts.

Finally, the fact that McCrone, like the other skeptics, spent much of his energy attacking the qualifications of STURP, should be a dead giveaway that his case cannot stand on its own merits. Here's a sampling of McCrone's criticisms:

> I feel like Hughes Mearn's "little man who wasn't there" . . . forced to quit STURP for his unorthodox opinions. . . . I was completely ignored . . . I think they were the wrong people for the job. . . . I seem to run into minds already made up . . . no one in STURP has the specialized background in small-particle identi- fication . . . the problem with members of STURP is they want to believe it is real so badly that they are blinded to the science. . . .[13]

Perhaps most devastating to McCrone's case is McCrone himself. To begin with, his identification of the chemicals he claimed were painted on the Shroud was based strictly on viewing characteristics, which he believed only he had the expertise to determine. In other words, he thought the image "looked like"[14] a painting:

> Only the microscopist was able to observe the details necessary to lead to the correct conclusion . . . only the microscopist was able to publish a definite conclusion and defend it with complete confidence . . . only the

ability to resolve and identify individual sub-micrometer particles and to observe their pattern of dispersal on the fibers and their manner of attachment to these fibers could lead to the correct answer. . . .[15]

And what is "the" answer? McCrone said, "The 'orange to red' pigment particles are red ochre, iron oxide, and red vermillion." He added, "No one untrained in the use of PLM (Polarized Light Microscopy) could have come to this conclusion."[16] Certainly it can be argued that to make a major scientific statement on the basis of what the image "looked like" in the face of all other scientific data seems highly subjective. It's interesting to note that the image over the entire Shroud is a straw-yellow color. *There is no red in it.*

As multiple sources indicate, STURP has never denied the presence of FE_2O_3 (iron oxide) on the Shroud, but FE_2O_3, *has nothing* to do with the image per se: ". . . amounts of iron . . . on the cloth are consistent with the retting process in common use in the preparation of linen."[17] The image is composed of straw-yellow fibers of dehydrated cellulose, not the red particles of iron that have been identified in three forms on the Shroud and that are separate from the image except in blood-image areas such as the scourge wounds. As one member of STURP put it, "If the blood on the image were the result of iron oxide and mercuric sulfide, it would show up far more distinctly on the X-ray than the water stains, but quite the opposite is true. This represents only one of the many examples why McCrone's theory cannot be viable."[18]

More importantly, the single most significant conclusion of STURP was that the Shroud image cannot possibly be a painting. Two of STURP's members, Rogers and Schwalbe, stated for the team: "The primary conclusion is that the image does not reside in an applied pigment. The reflectance, fluorescence, and chemical characteristics of the Shroud image indicate . . . some cellulose oxidation/dehydration process."[19] Naturally speaking, some form of drying, aging

(advanced decomposition) process has occurred to the image fibrils.

Furthermore, STURP has never claimed to have the only answer to the cause of the image or blood stains, choosing instead to leave the issue open for further study. This represents an excellent example of how STURP's unflinching attention to scientific credibility has paid off. Nowhere does STURP succeed better than in laying to rest the theory that the Shroud was the work of a human hand. Though I would in most instances eschew the ad homineun approach, perhaps these remarks by Meacham best explain the incredible gulf between STURP and the skeptics:

> Even if one ignored the very compelling evidence to the contrary and granted McCrone's interpretation of the iron particles and protein, all one could conclude would be that minute traces of a solution or ointment containing pure hematite are present in the body imprint. This is a far cry from proving the image to be a painting. As STURP responded to McCrone's first pronouncements, microscopic observations do not exist in a vacuum. McCrone is somewhat like Mearn's little man who wasn't there again today. He declined at least two invitations to discuss his findings in the multidisciplinary framework of STURP. He declined invitations to present his work at scientific congresses. He did not follow the STURP "Covenant" which he signed, to publish in peer reviewed scientific literature. And as he admitted, he has not responded in print to the arguments of Heller and Adler, Pellicori, Riggi, and Schwalbe and Rogers on the physics and chemistry of the image. He has abandoned his earlier claims of a synthetic iron oxide (Post-1800) in the image and of a pigment enhancement of a genuine image . . . the established facts are more then sufficient to refute the medieval clever-

artistry hypothesis. A forger could have obtained a middle-east cloth, could have used some primate blood (and serum), could have depicted the body in flawless anatomical detail, and the pigment could have disappeared leaving a faint dehydration image—but that all of these unprecedented circumstances should have coalesced in the production of a single relic is virtually impossible to imagine.[20]

The bottom line for McCrone and all who follow with various painting-based hypotheses, is that the now heavily documented, independently confirmed, peer-reviewed work of STURP clearly has eliminated the possibility that the Shroud image could be the result of an applied pigment. All of the electromagnetic spectrum, all of the chemical data, even all of the physics of the image mitigate against a man-made image.

Unfortunately, Mueller, Nickell, and others who had jumped onto the McCrone bandwagon seem blissfully unaware that for purely technical reasons the painting theory, regardless of the methodology, is a dead issue. Amazingly enough they continued to flog away at the now rotting carcass of this long dead horse.

Nickell, for example, touts a dusting/rubbing method which obviously would leave a heavy distribution of chemicals between the fibers of the cloth and on its reverse side. Body paintings and rubbings invariably contain pigment layers and distortion in three-dimensional projection, all of which are absent on the Shroud.

In addition, STURP member John Jackson, using the Nickell technique, found severe difficulties in its lack of distance information.

Although not strictly an action-at-a-distance hypothesis, another bas-relief based mechanism had been proposed by Nickell that involves contouring cloth to the bas-relief and

"dusting" the deformed cloth surface so as to produce an image. . . . We conformed, as Nickell indicates, wet linen to the bas-relief so as to make all image features (eyes, lips, etc.) impressed into the cloth. We then "dabbed" the cloth with fine tempera powder . . . the shaded image seemed to contain more curvature than distance information of the face. In addition, I noted large quantities of powder falling through the cloth weave structure and accumulating on the reverse side. Accordingly I conclude that this mechanism is unacceptable.[21]

Keep in mind that this method was investigated despite the fact that it *failed to match the known chemical characteristics of the Shroud.* Nor was the technique known in medieval times:

> Clearly, to be testable and viable, the hypothesis must derive from or at least not conflict with the known elements of 14th-century art. This it manifestly fails to do . . . there is no rubbing from the entire medieval period that is even remotely comparable to the Shroud, nor is there any negative painting. Nickell's wet-mold-dry-daub technique was not known in medieval times according to art historian Husband and even that technique fails to reproduce the contour precision and three-dimensional effect, the lack of saturation points, and the resolution of the Shroud image.[22]

Mueller, another virulently anti-STURP scientist, is the next person I will consider since he severely downplayed three-dimensionality. As he stated:

1. The celebrated "three-dimensional effect" begs the question as to whether the Shroud ever contained a full relief (statue or body). . . .
2. All of the extensive chemical and microscopic evidence is consistent with a hypothesis (based in part on the shroud-

like rubbings from bas-relief sculptures done by Joe Nickell).[23]

With these few words, Mueller sweeps away the years of demonstrated work on both three dimensionality and image chemistry, brings out the same tired Nickell rubbing technique, and tries to refute all without the slightest demonstrable reference other than a "fair" negative which is perhaps the easiest characteristic to duplicate in an age that understands negative imagery. But as Dr. Jackson demonstrated, the Shroud image is three-dimensionally "consistent with a body shape covered with a naturally draping cloth and which can be derived from a single, global mapping function, relating image shading with distance between these two surfaces."[24] In short, though none of the Shroud opponents would willingly concede this point, the three-dimensional effect is the Waterloo for all artistic theories. That same effect has been scientifically demonstrated and subjected to the best peer review. And it still stands.

Also, this same characteristic proves to be the acid test for all the image formation theories Dr. Jackson tried regardless of how well they met or failed to meet the other known Shroud image characteristics. A catalog of ruled-out theories includes the following: direct contact, diffusion, lab-induced radiation from a body shape, engraving, powdered bas-reliefs, electrostatic imaging, phosphorescent statues, hot statues or hot bas-reliefs.

The last theory, hot bas-relief, has been advanced as the solution to the Shroud question by sindonologist (Shroud researcher) Father Robert Wild, S.J. In his *Biblical Archaeology Review* article, Father Wild incorrectly asserted that statue-scorching is rejected only because of the problem of burn through and that such a technique would be three-dimensional like the Shroud:

> Those who reject the "scorching" theory argue that a
> statue, when heated enough to scorch a piece of cloth,

will burn holes in the fabric where raised portions like the nose touch it. If the scorching theory is correct, I would have to reply that modern experimenters—and there have not been many—have simply not yet mastered a technique that was available to some medieval craftsman.[25]

Not only do these remarks show little understanding of the issues involved in confirming any Shroud hypothesis, but they do a great disservice to the many sindonologists who have attempted various scorching mechanisms since 1978. Excluding the members of STURP, who all have been involved in such research, I have personally received materials from researchers all over the globe, including, but not limited to, Oswald Schuermann and Alan Whanger, plus researchers in France, Denmark, and even Japan, all of whom have done major scorch research for years. Even I have had to rethink seriously the entire issue of the "scorch theories." Nevertheless, statue-scorching is one scorch theory that cannot be accepted. It fails in regard to three-dimensionality, fluorescence, and a host of other difficulties. One researcher summarized the problems this way: "Jackson has done both theoretical and experimental work to address three-dimensional hot-statue hypotheses. He found that a simple isotropic radiation source could not yield the observed Shroud-image shading and resolution . . . (even allowing attenuation) the resulting directionality of the radiation would introduce an unacceptable distortion of the image. . . ."[26] His conclusion: *at least in so far as known forms of scorching are concerned* brings the entire "scorch" theory into question.

Science and the Shroud

There are, however, other specific areas of scientific research that can help provide identification of the man of the Shroud as well as deal with the major Shroud questions. Since science to this point seems to have ruled out the possibility of human artifice, I think it is safe to conclude that we are

dealing with a genuine artifact—in other words, the Shroud is a real burial garment. Much evidence has been set forth to document this fact.

On the issue of a body, STURP commented, "If the blood images were made by contact with wounds, it follows that the cloth was used to enfold a body; we have evidence that the cloth was used in this way.... If we couple this argument with the testimony of the forensic pathologists, we can say more: not only was it a human form, but further, it was a human body."[27] William Ercoline demonstrated that the Shroud contained a three-dimensional body. More importantly, he provided a satisfactory explanation for some of the image's oddities and also provided corroborating evidence that the image projected from that body rather than had across-the-board contact with it. He concluded, "The Shroud image contains distortions which cannot be explained by anatomical variation, cloth stretching, or photographic perturbation.... These distortions seem to be consistent with those induced by draping a cloth over a full three dimensional body form . . . the character of the distortions and some anomalies of the image seem to be best explained by a vertical mapping process."[28]

Therefore, it certainly is not too farfetched to conclude that if this cloth contained a body with bloody wounds and that body left a three-dimensional human profile on the cloth, then it was most likely a human body—the body of a human being who suffered precisely as the Gospels state Jesus did. Nor would it be bizarre to conclude that, barring evidence to the contrary, the most likely person to have been in that cloth was Jesus. I discuss this probability further in Chapter 8.

Another interesting researcher to be considered in post-1981 Shroud literature is Dr. Alan Whanger. He uses a very detailed method of analysis called polarized image overlay technique. When two superimposed images are simultaneously projected onto a screen through-polarizing filters, a

third filter will allow a close-up comparison of details. The Whangers have repeatedly demonstrated that the Shroud image was known and used as a model for everything from icons to coins. Specifically, they isolated icons of Christ from the sixth century and coins bearing His image from the seventh and demonstrated 170 points of congruence for the coin and 145 for the icon. The significance of this research is that it only takes "45 to 60 points to establish the identity or same source of face images" in a court of law.[29]

By their method the points of congruence between the artifact in question and the Shroud image itself can be clearly seen by everyone present. Some of the artifacts (for example, catacomb images of Christ) most recently studied in this fashion date as early as the first century, which lends tremendous credibility to Ian Wilson's theory concerning the years the Shroud was missing (see Chapter 7). These artifacts also provide corroborating evidence for the antiquity of the cloth before the 14th century. They have provided strong evidence to support theories concerning foreign objects such as coins or phylacteries on the facial image.

Dr. and Mrs. Whanger traveled to Switzerland to visit the home of the late Dr. Max Frei (Dr. Frei's work is discussed later in this chapter and also in Chapter 7). The Whangers retrieved the remaining samples of Dr. Frei's botanical studies of the Shroud. These have in turn been passed along to Paul Maloney of the Atlanta International Center for Continuing Study of the Shroud of Turin (AICCSST) for further research.[30]

One point that drew flak in Shroud research has centered on the "coins on the eyes." Some have considered such research pseudo-science and have given it little if any credence. Many scientists themselves felt that since the 1978 photographs failed to reveal such data then the artifacts seen earlier must have been merely anomalies in the cloth weave. One sarcastically commented that he could even "see swans in the weave if he looked long enough."[31] However, Dr.

Robert Haralick used the initial work of the Whangers and the late Father Francis Filas to demonstrate through digital image enhancement the following evidence:

1. The right eye area of the Shroud image contains remnants of patterns similar to those of a known Pontius Pilate coin dating from A.D. 29 (see Chapter 6).
2. The photographic negative of the Shroud image has qualities similar to three dimensional range data.
3. The face of the Shroud image is similar to the face on an icon of Jesus dating from the sixth century.[32]

Here from an independent researcher is confirmation not only of the coins, but also of Jackson's 3-D work and of iconography, both the Ian Wilson theory and the Whangers' backup data. Though some in the past were quick to say that such research was about as significant as looking at a Rorschach diagram, that opinion is no longer valid. To begin with, as the Whangers' (who also found seventy-four points of congruence for the Pontius Pilate coin) pointed out in *Applied Optics:*

> Comparing the same area on the 1931 and 1978 photographs, this technique shows that the cloth is not in exactly the same position and drape for the two photographs and that threads over the eye area might have been stretched or rotated. This accounts for some apparent distortion of the letters and images in the 1978 photographs indeed making it more difficult to see them on these photographs.[33]

We know that the 1931 photos were taken with the Shroud stretched taut while our testing platform was specifically designed so as not to stretch or put tension on the cloth. Another interesting consideration is that perhaps this simple technique has given evidence concerning the image formation process. The Shroud must be taut in order to show the images of coins, perhaps the Shroud was taut when those images were first formed. Certainly if testable, this would be

a strong piece of evidence against the German-Pellicori hypothesis, which states that the Shroud image was the result of "time lapse chemistry." In other words, chemicals on the body altered the cloth over several hundred years. It goes without saying that quickness to reject this data now undermines the scientists' own work.

In the work of the late Dr. Frei, once again we find a variance in how significant various researchers feel his pollen finds actually were. Some argued that the pollens meant absolutely nothing. Others simply found fault with his methodology, particularly his controls and documentation. The major complaint seemed to be that the pollen could have been airborne, no matter what the country of origin. Frei responded:

> Groups A, B and C of plants on the Shroud from Palestine and Anatolia are so numerous, compared to the species from Europe, that a casual contamination or a pollen-transport from the Near East by storms in different seasons cannot be responsible for their presence.... The predominance of these pollens must be the result of the Shroud's stay in such countries.... Migrating birds or contamination with desert plants by pilgrims can be excluded because they had no possibility of direct contact with the Shroud.[34]

These comments concern only those pollens analyzed before Dr. Frei's demise. It is my understanding that the samples now being analyzed by ASSIST could require years of further study. In addition, Frei concluded that many pollens matched species found "almost exclusively" in microfossils from the Dead Sea. To his mind the preponderance of evidence mitigated against a medieval fraud. Consider the facts that this was Frei's field of expertise and that his work has been confirmed by Dr. Giovanni Riggi, who also found "minute animal forms 'extremely similar in their

aspects and dimensions' to those from Egyptian burial fabrics."[35] Meacham rightfully concluded, "pollen . . . is empirical data . . . ipso facto evidence of exposure to the air in those regions."[36] As to the concern that STURP only found one pollen, Frei's hand application of tape to the Shroud (which earned him much criticism from other researchers) ensured the transfer of particles that the nonpressure method of STURP obviously missed.

Another extremely important aspect of Shroud study after 1981 revolves around the two points I was most taken to task for in *Verdict on the Shroud:* the "scorch" theory and the resurrection connection. Let me begin with the scorch theory. In its summary report STURP stated the following:

> The primary conclusion is that the image does not reside in an applied pigment. The reflectance, fluorescence, and chemical characteristics of the Shroud image indicate rather that the image recording mechanism involved some cellulose oxidation/dehydration process. It is not possible yet to say definitely whether these chemical modifications were produced by scorching or by some sensitized thermal or photochemical reaction. The fluorescent properties of scorches *may* eliminate them from consideration, but more detailed investigations are required to rule out scorch hypotheses generally.[37]

Much has been learned about the density shading and chemical properties of the image, but so far, there are no firm ideas about how the image may have been applied to the cloth. Again, Jackson's three-dimensional studies and the global consistency of the image suggest that some global mechanism was involved; however, nothing more specific can be concluded. Nonetheless, the choices are narrowed.

Resolution considerations and the absence of gross distortion of the image in high profile-gradient regions argue against three-dimensional "hot-statue" hypotheses,

although the remote possibility of contact or radiant thermal energy transfer from a flat model cannot yet be dismissed. If the image proves to be a chemically-induced cellulose modification instead of a scorch, it would be seen that the material transfer must have been accomplished by direct contact. (The superficial nature of the image eliminates a vapor diffusion mechanism.) Several contact-transfer models were considered, but none seems totally practical or convincing. . . . The *most* outstanding problems pertain to the image transfer mechanism. Briefly stated, we seem to know what the image is chemically, but how it was created remains a mystery. The dilemma is not one of choosing from among a variety of likely transfer mechanisms, but rather that *no technologically-credible process has been postulated that satisfies all the characteristics of the existing image.*[38]

At this point science begins to clash with the overall Shroud question. If all evidence points to a real burial garment and if the best explanation of that evidence appears to involve some sort of energy transfer, then to suggest an unknown form of "scorch" seems perfectly logical. In my opinion, STURP balked at this because of all people they know full well the ramifications. If they agree to a "scorch," are they not also agreeing to the Resurrection, just as many opponents have claimed? Given the possible ridicule of fellow scientists and the concern that such a revelation might call all of their work into question, I would expect STURP to tread cautiously around this issue. Instead of caution, however, what continually appears in print is denial. It would seem that STURP has succumbed to one of the two major human fears: fear of people or fear of failure. I hasten to add that while I agree that any known form of scorch causes fluorescing and the Shroud image does not fluoresce, I find that to be much easier to accept than a theory which has three or four problems and requires a mind-boggling series of happenstance even to postulate. Which theory requires more faith?

For obvious reasons, I concluded a "scorch" to be the most likely image formation process. Though this resulted in complaints that *Verdict on the Shroud* was "unscientific," some scientists such as Jackson generally agreed with me. Since that time, the scorch theory has led to more intemperate rhetoric than any other single issue. In spite of the fact that many of the scientists themselves have been quoted as giving theories that clearly would be interpreted as a scorch by anyone who heard them.

The party line currently seems to be that the scorch theory has been eliminated from consideration. Technically speaking, I agree. Any known form of scorching has been ruled out. Nevertheless, the current conclusions of STURP suggest that it's not that simple. For instance, the image is called a "more advanced stage of natural aging-type decomposition."[39] The process is described in this fashion: "This yellowing is due to the natural process of dehydration, oxidation and conjugation typical of low-temperature cellulose decomposition."[40] Additionally, though the best lab results have come from "catalyzed-decomposition contact mechanisms" (German-Pellicori samples "baked" to simulate aging), they quickly added what we've said all along. The Shroud's three-dimensionality alone not only poses thus far insurmountable problems for contact, but also suggests a "projection" mechanism.[41] Chemist Alan Adler admitted that of the three working models even the two most promising theories are "energy transfers," which are also problematic.[42] One of these is Giles Carter's theory that the energy transfer mechanism was x-rays emanating from the body. Adler stated this was "fine chemically, fine physically yet bizarre biologically" and quipped that "the man would have been so radioactive that he glowed in the dark. Not to mention he would have been dead long ago from the radioactivity."[43] The other mechanism involved a high voltage, high energy transfer that Oswald Scheuermann, a respected physicist and sindonologist, has been experimenting with

for several years. Using a dry cloth Scheuermann can produce an image very close to that on the Shroud using high voltage electricity.

Images with virtually the same detail and physical and chemical characteristics as those on the Shroud can be produced on linen by means of radiation from high voltage, high frequency AC electrical currents . . . the ionizing electrical energy spreads over the surface of any object in the electrical field, whether it be tissue, hair, cloth, leather, or metal. The sparks or ions then tend to be discharged as streamers (coronal discharge). This helps to explain why one can get detailed images on the Shroud of such objects as the Pontius Pilate coin over the right eye.[44]

But again the question seems to be how? Perhaps an unusual phenomenon such as tall lightning, but how does one duplicate such a thing? In addition, all of Scheuermann's samples which I have seen seem to penetrate the cloth, something the Shroud images definitely do not do. Adler has suggested that the use of a larger, thicker model (at least five to six inches) would overcome some of the problems in Dr. Scheuermann's work, but that it would be extremely difficult to accomplish because of the amount of energy required, an estimated 50KV at 10 amps over a body-sized object.[45] (Reviewing these theories, scientist Igor Bensen suggested 50 watt-seconds/square centimeter for a power source of at least 1,100 kilowatts for 1/10 second). Dr. Scheuermann suggested a solution to this dilemma that might make some uncomfortable:

> Either there was a chain of coordinated processes of cause and effect due to laws that are still unknown or an inexplicable phenomenon of a supernatural kind left traces of a natural kind. . . . Consequently, it is high time now to completely record the primary aspect and add the phenomenon "resurrection" to the fact "corpse . . . Resurrection," even if inexplicable,

must not be excluded as a point of reference or an action principle. . . . It has to be admitted that I know hardly anything as to how that Resurrection is to have taken place; but that does not exclude that it could have left palpable traces—despite many a theological opinion—not only an empty tomb and all the attendant circumstances, but also a very informative image.[46]

Once again, the evidence seems to point to the empty tomb and the Resurrection.

Conclusion

In fairness to those STURP scientists who may also believe that the image was caused by the Resurrection, I have to consider politics. In Turin a select group of people in essence controls the destiny of the Shroud. When *Verdict on the Shroud* was first published, some in this group took the position that there was no further need for testing because the Shroud had been "proven" authentic. As the former spokesman for the STURP team, I can attest that very explicit directions were given to each STURP member as to what could and couldn't be said in public. Furthermore, despite the fact that everyone supposedly had the liberty of a "personal opinion," such liberty was for all intents and purposes sacrificed for objectivity and credibility. In a classic example, I was told that as the spokesman, I no longer had that liberty. Admittedly this occurred after a series of media misquotations (all by STURP members) had ruffled a few feathers in Turin. Given the alternatives, some of the scientists may have felt more concern over the consequences than courage of their convictions.

Again the issue of identity seems to offer an out and a problem at the same time. If this cloth held the crucified body of Jesus of Nazareth, then perhaps the Resurrection is involved. Obviously there is no known way to duplicate that

feat, and therein lies the rub, not to mention the eagerness of adherents to cry, "Miracle! Miracle!"

On the other hand those who pursue the totally natural avenue continue attempting to develop the Pellicori-German model. The primary problems with this model are three-dimensionality, superficiality, capillary-flow, and the ability to produce all known points of image contact. Though German and Pellicori are confident that given the proper environment—specifically a humid one—the once stiff cloth would sag sufficiently to produce the proper 3-D gradient and contact pattern and that the right body oils would only produce a superficial stain and would therefore not evidence noticeable capillary flow, they have so far failed to produce such an image in any of their laboratory tests.

In past Shroud research, the major failing has been not cooperating to coordinate the methodology, data, and results. Also entire fields of expertise have been ignored or simply not consulted. Finally, little if any of what was learned ever received widespread dissemination. (Most of these comments specifically target the so-called "secret" 1973 commission.) STURP initially did a fairly good job of avoiding these errors both before and after Turin. However, for whatever reasons, STURP became somewhat parochial in later years and has (in my opinion) failed to capitalize on the excellent results it did achieve. For example, some members of STURP seemed overly concerned about sensationalistic news reports. After one such report, a STURP member inaccurately concluded that "the credibility of STURP is in ashes."[47] In reality, the incredibly well-documented and peer-reviewed articles by STURP have met with respect, stimulated much discussion, and led to further research in a variety of new fields. Also STURP has by its own admission had an incredible fear of the religious issue and tried to avoid it at all costs. In my opinion, a far wiser course of action would have included biblical and archeological experts to

deal with such issues as the identity of the man, Jewish burial customs, as well as textile and coin experts.

Likewise, in *Verdict on the Shroud* I made some mistakes, many of which I already mentioned. The primary one was underestimating the way a book written for public consumption could be misinterpreted and twisted. Second, in my excitement, I was perhaps too strong in my espousal of the scorch theory as I understood it at the time. Also it was perhaps premature in attempting the definitive book.

Where did we stand in the 80s? Scientifically speaking, the Shroud is not a painting of any type. It rather seems clearly to be a genuine burial garment, stained with real blood and containing an image of the male body it once contained. Chemically, that image is composed of dehydrated-oxidized cellulose of the linen itself. The previous carbon-14 dating had raised more than a few concerns. Touted far and wide as proof that the Shroud is a hoax, this late addition to the Shroud investigation is not at all what it is cracked up to be. In short the C-14 data flies in the face of all the other data and yet is expected to stand by virtue of its name alone—in spite of the fact that most scientists will readily admit that C-14 is not infallible. As we shall see in the next chapter, the dating as it has been presented to the public (with limited and secondhand facts at best) is severely flawed and in fact proves nothing.

On the other hand, multiple fields of research indicate scientific evidence, including pollen, coins, mites, and textile data, to support the Shroud's antiquity and its Middle Eastern origin. Photographic research confirms that it was known and copied long before its appearance in medieval France, and possible pigment contaminants may also confirm that.

Though the cause of image formation is not yet known, only three have any semblance of validity. One, the German-Pellicori natural latent chemistry model has no known precedent, has defied reproduction and seems to violate

three-dimensionality, superficiality, capillary-flow, and the detail of the image. The second, Dr. Carter's theory—namely that the victim's bones emitted X-rays that created the Shroud's image—seems bizarre from a biological standpoint, which would contradict or at least compromise the otherwise straightforward chemistry of the image. Finally, the high voltage, high energy transfer approach is also without precedent and has defied reproduction thus far, but it seems promising in my opinion.

What did it all mean then and what does it all mean now? That's the central question this book will address.

5

The New Testament and The Shroud

The image of the man of the Shroud contains much information about how the man died and was buried. How does it compare with what we know of Jesus' crucifixion and burial as recorded in the Gospels? This question is important for both scientific and religious reasons. The Gospels have been shown to be reliable sources; they tell us much of what we know today about Roman crucifixion practices and Jewish burial customs. If, as the image indicates, the man in the Shroud is a Jew crucified by the Romans, the circumstances of his death and burial should be consistent with what the Gospels say about these things.

The religious reasons for this comparison should be obvious. If the Shroud is the actual burial garment of Jesus, then it should be consistent with the New Testament texts. This condition must be satisfied before anyone can identify the cloth as Jesus' burial garment.

Crucifixion

There are some definite parallels between the man of the Shroud and Roman crucifixion practices. A closer look at these parallels reveals a remarkably close correlation. Let us compare relevant New Testament texts with details of the Shroud image.

> *Then Pilate took Jesus and scourged him.* (John 19:1. See also Matthew 27:26; Mark 15:15.)

Approximately 120 scourge wounds can be observed on the body of the man of the Shroud. They apparently were inflicted by the Roman flagrum, a multi-pronged whip which was designed to rip out pieces of flesh with each blow. The scourging was so severe that some pathologists believe it was the primary cause of the man's death. It certainly hastened it.

> *They struck his head with a reed, and spat upon him.* (Mark 15:19. See also Matthew 27:29; John 19:2.)

The face of the man of the Shroud is disfigured with bruises and swellings. The right eye is nearly swollen shut, and his nose is twisted. The man was almost certainly beaten in the face.

> *And when they had plaited a crown of thorns they put it on his head.* (Matthew 27:29. See also Mark 15:17; John 19:2.)

The head of the man of the Shroud bled profusely from numerous puncture wounds in the scalp. These were probably caused by a cap of thorns which covered the top and sides of his head.

> *So they took Jesus, and he went out, bearing his own cross.* (John 19:17.)

Bruises on the shoulders indicate that the man of the Shroud carried a heavy object. This had to have occurred *after*

the scourging because the shoulder rubbing slightly altered the scourge wounds underneath.

And as they led him away, they seized one Simon of Cyrene, who was coming in from the country, and laid on him the cross, to carry it behind Jesus. (Luke 23:26. See also Matthew 27:32; Mark 15:21.)

The implication of the Gospel account is that Jesus, weakened by the savage scourging, was not able to carry the crossbeam to the place of execution, as crucifixion victims were usually forced to do. It is quite possible that Jesus fell before His executioners seized Simon to carry the cross for Him. The Shroud image shows cuts on both knees, especially the left knee, indicating a bad fall on a hard surface.

"Unless I see in His hands the print of the nails, and place my finger in the mark of the nails, and place my hand in His side, I will not believe." (John 20:25. See also Luke 24:39.)

These words reveal that Jesus had been nailed to the cross in crucifixion. The Shroud image likewise reveals that the man had been pierced through the wrists at the base of the palms, as well as through the feet. Medical experts have no doubt that the man of the Shroud was crucified, as Jesus was.

And Jesus uttered a loud cry, and breathed his last. (Mark 15:37. See also Matthew 27:50; Luke 23:46; John 19:30.)

The man of the Shroud is dead. His swollen abdomen indicates that he died by asphyxiation, the way crucified victims died.

But when [the soldiers] came to Jesus and saw that he was already dead, they did not break his legs. But one of the soldiers pierced his side with a spear, and at once there came out blood and water. (John 19:33–34.)

The legs of the man of the Shroud are not broken. The

image also shows a wound in his side and a blood and water mixture flowing from it.

In summary, the man of the Shroud was crucified the way Jesus was. The comparison of the New Testament and the Shroud image lines up at every point.

The Burial

A comparison of the burial of the man of the Shroud with Jesus' burial is quite fascinating. The Gospels contain more information about the way Jesus died than about how He was buried. The same is true for the Shroud image. A comparison of the two requires careful research, as well as an understanding of key words in New Testament Greek.

Jewish Burial Customs

The first point of comparison is the cloth itself. The Gospels say that Jesus was buried in a cloth (or cloths); the Shroud of Turin appears to be a burial cloth which medical experts say once held a dead body. The image reveals a man lying on his back with his feet close together. His elbows protrude from his sides and his hands are crossed over the pelvic area. We can ascertain that the linen sheet was laid lengthwise up the front and down the back of the corpse.

Is this kind of burial compatible with the New Testament reports? It is at least compatible with Jewish customs as we know them from extra-Biblical sources. Recent archeological excavations at the Qumran community found that the Essenes buried their dead in the way represented on the Shroud. Several skeletons were found lying on their backs, faces pointing upward, elbows bent outward, and their hands covering the pelvic region.[1] The protruding elbows rule out an Egyptian-type mummified burial. Also very instructive is the *Code of Jewish Law,* which discusses burial procedures in its "Laws of Mourning." It instructs that a person executed by the government was to be buried in a single sheet.[2] This is another parallel with the Shroud.

Although the New Testament's description of typical first-century Jewish burial customs is not overly detailed, it does give the general features. The body was washed (Acts 9:37) and the hands and feet were bound (John 11:44). A cloth handkerchief (Greek, *sudarion*) was placed "around" the face (John 11:44; 20:7). The body was then wrapped in clean linen, often mixed with spices (John 19:39–40), and laid in the tomb or grave. The *Code of Jewish Law* adds that the Jews usually shaved the head and beard completely and cut the fingernails before burial.[3]

However, the Gospels tell us that Jesus' burial was incomplete. Because the Sabbath was about to begin, he was removed from the cross and laid in the tomb rather hurriedly. This is why the women returned to the tomb on Sunday morning. They had prepared spices and ointments for Jesus' body, and they went to the tomb to apply them (Luke 23:54–56). It is not often noticed why the women went to the tomb. They certainly did not expect Jesus to rise (Luke 24:3–4; John 20:12–15). Rather they came in order to finish anointing Jesus' body with the prepared spices (Luke 24:1; Mark 16:1). They were worried about who would help them to move the stone from the entrance of the tomb.

The Gospels do not say to what extent the burial had been left unfinished. The New Testament says that Jesus was wrapped in linen with spices and a handkerchief after the custom of the Jews (John 19:40), but it does not say that His body was washed. At least to some degree, the anointing with spices was incomplete because the women returned to the tomb to complete the process. The scripture does not state specifically what other parts of the burial process were unfinished, if any. Although apparently a Jew, it appears to some that the man of the Shroud was not buried in accordance with the complete ritual of Jewish burial. He was laid in a shroud, as Jews were, but His body was unwashed. Stains of what looks like blood are visible on the body image and on the cloth itself. Neither was His hair trimmed. Despite what

looks like a hurried burial, He was wrapped in a shroud of good linen. However, the wrapping in linen is consistent with first-century Jewish custom.

The Wrapping

It is quite difficult to determine from the Gospels the precise method used to wrap Jesus' body in the cloth since the four evangelists use several different Greek verbs to describe the process. Mark 15:46 states that Jesus was wrapped *(eneilesen)* in a linen sheet. Matthew 27:59 and Luke 23:53 describe the body as being wrapped, or folded *(enetylixen)* in the linen cloth. John 19:40 says that Jesus was bound *(edesan)* in linen clothes. These Greek words are similar, yet they do not reveal the exact method used.[4]

McDowell and some others detect a problem in John's word to describe the "binding" of the body.[5] They suggest that Jesus' body was wrapped tightly like an Egyptian mummy, a procedure which would not have yielded an image such as the one on the Shroud. However, the mummy idea largely rests on variant readings in the extant manuscripts of John's Gospel. One late manuscript uses a verb in 19:40 which suggests a tight binding of the body. The accepted verb, however, is *edesan,* a verb which means to "wrap" or "fold" and which is quite compatible with the synoptic verbs. The idea that Jesus was tightly bound like a mummy is also incompatible with John's earlier description of the way Lazarus emerged from the tomb after Jesus raised him from the dead (John 11:44). Lazarus, who was buried according to Jewish custom, was able to proceed from the tomb by his own power, although he was impaired and had to be "unbound." He had his hands and feet bound, as was the custom, but he was not completely wrapped up.[6]

In other words, the type of wrapping depicted in the Shroud is compatible with Jewish burial technique. In particular, the burial methods depicted both in the Essene

cemetery and described in the *Code of Jewish Law* favor the Shroud. Along with the Lazarus account, these sources convince us that the type of wrapping demanded by the Shroud was at least practiced in Israel in Jesus' time, and may even have been the most popular practice. At any rate, it cannot be asserted that Jesus must have been buried as a mummy.

The Grave Clothes

Another issue concerns the difference in the words chosen by the Gospel writers to describe the grave clothes that Jesus was wrapped in.[7] The synoptic evangelists say that He was wrapped in a *sindon*, a Greek word meaning a linen cloth which could be used for any purpose, including burial. John, on the other hand, says Jesus was wrapped in *othonia*, a plural Greek word of uncertain meaning. *Othonia* is sometimes translated as "strips of linen," a meaning that would seem to be incompatible with a fourteen-foot-long shroud covering the front and back of the body. However, it is likely that *othonia* refers to *all* the grave clothes associated with Jesus' burial—the large *sindon* (the shroud), as well as the smaller strips of linen that bound the jaw, the hands, and the feet. This interpretation of *othonia* is supported by Luke's use of the word. He says (25:53) that Jesus was wrapped in a *sindon*, but later (24:12) that Peter saw the *othonia* lying in the tomb after Jesus' resurrection. Luke, then, uses *othonia* as a plural term for all the grave clothes, including the *sindon*.

Furthermore, as seen earlier, Jewish burial customs do not support the idea that John's othonia refers to the wrappings of a mummy. Jews did not wrap up their dead like mummies, but laid them in shrouds, as indicated by the Gospel of John, the Essene burial procedures, and the *Code of Jewish Law*. John himself insists that Jewish customs were followed in Jesus' case (19:40). Thus, there is good scriptural evidence that Jesus was laid in the tomb wrapped in a shroud.

Therefore, the Gospels refer to the grave clothes in both the singular and the plural. When a single cloth is spoken of, it is obviously the linen sheet itself. However, since Luke (or early tradition) had no difficulty in using the plural (24:12) to describe what he earlier referred to in the singular (25:53), the term "clothes" may still refer to a single piece of material. On the other hand, if more than one piece is meant, "clothes" is most probably a reference to both the sheet and the additional strips which were bound around the head, wrists, and feet, as indicated in John 11:44 (cf. John 19:40). Interestingly enough, bands in these same locations can be discerned on the Shroud of Turin. At any rate, it is a reasonable conclusion that at least one major linen sheet is being referred to in the Gospels.

Another apparent problem crops up in the descriptions of the grave clothes the disciples saw in the tomb on Easter morning. Both Luke and John describe grave clothes in the tomb. Luke says that Peter went inside the tomb and saw the *othonia*— the generic term for all the grave clothes, including the Shroud and the smaller pieces used to bind the jaw, hands, and feet. John, however, gives a more detailed description of what he and Peter saw, and he introduces another term into the grave clothes listing. When they went into the tomb, they saw not only the *othonia* lying on the ground, but also the *sudarion* lying rolled up in a place by itself, apart from these *othonia*. John adds the detail that the *sudarion* had been "around the head" of Jesus.

Sudarion means "napkin" or "sweat cloth." It is, at any rate, a rather small piece of cloth. If it had been placed over the face of Jesus in the tomb, no image of Jesus' face would have appeared on the Shroud. Since the Shroud of Turin bears the image of a face, the reference to a *sudarion* seems to challenge the authenticity of the Shroud. Indeed, some Christians have pointed to this passage as evidence that the Shroud is incompatible with Scripture.

However, a number of biblical scholars do not think that

the *sudarion* was a napkin or cloth placed over Jesus' face. The Mishnah instructs Jews to tie up the chin of the corpse (Shabbath 23:5). The *Code of Jewish Law* also commands the practice of binding the chin.[8] Lazarus' napkin was wrapped "around" his face (Greek, *perideo*), a position that is more consistent with the jaw being tied shut. Additionally, John's observation that Jesus' napkin was found "rolled up" (Greek, *entulisso*) in the empty tomb corresponds closely to the cloth being used to bind the jaw.[9]

John A. T. Robinson, the British New Testament scholar, gives the most plausible explanation for the *sudarion*. He says it was probably a jaw band, a piece of linen rolled up into a strip, placed under the chin, drawn up around the face, and tied on the top of the head. Its function was to keep the jaw shut before rigor mortis set in. Not only does the New Testament not state that the napkin was placed over the face so as to cover it, but the combination of "wrapped up" and "around the head" (John 20:7; cf. 11:44) fits what is depicted in the Shroud.

Jaw bands are used for this purpose today and there is every reason to believe that they were used in first-century Palestine. There is evidence for just such a jaw band on the three-dimensional image of the face of the Shroud. The hair of the man seems to be separated from the cheeks. The hair on the left side of the face hangs out over the edge of an object, probably the chin band.[10]

Why did the Gospel of John include this detail about the *sudarion*? The author seems to attach great importance to it. He describes the burial cloth on the ground and the *sudarion* rolled up in a place by itself, and then adds that this discovery caused belief. The Gospel states ". . . he saw and believed" (John 20:8).

It is not easy to tell from the Greek exactly what it was about the placement of the grave clothes that caused belief (John 20:8), but Robinson has a plausible interpretation of what is being described here. We are told that the disciples

entered the tomb and saw the shroud and the other linen cloths lying flat. But the *sudarion* was apparently still in its twisted oval shape, the way it had been when tied tightly around Jesus' head to keep the jaw closed. Something about this scene convinced them that someone could not have stolen the body, as Mary Magdalene had feared after she discovered that the stone had been moved away from the tomb. Until this moment, the Gospel explains, the disciples had not understood that Jesus would rise from the dead. Now, looking at the grave clothes, they believed.

The Unwashed Body

Another issue in the Shroud New Testament correspondence, one already mentioned briefly, is Jesus' unwashed body. Since the Shroud unquestionably depicts an unwashed body, we should determine whether the New Testament says anything about this crucial fact. The Jews washed the bodies of their dead before burial, as people in most cultures do. However, the Gospels do not say specifically that Jesus' body was washed. There is good reason to think it was not.

The Gospels say that the coming of the Sabbath curtailed some of the activities involved in Jesus' burial (Luke 23:54–56). The Mishnah allows for the anointing and washing of a body on the Sabbath, but only if not a single portion of the body was moved (Shabbath 23:5). In other words, the body could have been washed, but not wrapped in a shroud and laid in the tomb. Therefore, if the whole burial process could not have been completed by the beginning of the Sabbath, there was sufficient reason to leave the body unwashed. We should remember here that the women returned to anoint the body with their prepared spices (Luke 24: 1; Mark 16: 1), which were used for several purposes, including cleansing. Since the Gospels do not record the washing, it might be inferred that this was not done, but was left for the women after the Sabbath.[11]

Again the *Code of Jewish Law* assists us. The law relates that while washing and cutting of the hair and fingernails

was the normal procedure in Jewish burial practice, these acts were not performed on persons who were executed by the government or the state, or those who died a violent death.[12] Since both these exceptions apply to Jesus, the washing of His body would have been prohibited on two counts, especially to Joseph and Nicodemus as members of the Sanhedrin.

An alternate view, however, claims that Joseph of Arimathea was a disciple of Jesus and therefore would have ignored the specific custom and washed the body since, as he saw it, Jesus was not a criminal and should not be treated like one (Matt. 27:67; John 19:38; see also Mark 15:43; Luke 23:41).

There is one other suggestion that Jesus' body was not washed. This is John's statement that Jesus' body was wrapped in a large quantity of spices before burial (19:39-40). Since the women were returning to the tomb on Sunday in order to anoint the body with spices, what was the difference between the first anointing and the second?

The most likely explanation is that the large quantity of spices had been packed around Jesus' body before the burial precisely because the body had not been washed. This large quantity of spices, possibly in dry form, could have been intended to serve as a disinfectant to arrest decomposition until the women could properly anoint the body after the Sabbath. The spices which the women were bringing with them on Easter morning would probably have been applied during or after they washed the body. As it turned out, however, the temporary packing with spices just before burial was the only anointing Jesus' body received. Again, the New Testament does not indicate exactly how the spices were distributed, and there is no contradiction between the Shroud and the Gospels. In fact, there is no contradiction between the Gospels and the Shroud on any point.

One other issue might be quickly mentioned again. The Gospels relate that Jesus' hands were nailed to the cross (Luke 24:39; John 20:20, 25-27) while the man of the Shroud was nailed through the wrists. There is no discrepancy here,

for at least two reasons. First, the Greek word for "hand" can also refer to the wrist, thereby including both with the same word. Second, the man of the Shroud was nailed at the base of the palm, in an area that could be described as either "hand" or "wrist." Even apart from the Shroud, scholars have long believed that crucifixion victims (including Jesus) were nailed through the upper wrist, since the palms would not normally sustain the weight of the human body.

Conclusion

What can we conclude from this comparison of the Shroud with the New Testament texts? The first conclusion is a historical one. The burial received by the man in the Shroud is compatible with first-century Jewish burial customs as we know them from the New Testament, the *Code of Jewish Law*, and the Essene archeological find. All these sources indicate that dead Jews in the first century were not bound up like mummies but were laid in tombs wrapped in a shroud. This was the way the man of the Shroud was buried. This is a very general conclusion. We cannot absolutely assert that burial like that seen in the case of the man of the Shroud was the universal custom in first-century Palestine. However, this study does suggest that wrapping in a shroud was a likely procedure. The Mishnah, the *Code of Jewish Law*, the Essene burial customs, and especially the New Testament texts such as John 11:44 and 20:7 show that the burial method used in the case of the man of the Shroud was, at the very least, a viable option known to be used by Jews in the first century.

Second, we can conclude that the burial of the man of the Shroud closely resembled that of the first century Jew about whose burial we know the most—Jesus Christ. Some of the burial rituals prescribed in Jewish law were not completed in his case and subsequent events prevented them from being completed after his entombment. As was probably true in Jesus' case, the body of the man of the Shroud was not washed. We can draw a third conclusion which is relevant to

the question of whether the man of the Shroud *is* Jesus Christ. Nothing in the New Testament rules out the possibility that the man is Jesus. This conclusion is possible because the New Testament describes the general Jewish burial customs of the first century, but it does not describe the exact procedures used in Jesus' case. The exegetical study here cannot prove that the man is Jesus, but we could conclude that he is not Jesus if the Shroud image differs in any significant way from what the New Testament says about how Jesus was crucified and buried. The Shroud meets this test. The man of the Shroud was crucified the way Jesus was, and a close study of the texts reveals no incompatibility with the New Testament description of his burial.

Another point is worth making here. Something like the Shroud of Turin is not what one would expect a medieval forger to paint if he intended, as he certainly would, to base his artistry on the Gospel descriptions of Jesus' burial. He probably would have painted a face cloth—the most obvious meaning of John's ambiguous *sudarion* in 20:7. He may have painted a washed body, because Acts 9:37 notes that the Christians washed Tabitha's body before they laid her out. He might even have painted a mummy. In addition, he would likely have shown the wounds in the palms of his hands as depicted in all historic paintings of the crucifixion. Bishop John A. T. Robinson says that his natural predisposition to skepticism about the Shroud was shaken precisely because "it could not at all easily be harmonized with the New Testament account of the grave clothes."[13] Nevertheless, the issue of the authenticity of the Shroud must be finally settled on other grounds such as scientific testing. The Shroud of Turin is compatible with the New Testament texts and favored by important Jewish writings and customs. If rigorous scientific tests validate it, we will have a strong case for its authenticity.

6

Carbon 14 – Is the Shroud a Medieval Object?

The hottest issue in the Shroud story during the late 1980s was the already heavily debated carbon-14 (C-14) testing. The media reporters were bursting with the news that the Shroud had been dated by the controversial C-14 process. On the basis of those reports, many were writing the Shroud off as a medieval artifact. To them it had become just a scientific curiosity. Others, apparently ignorant or perhaps biased about the wealth of data against human artifice, have claimed that the Shroud is a forgery.

Was C-14 a valid method of dating an article such as the Shroud? What range or margin of error must be allowed in dating the cloth? If in fact it does not date two thousand years old, does that finally settle the major questions for most scientists? On the other hand, does a younger date completely eliminate any possibility of authenticity? Who conducted these tests that are now in question? What methods did they use? Was adequate attention given to their controls and protocols? Who supervised their work, and has it met with

the same level of successful peer review that made the work of STURP such a milestone in Shroud studies? What results did they in fact get, and are those results reliable? These were the major issues concerning the C-14 dating of the Shroud of Turin.

Even before STURP's first journey to Turin in 1977 to propose testing the cloth to a panel of appointed authorities and sindonologists, plans were included for dating the cloth. Dr. Jackson went so far as to contact Dr. Libby who was credited with the development of modern carbon dating. Dr. Walter McCrone, who joined STURP in Turin, proposed a dating procedure at a cost of approximately fifty thousand dollars. Not convinced that his proposal met with a favorable response, McCrone called on the late King Umberto II, last surviving monarch of the royal house of Savoy and legal owner of the Shroud. The resulting fracas nearly capsized the entire STURP expedition before it got under way. However, careful distancing ensured that STURP testing would be proposed independently of the then *persona non grata* McCrone. Much later I learned that McCrone and his associates were not even properly equipped to conduct the dating. Nor were they experienced in the field.

After STURP arrived in Turin in October 1978, I was practically accosted by Dr. Harry Gove of the University of Rochester who interrupted my press conference to question what made me an "expert" on carbon-14 dating. I had at no point claimed such expertise. The issues surrounding C-14, as well as the media's constant claim that the church was refusing the test because it had something to hide, had necessitated a statement of STURP's official stance on C-14. As team spokesman, I had been quoted delineating the caveats for such testing. Gove didn't agree with the caveats at all. When the dust settled, he became one of the representatives of several labs to propose a formal dating plan for the Shroud. As you shall see later in this chapter,

however, perhaps even Gove would agree the STURP caveats were well advised after all.

Carbon-14, also known as radiocarbon, is radioactive and has a documented half-life of roughly 5,730 years. Since living organisms can absorb C-14 and dead ones cannot, the dating theory of radiocarbon requires measuring the residual C-14. Due to the fact that C-14 decays at an exact and constant rate, an approximate age can be determined. C-14 has been somewhat controversial since its development, and experts have often been hotly divided over its reliability. At one point some even suggested that those pushing for a Shroud dating would use the cloth as a "guinea pig" for testing new methodology. While I certainly would not question the sincerity of all C-14 researchers, such use of the Shroud was indeed a real concern. Now that very concern overshadowed all the media statements on C-14 dating.

Laboratory Selection

One thing that really affected the dating issue was the "on-again, off-again" secrecy hang-up of the Center of Sindonology operation. Before leaving Turin, Archbishop Ballestrero publicly announced that C-14 testing had been approved in principle with certain very reasonable stipulations and that proposals that met those guidelines would be accepted and fairly evaluated. This was one of only three things that I *could* state publicly after Turin without compromising the data reduction—including analysis, discussion, and publication and peer review of the testing methods and the obtained results—that would be ongoing for three years. Notwithstanding that announcement, STURP and Professor Luigi Gonello, a representative of the arch-bishop, hotly protested the distribution of *Verdict on the Shroud* on the grounds that it would hinder the approval of carbon dating. Gonella, whom I still consider a personal friend, even wrote me an extensive letter arguing the point as if I had not been present or had a faulty memory. In

retrospect, some may have truly believed that *Verdict on the Shroud* was strong enough to negate the need for C-14 in the minds of the Shroud's custodians. The truth of the matter is that, for whatever reason, the Shroud question is touchiest with those who control its destiny. They move in "strange and mysterious ways," ostensibly to protect it, but the end result is that outsiders often feel the custodians have something to hide.

The gist of Turin's dating stipulations presented in 1978 was as follows:

1. The laboratories selected to do the dating must agree on methodology so as to provide an equal comparison. (Later proposals suggested alternate methods to increase objectivity on the date received; unfortunately, however, the alternate protocol was dropped.)

2. They must also agree to conduct a double blind study. (Typically a scientific double blind study ensures objectivity by requiring the lab to test at least two unidentified samples simultaneously—one of a known date. This too was apparently violated.)

3. They must first successfully date a sample of known origin. (During this test one of the selected labs was off by over a thousand years).

4. They must (as we did) first brief the archbishop or his representative on all results. (Though the wisdom of this point was questioned in *Verdict on the Shroud* I stand by it. I was asked to do this as a courtesy, and I agreed. Apparently, so did the C-14 labs.)

The C-14 situation progressed significantly. Dr. Gove and his associate were deleted from the C-14 testing (although I understand that he worked with Paul Damon, C-14 expert at the University of Arizona who headed their dating work there on the Shroud) reputedly for having a different orientation from the selected labs (which use the gas counter method).[1] The samples were received by three

laboratories, the University of Arizona, the Federal Polytechnic Institute in Switzerland, and Oxford University in England.[2] The results began to leak first from Oxford and then from multiple sources. Finally, in exasperation, the representative for Archbishop Ballestrero announced that the dating was completed and the age medieval. But serious questions about both the dating procedures and the stated results have been raised from many quarters.

Methodology

To begin with, let's understand the chosen methodology. Unlike the Libby method, which requires pieces of significant size, the selected process uses an accelerator to do mass spectrometry to determine age. This method requires substantially less material for analysis. The pretreated, chemically modified sample (converted to graphite) is ionized and passed through an electric field to strip electrons from its atoms, leaving highly charged individual atoms. These in turn are accelerated and bent (the bending is a function of atomic weight and imposed magnetic field) along different paths specific to each atom—even to its isotopes. This step occurs in a cyclotron which detects these accelerated atoms much like a centrifuge. Only atoms with the masses of C-13 and C-14 are detected. Filtered beams (filtering removes nitrogen 14) of the remaining carbon atoms strike detectors that count the C-13/C-14.[3] Most labs claim an accuracy of ± 200 years. This technique only required a few centimeters of material, a piece no bigger than the nail on your little finger. Even if they had used pieces of a large fragment that was removed in 1969, many tests could have been done simultaneously. However, the use of this larger fragment would have been extremely ill-advised since it would introduce too many unknowns into an already difficult situation. As Meacham accurately described it, "Certainly most archeologists would have rejected the use of samples subjected to a long separation from the object to be dated and

held under unknown conditions of storage and handling."[4] Unfortunately, as we shall see, the particular sample selected may have been an equally serious error.

According to the Los Angeles Times, the entire dating "process (was) being supervised by the British Museum, Pontifical Academy of Sciences and a representative of the Archbishop of Turin."[5] While the museum claims it was in fact not supervising the dating but was merely the institution selected for the C-14 symposium, it was definitely responsible for the certification of the Shroud samples and the statistical analysis of the data itself. Even though the labs were given three cloth samples to conduct the blind study (they were not told, of course, which came from the Shroud), Michael Tite of the British Museum also noted, "a laboratory could if it wanted to, distinguish the Shroud sample from the others, so the *blind test depends ultimately on the good faith of the laboratories.*"[6] To my horror, I discovered that the labs openly admitted they knew when they were dating the Shroud: "He [Paul Damon] was looking at a quarter-inch-square piece of the Shroud of Turin."[7] The significance of this statement will be discussed in detail later in this chapter.

I want to make it clear from the outset that if we are to arrive at a solid conclusion concerning the age of the Shroud, C-14 is not nor should it be the acid test of the Shroud's possible authenticity. Meacham put it extremely well at the 1986 Hong Kong Shroud Symposium:

> There appears to be an unhealthy consensus approaching the level of dogma among both scientists and lay commentators that C-14 dating will settle the issue once and for all time. This attitude simply contradicts the general perspective of field archeologists and geologists, (notice these are the ones most likely to need accurate dating on a regular basis) who view possible contamination as a very serious problem in interpreting the results of

radiocarbon measurement. . . . I find little awareness of the limitations of the C-14 method, an urge to "date first and ask questions later," and a general disregard for the close collaboration between field and laboratory personnel which is the ideal in archaeometric projects . . . statements quoted (from Shroud researchers both pro and con) reveal an unwarranted trust in radiocarbon measurement to produce an exact calendar date. . . . I doubt anyone with significant experience in dating . . . would dismiss . . . the potential danger of contamination and other sources of error. No responsible field archeologist would trust a single date, or a series of dates on a single feature, to settle a major historical issue. . . . No responsible radiocarbon scientist would claim that it was proven that all contaminants had been removed and that the dating range was . . . its actual calendar date.[8]

If space permitted, I would reproduce Meacham's entire article, for it masterfully delineates all of the problems and issues facing the Shroud dating laboratories.

Meacham recognized that C-14 "is not an infallible technique, and . . . contamination . . . is always to be taken seriously." Nevertheless he "excavated and prepared and submitted . . . more than 70 samples . . . and had liaison with major C-14 laboratories at Oxford a selected lab, Canberra and Teledyne"[9] in his own archeological work. The *McGraw-Hill Encyclopedia of Science and Technology* also has some important facts to add concerning C-14 dating relevant to the Shroud. To begin with, it points out several critical forms of "variation" that are problematic to all C-14 dating. These include secular variation and the DeVries effect and they result "in the necessity to calibrate conventional C-14 dates."[10]

Secular variation refers to a general long-term variation

in C-14 dating in which the radiocarbon years and calendar years are not equivalent. This form of variation exhibits a sine-wave function of 150 to 800 years in deviation. The causes of it are not yet totally understood. Nevertheless, in the case of the Shroud, secular variation alone could cause the C-14 testing to give faulty data.

The *DeVries effect* is a high frequency variation in dating which causes anomalies in the dating process. As a result of this effect, an article can reflect "two or more points in time" for a single artifact being dated. Furthermore, neither the scientists nor the current store of data are internally consistent on artifacts that date from before 1000 A.D.

Due to secular variation and the DeVries effect, articles "between about A.D. 1300 and the later part of the first millennium B.C. *register too young.*"[11] There is also "a lack of complete agreement concerning the frequency and magnitude of relatively rapid periods of oscillation before A.D. 1000."[12] If that were not enough in the way of caveats, the article goes on to say that "variations equivalent to up to several hundred years can result."[13] Therefore they conclude, "C-14 has lost a considerable amount of its significance."[14]

I by no means want to imply that C-14 is useless or should not have been used. Quite the contrary, I believe it should have been done, but under totally different conditions and protocols than were used. In addition I do not feel that C-14 alone will ever settle the matter.

More germane to the issue is the dry run of C-14 testing, which was detailed in the journal *Radiocarbon* in 1986. Scientists used C-14 to date an Egyptian Bull Mummy linen (the wrappings from an ancient Egyptian burial) as well as two Peruvian linen cloths. The results of this testing using the new accelerator method were extremely revealing. First of all, it underscored the fact that the method is somewhat wanting in accuracy. On the Egyptian Bull Mummy linen, the dates ranged from 3440 to 4517 B.P. (before present)—a span of 1100 years. Although the known age of the cloth was

3000 B.C., the closest date they could get using C-14 was 2528 B.C., a date which required a calibration of 472 years to correct it. That should raise plenty of eyebrows. The second sample, one of the Peruvian cloths, was not much better, with a span of 450 years and the closest date 250 years off. Finally, the third, also a Peruvian cloth, had a span of over 1100 years and the closest date less than 100 years off. This Peruvian cloth was a much easier target to hit because the date was "guesstimated" between 1000–1400 A.D. That range gave the testers a built in window of ± 200 years to start with!

After the tests on these three samples were run, the farthest dates were 1549 years, 709 years, and 439 years off respectively. To allow that margin of error on calibration alone would be ridiculous. Moreover, even admitting that errors of contamination would radically affect the test results still underscores the inherent weaknesses of this dating method. In fact, when the testers accredited these poor results to contamination during pretreatment and reran the tests with significant improvement, the oldest cloth still showed an error of nearly 1,000 years. Most importantly, it was 1,000 years *on the young side!*

The significance of all of these dates is that they clearly demonstrate that serious anomalies not only exist but that even the calibration techniques used to correct them are not an exact science. For example, let's look at the calibrated results themselves. The three samples gave the following date ranges after calibration: 3255–2827 B.C. (on a 3000 B.C. cloth), 1400–1668 A.D. (on a 1200 A.D. cloth), and 1289–1438 A.D. (on a 1000–1400 A.D. cloth).[15] Admittedly the calibrated results were much improved, but being over 400 years off on a known sample seems significant. Indeed, these results confirmed what the experts had said concerning C-14 dating and its known drawbacks. I must point out, however, that the article in *Radiocarbon* very glibly understated these problems and, in fact, concluded the following:

Overall, there is good agreement between the results obtained and the expected historical dating of the samples. . . . A coherent series of results can be obtained when several laboratories undertake separate blindfold measurements of the same sample . . . there are *no special difficulties* in dating textiles by C-14 using small sample techniques . . . the distribution (span) of the results . . . *lends added emphasis to the need for the dating* of any important relic such as the Shroud of Turin to be shared by several laboratories if the results are to have maximum credibility . . . as a further check, *exchange of pretreated* samples . . . might be desirable.

You need to understand that the number of labs was reduced to three from the seven proposed; one of the three selected labs was the lab which had the most "outlying results"; one of the protocols or methods of testing was totally eliminated; and the samples were sent in such a fashion that Tito, spokesman of the British Museum, admitted the test was not truly a blindfold test. Furthermore, the two labs that in essence developed the accelerated method were eliminated from the testing.

Dates or Discrepancies?

As I was preparing *The Shroud and the Controversy*, articles began appearing everywhere stating that the Shroud was dated with 95 percent accuracy between 1260 and 1390. The worst part of it all was that many articles added that the Shroud was obviously a forgery. Nothing could be further from the truth. Even if the dating was not fraught with problems, the Shroud has been demonstrated to be a genuine burial garment and not a human endeavor. Certainly had the date been reported to be first century the opponents to authenticity would have raised an array of concerns, or merely claimed that the "artist" used an ancient cloth. But the mood of the day seemed to be to accept the dating without

question and to springboard to an unwarranted conclusion. Nevertheless, even the scientists involved in the C-14 testing have made comments that contradict such a facile reception of the medieval date. For example, the Oxford lab has stated, "At least 1 in 5 dates are contrary to expectation. . . . A major source of error in the dating procedure was in . . . their [the six labs doing the protesting, namely, Arizona, Bern, Brookhaven, Harwell, Oxford, and Rochester] method of pretreatment of samples, i.e., in removing contamination.[16] . . . Before AMS (the method used on the Shroud) is accepted as the final arbiter of chronology, criteria are needed to decide if and when an AMS date is unacceptable."[17] It's interesting in the light of these comments that Oxford, with very little experience in dating cloth, dated the Shroud and was among the first to leak the reports that claimed the Shroud was a fake.

It seems incredible that the Oxford lab could so quickly pronounce the Shroud a fraud on a single dating in a field in which the lab has limited experience, especially given the caveats they themselves raised. But they are not the only enigma in the Shroud C-14 dating. Dr. Willy Wolfi of the Zurich lab, whose testing of the Egyptian Bull Mummy was so far off, stated "One single date, is no date . . . for the particular case discussed here [i.e., an Egyptian cloth] it is obvious that the number of 64 investigated samples is still too small to properly understand the observed disparity between radiocarbon dates and historical chronology."[18] If sixty-four samples from an Egyptian cloth were insufficient, how can such accuracy now be claimed in regard to the Shroud when only one sample was tested?

When discussing the Shroud testing, Dr. Gove himself, in a strong letter of protest to the British Museum, said in part, ". . . there are many people who are overly suspicious of this entire operation . . . I am astonished you would permit the British Museum to risk having its reputation called into question in what has become a somewhat shoddy

enterprise."[19] In addition, the C-14 results had yet to be published in acceptable scientific journals, much less subjected to the same intense peer review and criticism that were both a blessing and a curse to STURP. Initial reports indicate the following discrepancies:

1. The samples were all taken from the bottom of the Shroud, a mere two to three centimeters from a repair site due to the 1532 fire. This site selection created serious problems for the dating procedure. For example, if, as some sindonologists have suggested, the dating zone (or test sample) was actually an added strip of cloth and therefore not part of the original Shroud, we have no knowledge of its history and testing it would have resulted in an inaccurate age for the Shroud. Furthermore, I know for a fact that the Shroud was heavily handled throughout its history and that it was damaged by fire and repaired with strips of cloth during the Middle Ages. Each of these factors adds an unknown variable of contamination to the dating equation, making a definitive C-14 dating extremely difficult, if not impossible.

2. No testing or measurements were done to ensure that the fire damage in no way altered the cloth due to isotope exchange, which occurs at 300° even though the Shroud was in a fire of at least 960° and was also subjected to super-steam vapor when doused with water during the fire. When the Shroud was burned in the 1532 fire, carbon molecules from its silver casing, the case's silk lining, and its framing materials would have begun to mix with the Shroud's carbon molecules. This would have occurred at any temperature over 300°F. Dousing the Shroud with water would have also caused additional molecular exchange. By not checking out these factors and including them as part of the dating equation, the labs left themselves open for a faulty date.

3. Only one type and amount of solvent was used to cleanse

all three samples, though stronger solutions may have removed additional contaminants from the cloth and thereby resulted in an older date.

4. The small counter method (gas), which is considered much more reliable and effective for testing cloth samples was eliminated. (Remaining gas can even be redated.)

5. A true scientific blind study was never conducted: a) All labs involved in the dating were present at the removal of the Shroud samples, so they knew which samples were which; b) The linen was left intact with its unusual weave (3–1 herringbone twill with a "Z" twist), obviously recognized by the labs during the tests (it's been reported that some labs even found fibers of the red silk backing cloth during their preparations); c) The date of the "dummy" cloth was published and available to all the labs; d) The "dummy" cloth was of a totally different weave from the Shroud.

6. The textile expert present at the removal of the test samples had not made detailed public statements or published a report concerning the location, examination, or extrication of the samples for C-14 dating. This is a critical oversight, especially in light of reports that some stray threads on the sample were merely snipped off, not unwoven to help prevent contamination. I had received several letters concerning a video of this procedure. All the writers stated that it "appeared" to them that the test samples were from the side strip—a highly contaminated portion of the Shroud. One of these observers also confirmed the reports that stray threads on the sample were merely "snipped off."

7. There were no publications or peer review of the method and the results before boldly proclaiming the date results to the public.

8. The labs' interpretation of the dating results was prejudicial. The labs stated they had "proof of forgery," which certainly undermines their professed objectivity

in the light of the other published, peer-reviewed technical data on the Shroud that have not yet been successfully refuted.[20] Indeed, this data has been largely confirmed by others in their respective fields of expertise.

The final straw to be added to the back of this horribly overloaded camel is best reflected in the words of Wolfi of Zurich: "The C-14 method is *not immune to grossly inaccurate dating* when non-apparent problems exist in samples from the field. The *existence of significant indeterminate errors occurs frequently.*"[21] Keep in mind that this man's lab was the same lab that had the extreme outlying results during the dry run C-14 tests.

Furthermore, independent research seems to point out yet another scientific discovery that discredits the 1988 carbon 14 dating results of the first test profile. Dr. Leoncio A. Garza-Valdes, a San Antonio pediatrician with a specialist interest in ancient Mayan artifacts, had discovered a bacterium which grows on many ancient objects and produces a clear "bioplastic" coating on those artifacts. The acrylic-like and transparent bacterial coating is therefore a contaminant that could obviously affect carbon 14 dating results on all ancient artifacts. His discovery has led to an entirely new discipline called archaemicrobiology (over leaf *The DNA of God . . .* Doubleday Books, March, 1999).

After reading Ian Wilson's description of a "damask-like surface sheen"[22] on the Shroud, Dr. Garza-Valdes became convinced that the Shroud fibers which were tested by carbon 14 dating in 1988 were likely contaminated by this translucent bacteria buildup over the centuries. This contamination to the sample would have created errors in the radioactive carbon 14 dating by producing an error which would suggest the artifact was not as old as its true date. Since the bacteria growing on the artifact would naturally accumulate over the centuries this material would contain additional carbon 14 atoms that would reflect a much

younger age than the underlying artifact. If this bioplastic coating material is not properly cleansed or removed from the artifact, the presence of it would naturally produce serious errors in the radioactive dating process. When he studied samples of the Shroud, he found the contamination that he expected. "With a scanning electron microscope, I found that the fibers were completely covered by the bioplastic coating (polyhydroxyalkanoate) and by many colonies of fungi, which usually thrive on this polymer."[23]

Later when he compared the spectrum of the Shroud fibers, pure cellulose and one of his Mayan artifacts using an infra-red microscope for spectroscopy, there were differences. As he wrote, ". . . if the samples dated by the radio-carbon laboratories had been pure cellulose, as it was claimed, the spectra should have been similar. That they are not, immediately suggested that the cellulose in the samples dated in 1988 had an extra organic component, namely, the bioplastic coating."[24] In fact Dr. Garza-Valdes was to eventually determine that the bioplastic coating accounted for as much as 60% of the Shroud dating samples used by the three labs. He even got Professor Harry Gove to admit as much.[25] Another Shroud researcher, Dr. E. T. Hall, wrote an article in the February 1989 issue of *Archaeology* (31:92–95) entitled "The Turin Shroud: An Editorial Postscript" in which he discussed the controversy over the 1988 carbon 14 dating tests. In this article Dr. Hall revealed that a significant amount of bacteria contamination to the test sample would produce serious errors in the final date determination. "Assuming that the Shroud sample was 2000 years old, the linen would have to be contaminated with 40% of modern carbon in order to give it a medieval date."[26]

Some Shroud scientists claim that the standard cleansing of artifacts with hydrochloric acid and sodium hydroxide would have removed any bacterial contamination. However, according to research by Dr. Garza-Valdes this standard cleansing technique does not remove the bioplastic coating

that has been proven to be present on all ancient artifacts. A 60% bacteria contaminant in the Shroud samples, as proven by Dr. Garza-Valdes, would produce major errors in the radioactive dating process by including additional carbon 14 atoms from the contamination material that would mislead the researchers to conclude that the underlying sample was much younger than its true date.

A brilliant and respected British scientist specializing in Egyptian studies at the Manchester Museum, Dr. Rosalie David, confirmed that bacterial contamination did produce significant errors in the dating of ancient artifacts according to Ian Wilson's book *The Blood and The Shroud*[27]. Dr. David discovered that the carbon 14 dating of the linen wrappings on Egyptian mummies (which are also contaminated with bacteria) reveals significant differences in dating from the radioactive dating of the actual bodies. In fact, Dr. David revealed that the average radioactive dating error between the mummy body and the outer linen wrapping amounted to an average of 550 years. In every case studied, the contamination caused the linen wrapping to appear to be much younger than the body it wrapped. Therefore, Dr. Garza-Valdes' findings are extremely significant in the overall scheme of Shroud studies. I sincerely hope that Dr. Garza-Valdes' research will receive the follow-up study and credit it truly deserves.

Given all of the above, where did I stand with regard to the question of the C-14 dating of the Shroud? At the very least, the first round of C-14 testing has allowed the widespread publication and interpretation of data that has raised serious questions yet to be answered. At the worst, it has introduced inaccurate data that has been permitted to jeopardize the search for sound answers to the questions surrounding the Shroud's authenticity. In both instances, the 1988 C-14 tests did little to advance scientific study on the Shroud.

Conclusion

Whatever the final verdict on the initial C-14 testing, during the 80s it had only added a serious degree of confusion at a crucial turn in Shroud studies. Having built up the dating as the "be all and end all" of sindonology, Turin authorities are now faced with the extremely disappointing results. Moreover, they appear to have accepted very questionable data without question. Fortunately, however, efforts are even now underway to petition Turin and the Vatican to seek a more scientific "second" opinion. If all these tests had produced different dates, controversy would have raged for years while the main issues were pushed aside. Since all the tests apparently have produced a medieval date, even C-14 experts as diverse in opinion as Gove (who rejects the Shroud's authenticity) and Meacham (who accepts the Shroud's authenticity) are beginning to shout "Foul!" over the protocols alone.

Also no one has taken into account the bizarre history of the Shroud itself and what impact that might have had on the dating. Meacham spelled it out this way:

> For the Shroud, there is a 600-year history in a number of different environments and unknown handling situations, and a possible further 1300-year existence during which the object could have been in contact with virtually any natural or man-made substance in the areas it was held. To measure Shroud samples, one must therefore consider every possible type of contamination and attempt to identify and counter them all.[28]

The bottom line for the age of the Shroud is the same as the bottom line for the Shroud in general—we must view the Shroud's age in its entirety with every possible piece of relevant data taken into account. Then when all of the evidence is in, we can make an educated guess as to the most likely age of this cloth. As with the Shroud itself, no one piece

of data is enough, but the data as a whole is overwhelming. Since C-14 alone is not enough, and the current C-14 test is so debatable, let's move on to discuss other considerations about the age of the Shroud—considerations that have been tested, retested, and thoroughly reviewed.

Before I do, however, one final remark on the 1988 C-14 tests is in order. Although I, and many other sindonologists, have serious questions about the results of these tests, I do not question the overall validity of C-14 as a test for age. Certainly it has its weaknesses and pitfalls, but when properly used, it can be a helpful dating tool. My concern is over the use of C-14 to date the Shroud. In this instance, it appears that flaws in preparation and experimentation have resulted in a flawed conclusion, as the other tests for age strongly indicate.

7

Other Tests for Age: Their Reliability and Their Results

Given the problems surrounding the C-14 dating and realizing that the resulting controversy may well continue for years, other methods and scientifically credible techniques to arrive at an approximate age for the Shroud were also explored.

Unfortunately, STURP had no one truly qualified in archeology, or history (although there was an open liaison with Ian Wilson, an art historian well-known for his Shroud research, textile analysis, and biblical research)—the very fields most likely to have provided good evidence for the Shroud's longevity. Into this gap came Max Frei, Ian Wilson, Bill Meacham, Francis Filas, Al Whanger, and a host of others to whom I now turn again.

Scientific Research

To begin with, let's examine the first scientific statements made concerning the origin of the Shroud. In 1969 experts from various fields were called in to examine the Shroud in preparation for a television exposition. This group eventually became known as the secret commission, primarily because its efforts were unknown to the public until they were leaked to the press. Most of their efforts still are not widely known, and it was years before any attempt was made to translate their findings. One of that group, a textile expert, Professor Gilbert Raes, later concluded in part that the Shroud was consistent with cloth woven in the Middle East. The key factor in his conclusion was not the weave but the discovery of minute fibers of cotton interwoven in the cloth. Cotton was not used in Europe in the Middle Ages; however, it had been used in the Middle East for centuries. To the best of my knowledge, Raes was one of the only textile experts to have "hands on" experience with the Shroud, but he was not the last to place its origin outside of Europe.[1]

Thus, the documented history of the cloth is well established by the controversy surrounding it. After all, from the first public display of the Shroud in medieval France, the Shroud's whereabouts have been heavily documented precisely because its authenticity has been so hotly debated. Therefore, any individual factor that takes it outside of medieval France, automatically increases its longevity. For example, the cotton found on the cloth requires that the Shroud was woven in the Middle East. Other factors, such as pollen, coins, and cloth weave, also point to a much older and non-European origin for the Shroud.

In fact, several areas of research contribute significantly to the establishment of a reliable age for the Shroud. These other areas include the following:
1. Identification and origin of pollen and mites.
2. Identification and dating of artifacts such as coins or phylacteries on the image.

3. Verification and origin of archeological details.
4. Cloth/weave comparison and analysis.
5. Historical verification.

Though any or all of these methods might seem without merit to a chemist or a physicist, they are nonetheless a vital part of normal historical identification. Certainly all of these would be essential factors to an archeologist, and whatever else is certain about the Shroud at this point, it is most certainly an archeological artifact. For example, if an individual work of art were discovered and previously unknown, similar techniques would be used to make the case for its origin and manufacture. More importantly, these methods would be especially critical when the history of the artifact is cloudy or unknown.

Pollen

Perhaps the most significant work on the identification and origin of pollen on the Shroud was done by the late Dr. Max Frei, who founded the scientific department of the Zurich Police and whose doctoral thesis was on the flora of Sicily. Dr. Frei was present with STURP during the 1978 studies, primarily because he had previously identified key pollens that definitely placed the Shroud in both Palestine and Turkey at some time in the past. Though many pollens on the Shroud could be attributed to those areas, such as in the famous cedars of Lebanon, Frei only selected those pollens that are still unique to each specific area. In my opinion, the significance of the pollens cannot be overestimated.

For example, certain desert halophytes that he found on the Shroud led Dr. Frei to say, "These plants are of great diagnostic value for our geographical studies as identical plants are missing in all other countries where the Shroud has been exposed to the open air. Consequently a forgery, produced somewhere in France during the Middle Ages, in a country lacking these typical halophytes, could not contain such characteristic pollen grains from the desert regions of

Palestine."[2] The pollen analysis confirmed in scientific detail the history that Ian Wilson had developed from scattered references and artistic comparisons. According to Wilson, at some time in its history, the Shroud was exposed to the open air in Palestine and Turkey—precisely where it should have been if it and the Mandylion cloth are, in fact, one and the same. It is certainly doubtful that a medieval forger could have known, let alone produced, a cloth with just the right microscopic-size pollen spread.

In 1978, compared to the extremely detailed and orchestrated approach of STURP, Dr. Frei's methods seemed a little haphazard. In particular, his somewhat heavy-handed application of sampling tape earned him scorn from a few of his fellow sindonologists. In fact, however, STURP's meticulously applied tapes yielded few if any pollens, which led many STURP members to doubt Frei's earlier work.

Later scholars have helped to vindicate and confirm the wisdom of this man whose criminal expertise was respected throughout Europe. Apparently the hand application of tape was much more likely to contact the pollens that almost certainly would have settled deeper into the fibers and crevices. The purely surface roller method used by STURP barely disturbed the cloth, nor did it penetrate to the level of the pollens. Werner Bulst, in a response to the late Dr. Frei, made the following observations:

> . . . [of] Pollens from 58 species of plants . . . less than one third grow in France or Italy. . . . [This] astonishing . . . small number of European species can be explained by the history of the Shroud in Europe, for, normally kept in a closed reliquary, the Shroud was protected from pollen contamination. Only on special occasions was it exposed in the open. . . . The spectrum of non-European species is highly astonishing. . . . There is only one place where all of these plants—with the exception of three . . . grow in a very small

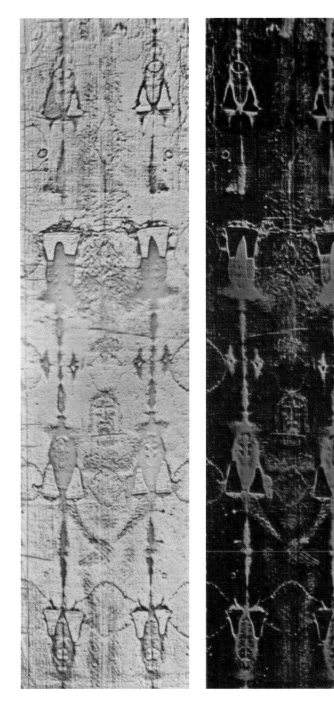

Shroud of Turin - Full Length
Positive Image (L) and Negative Image (R)

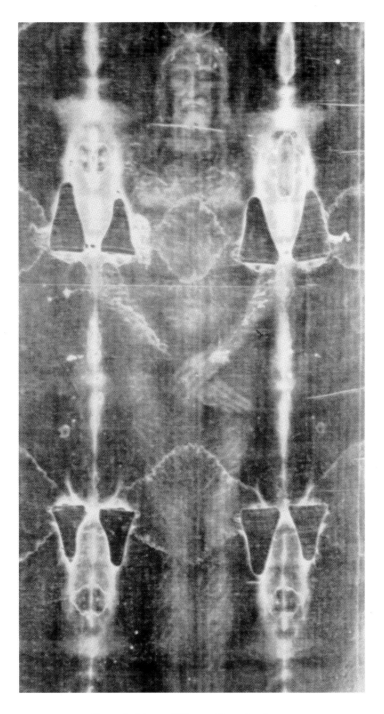

Shroud - Frontal View - Negative Image

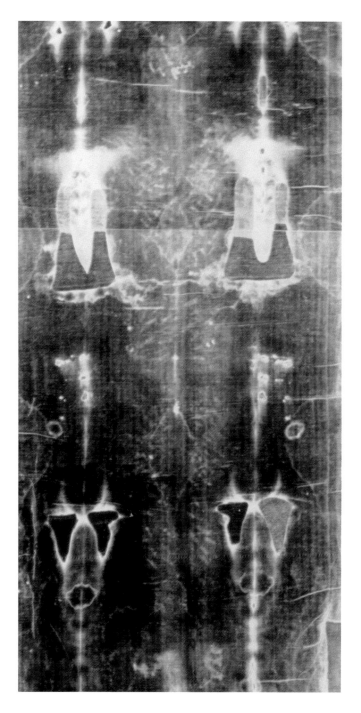

Shroud - Dorsal View - Negative Image

Facial Image - Natural Positive Image

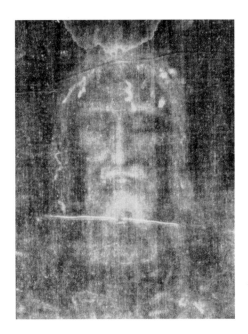

Facial Image - Negative Image

The Sudarium (Face Cloth), that has been in the Cathedral of Oviedo in Oviedo, Spain since A.D. 760, is examined by Dr. Mary Whanger

The Sudarium contains several types of microscopic pollen that originate only in Jerusalem as well as blood stains identical with those found on the Shroud of Turin

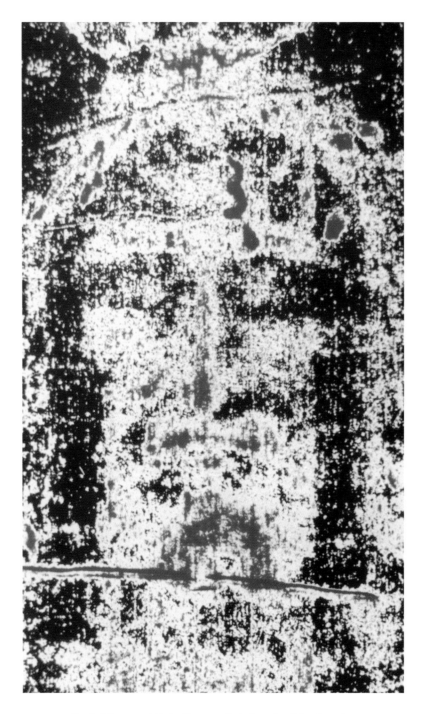

Facial Image - Digitally encoded showing blood stains

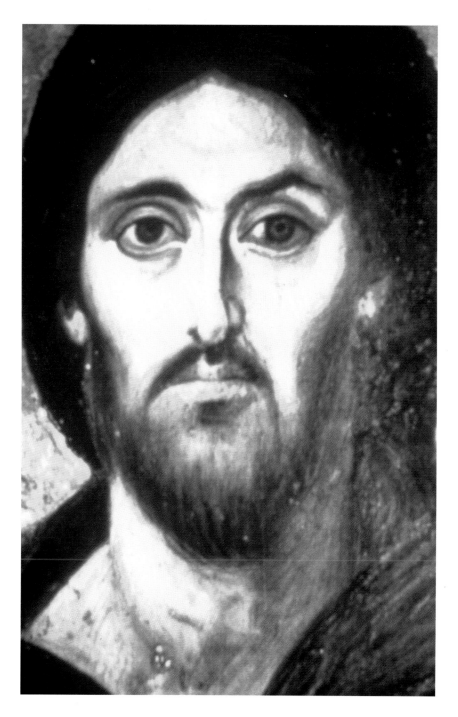

6th Century painting of Jesus found in St. Catherine's Monastery that reveals remarkable details that are similar to those found in the Image of the Shroud of Turin

Frontal and Dorsal Image - showing three dimensional data - VP-8 Analyzer

Three dimensional model based on data encoded in
the Shroud of Turin

*Photograph showing Shroud blood stains and yellowed linen
fibrils revealing image*

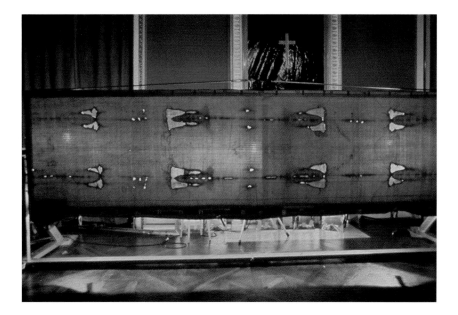

Shroud backlit to show that the image appears only on the linen's surface (the Shroud's image appears only on the linen's surface fibers; it is superficial only)

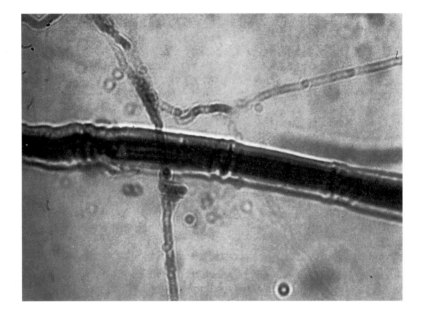

Photomicrograph of Shroud of Turin fiber
Flax fiber stained in purple showing bioplastic coating covering Shroud fiber
(Photo courtesy of Dr. Leoncio A. Garza-Valdes, "The DNA of God?")

radius: Jerusalem. . . . This cannot be an accident . . .
pollens could have been carried to Europe on winds
. . . but a transport of pollens from the Middle East is
highly improbable.[3]

In addition, the three isolated plants apparently are found in the Edessa and Constantinople areas where history again would suggest that the cloth received very little, if indeed any, open exposure.

Bulst's most impressive statement also clearly demonstrates the weakness of the argument that Middle East pollens are insignificant.

Pollen grains can come upon the Shroud only when it is exposed in the open. It would have been a stupendous miracle if, precisely in the few days when the Shroud was being exposed, storms would have brought pollens over a distance of 2500 km. and—even more miraculous—if those winds were carrying many more pollens from the East than from the European environment. Moreover, the pollens on the Shroud are from plants which bloom in different seasons of the year. Therefore the same improbable "accident" must have happened repeatedly.[4]

It should be pointed out that pollen analysis is acceptable evidence in a court of law and therefore certainly empirical data as to the Shroud's longevity and non-European origin. Furthermore, with the remaining samples from Dr. Frei's lab, which were generously donated to ASSIST (Association of Scientists and Scholars International for the Shroud of Turin) by his widow, much more can yet be learned from the folds of this cloth.

Mites

Another interesting aspect of the microscopic material found on the Shroud is the discovery of mites by Professor Riggi. During his analysis of samples vacuumed from between the Shroud and its backing cloth in 1978, he isolated and identified a mite peculiar to ancient burial linens, specifically

Egyptian mummy wrappings.[5] If the Shroud was a creation of the Middle Ages, then its forger must have ordered the mites to go with it.

Artifacts

Artifacts visible in the Shroud image areas are the next consideration. These include "coins" over the eyes, a possible phylactery upon the forehead (which logically should have a corresponding "prayer box" on the arm), and other "clothes:" such as a modesty cloth or "bands" at the head, hands, and feet. In 1978 Eric Jumper, John Jackson, and I co-authored an article which appeared in *The Numismatist* and postulated the theory that 3-D objects visible on the eyes might in fact be coins. Working with Ian Wilson, we suggested the lepton of Pontius Pilate because the size, shape, and markings seemed uncannily accurate.[6] The sample of the lepton I ordered and purchased for STURP was fairly well preserved, but I do not currently know its whereabouts. Though I asked for suggestions and admitted the research to that point was "inconclusive," I was in no way prepared for the hailstorm that followed.

To begin with, many lambasted *The Numismatist* for even including an article on the Shroud. Others suggested that I took great liberties in supposing that the use of coins was compatible with early Jewish burial customs. There were also some who made helpful suggestions for additional research. The final blow seemed to come when the 1978 photographs failed to reveal the same details over the eyes as was seen on the earlier photographs.

While at least one of my co-authors on the article may have changed his view, I retained an interest that has been somewhat vindicated by independent research.

First, the late Father Filas proceeded to find coins that matched the initial lepton, right down to a peculiar misspelling. The coin's inscription contained the letter sequence UCAI. The correct spelling should have been UKAI. Father

Filas found several extant copies of the lepton with this spelling error. Apparently, the dye used to make the coin was misstruck in the same way as a twentieth-century three-legged buffalo nickel. And it was used until the error was finally detected. Josh McDowell and many others who were suspicious of the Shroud's authenticity criticized Shroud supporters asserting that "the coin striker would have had to be either drunk or ignorant" to mint a coin with such an error.[7] It seems they forget that Romans, like the rest of us, made mistakes occasionally, even honest ones.

Second, Father Filas submitted that research to Dr. Haralick who independently confirmed the presence of the "coins" (see "What Was Science Saying?" on page 68).[8]

Finally, a separate 3-D analysis also confirmed the identification. It is most interesting to me that the 3-D photos of the "coins" actually reveal more clearly the letter shapes which match the Pilate coin inscription. Also, the earlier photographs were apparently taken with the cloth stretched tautly on a board. I searched the 1978 photos—the Shroud was only loosely held to the testing platform. This difference is significant in that the minute details visible on the earlier photographs would likely be hidden in the crevices of the Shroud when loosely held.

Personally, I spent some time with Jewish scholars in an attempt to clarify the burial custom controversy. Once again, however, the results were inconclusive. While some felt that nothing precluded the custom, others felt there was relatively little to support it either. Though no clear custom can be established, coins have been found in skulls in the Middle East dated in and around the first century A.D. For example, the tomb and ossuary holding the skeleton of the High Priest Caiaphas, who presided at the trial of Jesus, was found with a coin minted in A.D. 41 showing the head of King Herod Agrippa. Alternate theories can be advanced to explain this archeological fact, but no one knows for certain in the absence of either a written record or eyewitness testimony.

The primary significance is that if the coin is in fact the Pilate lepton, it is strong corroborating evidence that both the image and the cloth date to the first century. And with this form of dating, the margin of error is substantially less than with C-14. In addition, the overlay technique of the Whangers confirmed the presence of not only coins but also phylacteries. When the 3-D photographs revealed that the "box" on the dead man's forehead was apparently an artifact, Wilson and a Jewish cadet at the Air Force Academy both suggested a tephillin—a Jewish phylactery or prayer box which contains a portion of Scripture. When I later discussed this possibility with Eleazor Erbach, an Orthodox Rabbi from Denver, he not only confirmed its size and shape, but also suggested that the broken blood flow on the right arm might have been caused by the corresponding arm phylactery.[9] If indeed these artifacts are what they appear to be, then not only do they add to the case for longevity, but they also mitigate strongly against forgery. Additional researches by Whanger and Haralick seem to support the notion of other clothes, such as a modesty cloth in the groin area or "bands." But these are much more elusive from a technical standpoint, and they do not add much to the overall case for authenticity. Given that some of the scientists do not consider these studies validated even now, further expert testimony is needed.

Archeological Peculiarities

One facet of age determination that has been little developed is verification of archeological details and peculiarities. For example, researchers have often observed that all medieval artists have depicted the nails in the hands of the crucified Jesus, not in His wrists. Meacham noted, "The nail through the wrist is a solid historical indicator. After all, all of the evidence says that this is a crucifixion victim. So that puts the Shroud in the years of crucifixion—a date from 150 B.C. to A.D. 350. You can't do much better than that even with C-14."[10]

Another indication that mediates against the medieval date is the length of the dead man's hair. As Noel Currer-Briggs pointed out, "The fourteenth century was not alone in disapproving men with long hair.... [Medieval] contemporary inconography depicted Jesus with fairly short hair."[11] He even intimated that this may have incited the medieval inquisitors to attack the Templar Knights. The Templars were the same group art historian Ian Wilson suggests became custodians of the Shroud after it disappeared from Constantinople. What other indicators would a trained historical or scriptural expert come up with given a detailed firsthand study of the cloth?

Textile Studies

Textile comparisons also testify to the longevity of the Shroud. John Tyrer, a chartered textile technologist who has worked in that field for twenty-five years, discovered in his research that while Middle East linens similar to the Shroud exist that date as far back as 3600 B.C., not much medieval linen has survived. Additionally he determined, "It would be reasonable to conclude the linen textiles with 'Z' twist yarns and woven 3/1 reversing twill similar to the Turin Shroud could have been produced in the first-century Syria or Palestine."[12] Tyrer even suggested that textile analysis alone would aid in dating the cloth. He also confirmed what early Shroud researchers have suggested concerning the longevity of linen. Furthermore, he added that textile analysis might offer important clues to the effects of yarn variations on image-formation and to cloth draping. Tyrer concluded, "The Shroud is probably the most remarkable 'Standard Sample' for the interpretation of the history of textiles that has come down to us."[13]

History

Another area pertaining to the age question is historical research that has come out since 1981. Even given the excellent coverage of magazines such as *Shroud Spectrum*

International, it is a gargantuan task to remain current on the historical research being done on the Shroud. Some of the most exciting work has come from authors who have provided further evidence for the Wilson theory of iconography—the Edessa connection. In *Shroud Spectrum International* alone, articles from Fossati, Crispino, Pfeiffer, and Barber delved into the iconographical connection. With the exception of Pfeiffer, a synthesis of these articles suggests mounting evidence in support of Wilson's reconstructed history. In addition, these other researchers are filling in a few of the gaps in Wilson's work. Fossati, for example, disclosed that the Holy Face of Edessa (one of several Mandylions) found in the Vatican is actually painted on herringbone fabric which seems "similar" to the Shroud.[14] He went on to make the obvious suggestion that detailed studies of these icons could provide supportive details for sindonology. Rex Morgan and Noel Currer-Briggs also offered corroborating historical evidence that the image was both known and used as a basis for the paintings of Christ from as early as the first century.

Concerning his work, which involved comparing the earliest known paintings of Christ found in the catacombs and alleged to be made by eyewitness, Morgan cautiously concluded:

> If other researchers, by examining these repro-
> ductions of the earliest portraits of Christ, if that is
> what they are, can agree to any extent that they
> portray the same man as the Shroud of Turin image
> depicts, then we can take the date of the existence of
> the Shroud back to the time of Christ. . . . If the
> congruent features are sufficiently convincing, and I
> suggest . . . they are, then this discovery must add
> weight to the already considerable weight of evidence
> for authenticity.[15]

If these early art works, some of which are believed to be first century, could be subjected to the overlay technique

developed by Dr. Whanger (see *"Science and the Shroud")* and have the same level of congruence, it would again provide strong corroboration for the Shroud's existence before the Middle Ages. Furthermore, in a conversation, Morgan told me that he had now acquired an original photograph of the Templecombe image that is of a much finer quality than that which was published by Wilson and which again lends credence to the iconography theory.[16] The Templecombe image is the surviving link between the Shroud of Turin, a painted copy of the Templars' "treasure," and the "miraculous image of the Savior." It is strikingly similar to the Shroud in color and imagery. Its discovery strongly suggests that the Templars had the Shroud in their possession—again raising serious questions about a medieval origin for the Shroud. Morgan's book *The Holy Shroud and the Earliest Paintings of Christ*[17] brings out much evidence for a professional historian to follow up in detail.

Currer-Briggs after providing intricately detailed historical research for *The Holy Grail and the Shroud of Christ* in which he strongly bolsters Wilson's Templar connection said, "There is simply no genius of this caliber known to art historians capable of creating such a masterpiece at this period. . . . Highly intelligent and cultured men and women who saw it in the twelfth and thirteenth centuries believed that it was genuine . . . that the image of Christ . . . was not made by human hands. . . . They should have known the difference as there were enough representations of Christ's head in paint and mosaic for them to be able to tell. . . . [To them] it was the genuine Shroud of Christ."[18]

The only medieval voice alleging forgery appears to be Bishop Pierre d'Arcis (see Chapter 2) who claimed that the image was "cunningly painted." But he never turned up the artist who allegedly painted it, and the reigning Pope subjected the Bishop to "perpetual silence" on the matter— a peculiar demand that raises questions concerning d'Arcis' motives, or at least as Ian Wilson states, leads to the

conclusion that there was "more to the affair than any of the documents tell us."[19]

Perhaps one of the most overlooked areas of historical research is that of extra-biblical source references. My friend and former co-author, Dr. Gary Habermas, wrote his doctoral dissertation on "extra-biblical" evidence for the resurrection. When one of his referees (a Jewish Professor) noted that he missed the single most critical piece of "extra-biblical" evidence for the resurrection, Gary was shocked. That professor told him about the Shroud; a few weeks later we were on our way to *Verdict On The Shroud*. Extra-biblical evidence has a critical role to play in the Shroud story. There are three references that bear significantly on the Shroud story and therefore deserve special consideration where the Shroud's missing history is concerned: Jerome; Ephraim the Syriac; and the Gospel of the Hebrews.

Let's begin with Jerome, whose Latin Vulgate was still considered the authentic version of the Bible until the Reformation in A.D. 1520. He is also credited with the development of the modern usage of the term Apocrypha as referring to books NOT included in the Masoretic Hebrew Text. Jerome therefore was a 4th century post-Nicene writer of some import in both Catholic and Protestant circles where church history is concerned. His reference to the Shroud cites the Gospel of the Hebrews (more on this work later) and reads as follows:

> The Gospel also which is called the Gospel according to the Hebrews and which I have recently translated into Greek and Latin and which also Origen (another church father circa 185–254) often makes use of after the account of the resurrection of the Saviour says, "but the Lord, after he had given his grave clothes to the servant of the priest, appeared to James (for James had sworn that he would not eat bread from that hour in which he drank the cup of the Lord until he should see him rising again from among those that sleep)

and again, a little later, it says, "Bring a table and bread," said the Lord.

This story of the Lord giving his grave clothes to the servant of the high priest was mentioned by a number of Shroud scholars, but the mention by Jerome lends credence to the longevity of this story.

Ephraim the Syrian mentions the Shroud in "His Testament." Since this book is believed to have been written in preparation for his imminent death, the reference to the Shroud should carry extra significance. After all, the norm in such cases is that such times of preparation directly impact the import of what is shared by the dying.

"I Ephraim am at point to die: and I write my testament;

That I may leave for all men a memorial;. . . ."

"Blessed is the city wherein ye dwell: Edessa, mother of the wise, Which from the living mouth of the Son: was blessed by His Disciple.' This blessing shall abide in her: until the Holy One shall be revealed."

The reference clearly indicates that Ephraim was referring to the King Abgar legend as recorded early by the Christian historian Eusebius (260–340) in his *Ecclesiastical History*. Since Ephraim's testament is dated as 373, only a few decades after Eusebius, there is a strong probability that Eusebius' record is correct. This reference to the Abgar legend by another respected Christian scholar who was in a position to assess the credibility of the tradition lends weight to the elements of truth in the legend.

Finally, the Gospel of the Hebrews itself, which we have already quoted according to Jerome via Origen, speaks of the presentation of grave clothes to the servant of the high priest. As we have noted elsewhere, grave clothes would have been considered unclean. Further, the commentary on the Gospel states in part, "The handing over of the linen cloth to the

priest's servant points to a legendary working up of the resurrection story; if, as is possible, the linen cloth was intended to be to the "priest" (the high priest) a proof of the reality of Jesus' resurrection, then an apologetic motive here makes its appearance."

It has been my experience that frequently in the history of the Shroud, stories have been developed by man in an attempt to explain the relic: the Veronica legend and its obvious connection to the historical object we call the Mandylion immediately come to mind. Therefore it doesn't surprise me in the least that somewhere along its historical path someone might have set out to write an account to explain the existence of an artifact that otherwise would have surely been consigned to the flames by its very nature: an unclean, bloodied, burial garment. How could such an artifact ever be expected to be evidence of the resurrection? If anything you would expect the Sanhedrin to shout with glee, look at the evidence of His death, how can anyone so mutilated rise again. But when we compare these accounts with the other connected accounts we are confronted with of all things the image of a corpse. The Bishop's service mentioned it, the crusaders mentioned it, Eusebius mentioned it, even an early pope mentioned this "imprint of the Savior's body." One account goes so far as to say, "His naked body."

Again, what is most significant about all of these references is that the historians who recorded them for posterity with no possible knowledge of how their comments would be perceived over time nevertheless gave them credence, by their very inclusion in the record. At the very least, they make it clear that something very similar to what we call the Shroud was known, seen, and written about, long before any Medieval date and often by the very people we put so much stock in when it comes to other historical church matters. Why not the Shroud? We cannot ignore these accounts simply because they don't line up with C-14 dating or someone's modern attempt at interpreting who may or

may not have been attempting apologetics. Put all three references together in the context of other known historical, Biblical, and scientific facts and the case for authenticity mounts.

Conclusion

It should be readily apparent by now that the issue of the age of the Shroud is much the same as the overall question of authenticity. To arrive at any reasonable conclusion, all of the facts must be evaluated. When my first two books were being prepared, the one thing that repeatedly amazed me was the wealth of articles on the subject of the Shroud that I had never seen. It is perhaps little known that in Esopus, New York (a scant fifteen miles from where I sit), there is a well-stocked library dedicated to the Shroud. Many of the writings there have never been translated and date back generations. Who knows what lost historical details exist on those pages— details that could unlock the missing years of the Shroud entirely?

For now, I must summarize the case for the age of the Shroud:

- It was known, copied, and revered as the image of Christ, perhaps as far back as the first century.
- It obviously came from the Middle East and has cotton, pollen, and mites from that area imbedded in its threads.
- Artifacts from coins to hair style point to an early origin.
- It accurately displays a form of capital punishment not practiced since A.D. 350.
- The data as a whole match a historical path that is continually gathering support; after all, a cloth from the Middle East which was also exposed in both the southern steppes of Turkey and the area of modern Istanbul is much too close to the path Wilson postulates for mere coincidence.

Individually, none of these points would carry the day. But together they merit much more consideration than some

scientists have given thus far. The bottom line for many scientists seems to be that too much speculation is still involved. Nevertheless, I must add at this point that the human artifice theory is no longer feasible on scientific, historical, archeological, or biblical grounds. To imagine the genius necessary even to conceive, much less produce, such a level of historical detail seems beyond all reason. Just how well does all of this evidence match the historical traces of the Shroud? We'll examine that in detail in the next chapter.

Some Important Cautions

In a Shroud of Turin study like this, several critical points must be emphasized. First, I only speak for myself. I do not presume to be stating a position for any one else. I edited the 1977 Proceedings that presented the most extensive theorizing prior to STURP's 1978 trip to Turin. I was the editor for STURP. In addition, I also served as the official spokesman for the group during the scientific testing in Turin in October 1978.

Second, I, along with many others, believe that there are problems with the 1988 carbon-14 dating of the Shroud. While I acknowledge that the dating presents a serious challenge to authenticity, it is faced with major objections, many of which were already outlined in this book. In particular, the testing method calls its reliability into question.

Also, William Meacham, an archeologist, had raised several problems regarding carbon dating itself, from both published research and personal experience. Citing several non-Shroud studies, Meacham has observed peculiarities relevant to Shroud research, such as the wide dating variations in certain same-sample testings and inconsist-encies with known historical ages. He has also pointed out similar problems in research of which he was a part, testing which was conducted at reputable laboratories around the world, just as the Shroud carbon-14 testing was done in 1988.

Furthermore, there is the problem of many known contaminants on the Shroud as well as the effects of a fire and dousing in water, plus many unknowns like contacts with many who have held or copied it. The image formation process also minimally changed the cellulose in the fibers. The problems here are profound. If the cloth was not sufficiently cleaned before testing, these contaminants could significantly alter dating conclusions.

Then again, as critics note, a first-century date would not necessarily prove that the Shroud is that of Jesus. If I am correct in my assessment, the question of dating is still not solved, and considerable caution is called for.

Third, *whatever* the final conclusions of any study of the Shroud, another type of caution needs to be exercised. And this may be the most important warning of all. There are many examples of religious misuses of the Shroud. I firmly believe that the Shroud should not be esteemed as an object of faith. Christianity is faith in a person, not in a cloth or in any other artifact, whether it belonged to Jesus or not. Practices of worshipping or venerating the Shroud blatantly disobey Exodus 20:4–6:

> You shall not make for yourself any carved image, or any likeness of anything that is in heaven above, or that is in the earth beneath, or that is in the water under the earth; you shall not bow down to them nor serve them. For I, the LORD your God, am a jealous God, visiting the iniquity of the fathers on the children to the third and fourth generation of those who hate Me, but showing mercy to thousands, of those who love Me and keep My commandments.

God has forbidden the use of images of any sort, particularly in worship. Blessings and punishments are promised to those who obey or disobey this command.

Giving a similar warning, I addressed this vitally serious matter in *Verdict on the Shroud*; I did not wish to be guilty of

breaking such a command. Yet one reviewer still leveled this criticism: "The proponents of the Shroud are attempting to replace the Word of God with an image; as such they are, I would suggest, at variance with the intentions of Divine Providence."

Therefore I wish to stress once again that I am investigating the Shroud as a possibly authentic archeological artifact. *Even if the Shroud is the actual burial garment of Jesus (and especially if it is not), it is only a cloth.* It dishonors God to venerate or worship the Shroud or to celebrate it as a means of healing or to treat it as an object of prayer or faith. I strongly disavow all such nonbiblical practices. I have no desire to encourage any of them. Taking this work otherwise misconstrues its purpose.

Conclusion

In Chapter 12, I will begin my reinvestigation of the Shroud of Turin. My chief emphasis will be to present research results that have developed since 1989, paying particular attention to carbon-14 and the other tests for age, as well as presenting recent data on the nature of the image. It is my desire to outline some of the recent findings and draw some conclusions from them, while leaving the final verdict to the reader.

That my conclusions are stated in terms of probability indicates that absolute proof is not available here. As in all scientific arguments, results can change with different data. Nothing in the Bible, church history, science, or medicine demands that the Shroud be genuine. And Christianity itself would not suffer one iota even if the Shroud's authenticity were totally disproven. Neither Jesus nor Paul made any comments about this cloth, so their views are not in question here. Granting this, however, the Shroud still possibly provides evidence for the validity of Christianity. But even if it did not, studying it appears to involve few negatives: If the Shroud is not the burial garment of Jesus, comparatively

little is lost. Beyond the accuracy of the researcher's own views on this subject, the unfortunate possibility of someone worshipping the Shroud or misusing it in other ways is about the only other drawback. At any rate, one should not reject the Shroud as a fake before a thorough investigation is conducted. I have written this book to help meet this need.

8

The Burial Cloth of Jesus?

If, as I have argued, the Shroud is quite possibly a pre-medieval artifact, is perhaps even from the first century, it raises the question that everyone wants answered: Is the Shroud of Turin the burial garment of Jesus? For many people, this is the major question behind past and present interest in the Shroud. Even when the press questioned the scientists in the October 1981 meeting at New London, Connecticut, both publicly and privately, the primary concern was whether there was any possible connection between the Shroud and Jesus.

The earlier scientific testing had revealed that in all likelihood the Shroud was an actual archeological artifact. Even after testing many different models to explain how the Shroud image could have been crafted by human hands, the scientists concluded that the cloth apparently had held the body of a crucified Jew.

But now I appear to have a few options. In spite of the prior scientific findings, those who accept the carbon dating results released in the fall of 1988 will view the Shroud as something other than the burial garment of Jesus. Perhaps

this cloth will still be seen not as a fraud but as an authentic piece of medieval art. But if it is not a first-century object, the question of who may have been buried in the Shroud is basically moot, at least in terms of historical relevance for Christian apologetics, and this chapter is simply misplaced.

But for those who question the dating procedures, the possibility that the Shroud wrapped either the dead body of Jesus Christ or another Jewish crucifixion victim is still open. In other words, since the Shroud is still possibly an original object of archeological interest rather than a later creation and since research reveals that it wrapped the body of a crucified Jew, our options are that it wrapped either Jesus or some other crucified person. I will continue to address this last set of options.

In order to discover whether the Shroud of Turin is Jesus' burial garment, I need to know if the New Testament Gospels are reliable historical sources. As I pointed out in *Verdict on the Shroud*, I can only hope to learn whether the man in the Shroud was Jesus if I know that the Gospels are reliable, especially in their reports of the events leading to Jesus' death.[1] Because I treated the reliability of the Gospels in my previous books, I will not repeat that argument here. Instead, I will assume historical veracity and, initially, observe the major similarities between the Gospel accounts of Jesus' passion and the findings on the Shroud. Next, I will look at the question of identification. Last, I will consider some of the scientific researchers who have declared their belief that the Shroud is Jesus' burial garment.

Jesus and the Man in the Shroud

Even to one casually acquainted with the New Testament Gospels, there are numerous similarities between Jesus and the man buried in the Shroud. Of course, this is not the same as an identification. An artist or a forger could attempt a duplication. But there are many similarities, and few, if any, differences.

The Gospels relate that Jesus was subjected to numerous punishments before His crucifixion. At Pilate's order He was scourged by Roman soldiers (Matthew 27:26; Mark 15:15; John 19:1). There are various ideas of exactly how this beating was actually performed, but it was a serious administration of great bodily punishment, not superficial blows. Pilate apparently hoped that the Jews would regard the scourging as sufficient punishment for Jesus' alleged blasphemy, for on at least two occasions after the scourging, he tried to reason with the Jews to let Jesus go. But Pilate was unsuccessful (John 19:1–16).

The man in the Shroud was also beaten severely. Most researchers have discovered 100–120 scourge marks, and Guilio Ricci counted over 220 on virtually every portion of the body.[2] A flagrum, a whip-like instrument with a handle and several leather strips ending in pieces of metal or bone, was used by the Romans to inflict great pain.

The victim was often stripped and bent over to make a better target. Usually the force of the blows would knock down the victim and steadily weaken the body. Scourging was so painful that the subject twisted, turned, and even rolled on the ground in response to each blow.

In the case of the man in the Shroud, there is evidence that the flagrum may have had three dumbbell-shaped, perhaps sharpened lead tips. These tips sliced through skin, into small blood vessels, nerves, and even muscles. Either two men did the whipping, or one scourger moved from side to side, which would account for the different angles of the wounds.

The Gospels also record that Jesus was clothed with a robe and crowned with thorns (Matt. 27:28–29; Mark 15:17–18; John 19:2), largely to mock His claims to kingship. The Roman soldiers even knelt before Him and pretended to worship Him.

Likewise, the man buried in the Shroud was pierced throughout the scalp with a number of sharp objects. Blood

from these wounds is visible in the hair on top of his head, on the sides of his face, and on his forehead. On the reverse portion of the image, blood is especially visible throughout the hair at the back of the man's head. Because these wounds differ from the ones inflicted by the flagrum, they must have been caused differently.[3] A crown of thorns fits their characteristics quite well.

Jesus was also repeatedly hit on the face and head, including being struck with a rod or standard and spat on (Matt. 27:30; Mark 15:19; Luke 22:63–64; John 19:3). The man in the Shroud has multiple bruises about the eyes and cheeks and a twisted nose. Interestingly, in the three-dimensional photographs, a ridge is visible across the right cheek, nose, and left cheek, a ridge that may well have been made by one blow with a long, slender instrument.

Following these beatings and similar mistreatments, Jesus was forced to carry His own cross to the crucifixion site (John 19:17). But since he was apparently unable to complete the journey, a man named Simon of Cyrene was made to carry the cross for Him (Matt. 27:32; Mark 15:21; Luke 23:26).

The Shroud reveals a similar scenario. The man has large rub marks on both sides of his upper back in the scapular region. This came after the beating as is evidenced by the blood from the scourge marks, which is smeared at these points. The most likely cause for these rub marks is either a heavy object that was carried across the man's shoulders or the up-and-down motion of his body while he was suspended on the cross. Perhaps both are true.

Additionally, both knees have contusions. The left knee is cut particularly badly. Again, two conclusions are likely. These cuts and bruises could have been caused when the man repeatedly fell to the ground during the scourging. They could also have been caused when he fell under the weight of His cross. While the Gospels do not report this event about Jesus, it is a possible explanation for the fact that Simon of Cyrene was forced to help Him.

The Gospels assert that crucifixion in Jesus' case meant being nailed to a cross through the hands/wrists and through the feet (Luke 24:39; John 20:25–27). The man in the Shroud was also pierced through both wrist areas just below the palms. The exact locations of these wounds will be discussed in Chapter 9, but there is little doubt among forensic pathologists that the man in the Shroud was crucified as Jesus was.

The Gospels agree that due to the beatings and the crucifixion itself, Jesus did not survive. He died (Matt. 27:50; Mark 16:37; Luke 23:46; John 19:30). The man buried in the Shroud shows sufficient evidence of death (see Chapter 9).

One of the most interesting occurrences of Jesus' execution is recorded in the Gospel of John. In order to hasten death, normal crucifixion procedure involved breaking the victim's legs (John 19:31–32). This process is confirmed by the discovery of the skeleton of a first-century crucifixion victim (Yohanan), whose legs were broken in just this manner. When the soldiers came to Jesus and found Him dead, they did not break His legs. Rather, a Roman soldier pierced Him in the side of His chest with a spear, causing blood and water to flow from the wound (John 19:33–36).

Likewise, the man in the Shroud was stabbed in the chest, and the image shows no signs of broken legs. A stream of blood and watery fluid that flowed vertically down from the $1^3/_4$- by $^7/_{16}$-inch cut, located between the fifth and sixth ribs, is also apparent on the Shroud. The fluid is also visible in a horizontal flow across the lower back in the reverse side of the image.

Crucifixion was generally reserved for war captives and those involved in civil rebellion. Because of the nature of the crime and the embarrassment of the punishment, victims were usually given only the simplest of burials. Often the body was not even claimed, but was thrown in a common pit. However, the Gospels explain that Jesus' body was not only claimed, but was given a private and individual burial in new

linen by Joseph of Arimathea, a rich man who used his own tomb for this purpose (Matt. 27:57–60; Mark 15:42–47; Luke 23:60–63; John 19:38–42). Yet the hurried burial was incomplete before the beginning of the Sabbath (Mark 16:1; Luke 23:55–24:1).

Once again I perceive similarities with the man buried in the Shroud. His body was also taken and given a fine, individual burial in linen wrappings. There is also evidence that his burial may not have been complete.

The comparison between Jesus' crucifixion and burial and that of the man revealed in the Shroud of Turin is remarkable, to say the least. Even a cursory review of the similarities led many to this conclusion. The man of the Shroud was beaten, crucified, and buried as the Gospels say Jesus was.

The Identification of the Man in the Shroud

I must now consider the possibility that the Shroud of Turin is the actual burial garment of an unknown, crucified Jew. Some of what science can tell us about the Shroud has been set forth earlier. But having no tools to perform such an historical investigation, science is unable to reach any specific conclusion in this matter. It remains for historians and archeologists to try to ascertain who was buried in it.

History and archeology tell us much about Roman methods of crucifixion and Jewish burial techniques. When the knowledge from these two disciplines is coupled with the similarities between the extraordinary events surrounding Jesus' crucifixion and that of the man buried in the Shroud, a tentative conclusion is possible. I must judge the probabilities that two men could have been crucified in just the same way in so many unordinary circumstances.[4]

Several Shroud researchers have used and advocated the method of basing probabilities on the irregular points that are shared between Jesus and the man buried in the Shroud. Depending on which common aspects are used and how

they are evaluated, researchers have reached various conclusions.

After studying the irregularities held in common between the Gospels and the Shroud, Francis Filas, late professor of theology at Loyola University in Chicago, concluded that there is 1 chance in 10^{26} that the man in the Shroud was not Jesus.[5] Vincent Donovan's conclusion was much more conservative, but still estimated only 1 chance in 282 billion that the two men were not the same.[6] Engineer and Jesuit Paul de Gail arrived at an even higher figure than Donovan's in spite of the fact that his work was done in 1972, some six years before the major scientific investigation.[7] The lowest figure was given by Professors Tino Zeuli and Bruno Barbaris of the University of Turin's science faculty. In 1978 they concluded that there is 1 chance in 225 billion that the two men were different.[8]

Although statistical studies can be rather subjective in method, they are regularly used in scientific study and are not simply arbitrary guesses. Both the smallest figure of 1 in 225 billion and the largest of 1 in 10^{26} practically conclude that the Shroud is the burial garment of Jesus. Why do so many researchers agree on identifying the two men? I will not reproduce here the basis for the probability I presented in *Verdict on the Shroud*, but I will briefly note the major irregularities that both the Gospels and the Shroud reveal.

1. Both the Gospels and the Shroud plainly concern cases of crucifixion. While it is true that many persons were crucified in ancient times, the number is small in comparison to those who died by all other means combined. In other words, if the Shroud belonged to some person other than Jesus, it would probably have been that of a noncrucified individual, but that is not the case. The probability of identification is increased, though only slightly, by the fact that both victims were males. Occasionally, some females were crucified, hence, a small increase in probability.

2. It is also unlikely that a random burial shroud, especially one surfacing in Western Europe, would bear the image of a person of Semitic origin. Yet T. Dale Stewart of the Smithsonian Museum of National Sciences pointed out that the features of the man buried in the Shroud indicate that he was Caucasian and possibly Semitic. Former Harvard University ethnologist Carleton Coon concluded, "Whoever the individual represented may have been, he is of a physical type found in modern times among Sephardic Jews and noble Arabs."

3. The scourging and beating of Jesus at the hands of His enemies was unusual treatment for those marked for crucifixion. We are told that Pilate hoped in vain to satisfy the mob by punishing Jesus in these other ways, but the people demanded His crucifixion, rejecting the suggestion that Jesus be set free (John 19:1–16). Therefore Jesus was both seriously beaten and crucified. This was not a common procedure. A man who was to be crucified was generally not beaten nearly to death. Yet this double punishment was inflicted on both Jesus and the man in the Shroud. In fact, some believe that the man in the Shroud eventually died from the scourging while he hung on a cross.

4. One of the most unusual similarities between the two men is in the head wounds. Since the Romans were, to some extent, emperor worshipers, it is plain that they crowned Jesus with thorns to mock His claims to be the Messianic ruler or King of the Jews. But would this treatment be given to the average criminal who was to be crucified? Probably not. Yet the man in the Shroud had injuries a crown of thorns would create all over his scalp.

5. Another similarity is that both men were nailed to crosses instead of being tied to them. This is not as irregular as some of the other points, for Yohanan, the first-century crucifixion victim whose bones were discovered in 1967, was also nailed to his cross. But tying was an option.

6. The Gospel of John agrees with the Yohanan archeological find that normal Roman crucifixion procedure involved breaking the victim's legs to hasten death. But since He was already dead, this was not done to Jesus. The man buried in the Shroud did not have broken legs.

7. Beside the crown of thorns, the piercing of Jesus' side by a Roman spear is the most intriguing parallel. Since legs were regularly broken to hasten death, lancing the victim's side would be a superfluous procedure. But while neither of the two men had broken legs, both were wounded in the chest by a spear. Furthermore, it was reported that blood and water flowed from Jesus' chest wound as are visible from the wound in the man on the Shroud. The soldiers could have done nothing when they detected that the victims were dead, or they could have struck different areas of their bodies. The fact Jesus and the man in the Shroud were similarly wounded raises the likelihood that the two men are one and the same. Moreover, the flow of blood and water would not have occurred apart from the chest wound. John's description of Jesus' death coincides with the Shroud image in that a post-death wound was inflicted, the chest area was affected, and blood and water oozed from the wound.

8. Jesus and the man in the Shroud were both given fine, individual burials in linen, not the common burials generally given to crucifixion victims.

9. Jesus was buried hastily because of the approaching Sabbath. Therefore, the women returned with spices on Sunday morning in order to finish the burial process. There are also signs that the man in the Shroud was buried hastily (see Chapter 9). What are the chances that two men would be crucified, receive individual burials in fine linen shrouds, and still have to be buried hastily?

10. Last, the New Testament testifies that Jesus' body did not experience corruption (Acts 2:22–32), but that He was resurrected instead. No decomposition stains are present

on the Shroud. Since many of the burial garments in existence have even visible decomposition stains on them, the absence of stains on the Shroud is enigmatic, especially in light of the New Testament testimony concerning Jesus' resurrection (see Chapter 10).

These ten similar crucifixion anomalies between Jesus and the man buried in the Shroud are strong arguments for the identification of the two men. And yet a serious objection must be answered: Couldn't a person actually have been crucified to replicate Jesus' crucifixion? Could not some sadistic person kill another by patterning his death after Jesus', thus reproducing irregularities?

At first glance this is an excellent alternative argument because it claims to account for the rather exact agreements between the Gospels and the Shroud. But while attempting to explain one portion of the Shroud puzzle, it falls prey to numerous other problems. Presumably, the whole project was to make the victim look like Jesus as His death is portrayed in both the New Testament and ecclesiastical tradition. But this is precisely where this thesis is most vulnerable.

In point of fact, more has been learned and confirmed recently in this promising area of research. Two Israeli scientists, Avinoam Danin (Dept. of Evolution, Systematics and Ecology, A. Silberman Institute of Life Sciences, Hebrew University, Jerusalem, Israel) and Uri Baruch, (Israel Antiquities Authority, Jerusalem, Israel) joined forces with Dr. Alan and Mary Whanger (co-authors of *The Shroud of Turin: Adventure of Discovery*) for an exciting step forward in the research and identification of pollens on the Shroud. For openers, in a jointly published folio, *Flora of the Shroud of Turin* (Missouri Botanical Garden Press, 1999) they positively identified and confirmed 40 out of 47 of the original Max Frie pollen slides. This confirmation is extremely significant since the new researchers are themselves experts in the Flora

peculiar to the Middle East. Additionally their expertise played an even more crucial role when combined with the Whanger's PIOT (Polarized Image Overlay Technique).

For example, Capparis aegyptia, a flower which blooms in Israel from December through April, was not only found and confirmed via pollen analysis, but images of the same flower were found using PIOT. "Capparis aegyptia is also significant as an indicator for the time of day when its flowering stems were picked. . . . Flowers seen as images on the Shroud correspond to opening buds at about 3–4 o'clock in the afternoon. This was confirmed by a two-day experiment. . . ."[9] Surely pollen from a particular plant from Israel with corresponding images that even confirm the approximate time of day add important support to the Mideastern origin and antiquity of the Shroud. Furthermore, their joint research effort made the following discoveries:

1) A direct correllation of 120 congruent blood stains found both on the Shroud and the Sudarium of Oviedo along with a specific pollen, Gundelia tournefortii found on both clothes.[10]

2) Specific pollens correlated to the image of its flower, suggesting they were picked and placed upon the shroud the same day.[11]

3) "Two plant species identified as part of the Shroud beyond any reasonable doubt, are Gundelia tournefortii and Zygophyllum dumosum. . . . The high indicative value of Gundelia tournefortii's pollen grains derives from the fact that it is a monotypic genus . . . its pollen morphology is unique for the family and for the entire flora. . . .

The images of these two species together with the pollen grain . . . corroborate the following sequence of events:

1) laying the body on the linen;

2) placing flowering plants . . . with the body;

3) folding of the cloth over the body; as well as

4) the process that caused the formation of images."[12]

When the late Max Frei's work first came under intense criticism, issues were raised about the lack of independent corroboration of his pollen findings. Other experts claimed they were unable to find pollen on the Shroud in the numbers Frei noted and wondered if the pollen could actually originate in Europe. The independent, peer reviewed, confirmation from Israeli Jewish scientists who certainly have no Christian bias about the burial cloth of Jesus of Nazareth is significant. In addition, the corroboration of images through Dr. Whangers' Polarized Image Overlay Technique, the coronal discharge studies on plants, and comparative studies on the Sudariam (face napkin) of Oviedo, Spain, provide strong weight to the case for the authenticity of the cloth. It is noteworthy that both the Israeli scientists and Dr. Whanger suggest in their report that after evaluating this additional evidence about the Shroud, "the radiocarbon dating of the Shroud to only the Middle Ages [is] untenable."[13]

For instance, this scenario fails to explain the presence of the wrist wounds on the man in the Shroud. This failure is especially poignant in light of New Testament passages explaining that Jesus showed His disciples His pierced hands, feet, and side as further evidence of His identity (Luke 24:39; John 20:25, 27). Throughout the history of the church, the punctures in Jesus' hands have been pictured in the palms (or lower hands). Art historian Philip McNair claims that in his entire experience with hundreds of examples of medieval art, the nail wounds are always located in the palms of Jesus.[14] The Greek word which was translated as hands includes the wrists.

Likewise, the man in the Shroud apparently had his head covered by a full cap of thorns (or other sharp objects), as opposed to the traditional wreath set around the forehead. It is also possible that the man in the Shroud was nude. Should this be the case, it would also require an explanation, since this would similarly be contrary to traditional historical depictions of the crucified and buried Jesus.

If, as this alternative thesis supposes, the accounts of Jesus' crucifixion are the model for the Shroud, then these three difficult problems must be overcome. The wrist wounds would be especially noteworthy since the "artisans" would seemingly be forced to follow tradition in order to be believed (even if they thought otherwise or knew of a contrary example in Christian art).

In other words, the Gospels and church tradition would have to be followed for the cloth to be accepted as the burial garment of Jesus. But such is simply not the case in at least these three areas. On the other hand, if it was not the point to copy Jesus' passion, then why would there be such close agreement, especially at each of the anomalies I have noted? This alternative thesis encounters a major dilemma at this juncture.

Other problems abound for this strange forgery thesis. Medical studies have questioned the likelihood of blood and water flowing from typical chest wounds, but these fluids are present on the Shroud as they were with Jesus.

Another serious concern for this view is the cause of the image. This theory would probably require some sort of contact process or perhaps even some type of vaporograph, possibilities that have already been disproven. And against the response that the cause of the image is an equal problem for any view, since it is unknown, I would point out a crucial difference. In a case favoring the Shroud as the actual burial garment of Jesus, I would perhaps need to try to identify the cause of the image (see Chapter 11). But the replica thesis involving the crucifixion of another person seems to require a type of image formation that has already been disproven. Science may not know how the image was created, but it is amazingly adept at discovering that objects have been faked. And since the latter is all that is required, the fact that the Shroud image has not been duplicated is a tremendous blow to this forgery thesis.

Other problems for the replica thesis include the lack of

bodily decomposition on the Shroud, the detailed knowledge of Jewish burial customs, the possible presence of first-century coins over the eyes, and, in particular, the advanced medical specifications needed, probably beyond what was known (see Chapter 11).

Although this thesis is possibly the best of the skeptical alternatives, it clearly entails major problems. In fact, the very need to suggest it points out how similar the death of the man buried in the Shroud is to Jesus' crucifixion, especially in the anomalies.

One last consideration makes these similarities even more striking. I only considered the points these two deaths have in common. What is almost equally amazing is that there are no contradictions between the two. It would seem likely that, if they were different men, there would be some obvious disagreements—such as the man in the Shroud would have broken legs or no spear wound. But that is not the case and is simply incredible since the thesis that someone copied Jesus' crucifixion is apparently untenable.

Once again, it is not my purpose in this chapter to restate the probabilities I set forth in *Verdict on the Shroud*. But the facts lead me to believe that the Shroud of Turin is still very possibly the actual burial garment of Jesus. My view could be disproven in light of future data; additional carbon-14 dating for instance, still poses a critical, though not unanswerable, challenge. Nevertheless, the evidence at present favors this possibility.

The opinion that the Shroud is some sort of painting has been thoroughly investigated and rejected by the vast majority of published researchers. A thesis that the Shroud was painted by some particular method has, indeed, a difficult road to a proof. Even to accept the carbon dating results is not to prove that the Shroud is a painting. This would be an unjustified leap over relevant data, for various theses are certainly possible. Other theories postulating a medieval origin for the Shroud are likewise opposed by

substantial research. Contrary to some popular opinions, many views, not just those specifically opposing the 1988 dating attempts, must respond to the relevant scientific and historical data.

Scholarly Opinions

Before the results of the 1988 carbon dating were released, a number of scholars investigating the Shroud reached the conclusion that this cloth was probably the actual burial garment of Jesus. It is very difficult to know how many of these and others would still hold the same opinions today. Perhaps some still hold these views, rejecting the 1988 carbon dating for any of several reasons. Others are now perhaps undecided about their former views, and it is certainly possible that some have rejected their previous positions. Nevertheless, their views are part of the history of this subject, and the purpose of this book is to survey the state of the question since 1989.

Though the question of any possible identification of the man in the Shroud with Jesus is largely historical, many people are understandably interested in the opinions of some of the researchers. In spite of the often-pronounced skepticism on this issue, some offered their personal views.

Robert Wilcox, himself the author of a well-known 1977 book on the Shroud,[15] published a series of four long articles on the subject in 1982. Although little publicized, this series was a valuable report on the 1978 scientific investigation.[16] Wilcox's first article reported his interviews with twenty-six of the scientists in the October 1978 investigation. Of those interviewed, thirteen indicated their belief that the Shroud was the actual burial garment of Jesus, while most of the remaining thirteen did not answer this query. This was a startling revelation in light of what had been a relative hush on this subject.[17]

Some scientists not only stated their belief that Jesus was the man buried in the Shroud, but indicated that they were

also impressed by a line of argument which noted the points of similarity between Jesus and the man in the Shroud. Physicist John Jackson proclaimed, "This was no ordinary execution," noting that what happened to the man in the Shroud was consistent with the Gospel accounts of Jesus' crucifixion. One of the scientists willing to give an opinion concerning the identity of the man in the Shroud, Jackson observed that the scourge marks, nail holes, and blood flows on the Shroud are anatomically and medically correct.[18]

Pathologist Robert Bucklin shared Jackson's views most openly. He stated his conviction that "The imprint of the body on the Shroud is that of Jesus Christ."[19] This is shown by the exact consistency between the Gospels and the Shroud. In fact, the Shroud adds to our historical knowledge of Jesus and even provides evidence for His resurrection from the dead.

Biophysicist Dr. John Heller wrote a book entitled *Report on the Shroud of Turin*. In this book Heller admitted that there is much evidence to show that the Shroud is Jesus' burial garment—enough evidence to convince me without any doubt if the identity of a nonreligious person was the question. But since, presumably, too much of religious uniqueness is at stake with Jesus, he would not draw this conclusion.

With regard to this, I must take exception to Heller's conclusion:

It is certainly true that if a similar number of data had been found in the funerary linen attributed to Alexander the Great, Genghis Khan, or Socrates, *there would be no doubt* in anyone's mind *that it was, indeed, the shroud of that historical person*. But because of the unique position that Jesus holds, *such evidence is not enough!*

I disagree. Heller's conclusion reveals an unwarranted separation of faith and facts. Without any dispute from me, Jesus is unique, and the decision to follow Him is immeasurably important. Yet this is not to say that facts are

not quite as factual in the religious realm. I must guard against such differentiation of these two ways of knowing in religious and nonreligious areas.

Yves Delage addressed this very issue over eighty years ago. Professor of Comparative Anatomy at the Sorbonne in Paris, a member of the prestigious French Academy, and an agnostic, Delage concluded that the Shroud was Jesus' burial cloth. Answering the criticism of his "religious" conclusion, he stated:

> . . . a religious question has been needlessly directed into a problem which in itself is purely scientific. . . . If, instead of Christ, there were a question of some person like a Sargon, an Achilles or one of the Pharaohs, no one would have thought of making any objection. . . . I recognize Christ as a historical personage and I see no reason why anyone should be scandalized that there still exist material traces of his earthly life.[20]

Again, although religious stakes are much higher, I must draw my conclusions from the current facts. The data certainly allows at least the tentative conclusion that Jesus was very possibly buried in the Shroud. And if the facts do not favor this conclusion or if it is later disproven, then that will have to be faced squarely as well.

To be sure, the 1988 carbon dating results remain a serious objection, and I cannot pretend that they do not exist. However, I have also pointed out numerous reasons for some doubt. And if these tests are mistaken or even questionable, the evidence may then still favor the conclusion that the Shroud of Turin is Jesus' burial garment.

Heller's book points out that the Shroud is in agreement with the Gospel accounts of Jesus' passion. Could the Shroud be Jesus' burial cloth? Heller answered: "That question is not a trivial one. Nothing in all the findings of the Shroud crowd in three years contained a single datum that contravened the

Gospel accounts." Heller followed this statement with a long list of similarities between the two men.[21] Later Heller pointed out that, of the Shroud of Turin Research Project team members, John Jackson, Robert Bucklin, and Barrie Schwartz believed that the Shroud was Jesus' burial garment. Another team member, Donald Lynn, added that the Shroud "matches the Gospels historically," without himself making a commitment concerning identity.[22] By 1984, however, he had come to believe that the Shroud was Jesus'.[23] Cullen Murphy added chemist Robert Dinegar as another team scientist willing to say that he personally believed that the Shroud just might be "the real thing."[24]

According to an article in one popular publication, personal interviews have revealed other scientists who were willing to speak to this issue as well. STURP chief photographer Vernon Miller was quoted as saying, "I have no doubts that this is the Shroud of Christ. I have come to this as objectively and scientifically as I can."[25] Barrie Schwortz, another photographer from Santa Barbara's Brooks Institute of Photography and one of the Jewish members of STURP, said:

> The image on the Shroud matches the account of the crucifixion in the New Testament down to the 'nth degree. In my own mind, I believe the Shroud is the piece of cloth that wrapped the man Jesus after he was crucified.[26]

Conclusion

In spite of the carbon-14 test results from the eighties, enough facts can be martialed to conclude that the Shroud of Turin is still possibly the actual burial garment of Jesus.[27]

My conclusion about the identity of the man in the Shroud still may have to be reevaluated in light of future findings (see Chapter 12) but the evidence of the 80s was sufficient to sustain the possibility that the cloth wrapped Jesus.

That Wilcox's 1982 interviews revealed that half of the scientists contacted (thirteen out of twenty-six) had believed that the Shroud was Jesus' burial garment was, at the very least, enigmatic. It is remarkable that this many of them would publicly give their views when such conclusions are sometimes viewed quite negatively. As Wilcox stated, there are just too many "coincidences" in the agreements between Jesus' crucifixion and that of the man in the Shroud to be explained away easily. These similarities do not fit any other known victim of crucifixion except Jesus.[28]

9

Death by Crucifixion

The Discoveries and Disputes of Pathology

Since the Shroud of Turin may still very possibly be Jesus' burial garment, it may serve as an added testimony to Jesus' death by crucifixion. But it is crucial to understand that even those who reject this possibility can still perhaps gain much medical knowledge about crucifixion from the Shroud. Even if those who accept the carbon dating results believe that the issue is moot and even if they are correct, the Shroud could still preserve invaluable information about the effects of crucifixion and hence at least indirect evidence about Jesus' death. If the Shroud is not a fake but the garment of an actual crucifixion victim, it can provide important medical knowledge, whether it is Jesus' burial garment or not.[1]

Studies of the Shroud have always evoked special attention from the medical community, and questions about the nature of crucifixion and the cause of Jesus' death have been at the heart of their discussion. Medical doctors and other specialists have brought their expertise to Shroud study in the twentieth century.[2] In Paris near the turn of the century, biologist Paul Vignon of the Institute Catholique

and Yves Delage, professor of anatomy at the Sorbonne, led early endeavors. Pierre Barbet, a surgeon at St. Joseph's Hospital in Paris, has perhaps been the most widely read physician to address the Shroud. His monumental work was largely done in the 1930s.

In the 1950s German radiologist Hermann Moedder, of St. Francis Hospital in Cologne, experimented with crucifixion technique by suspending volunteer university students by their wrists to measure the medical impact of crucifixion. David Willis, an English physician, tabulated medical studies of the Shroud in the 1960s.

Giovanni Judica-Cordiglin, professor of forensic medicine at the University of Milan, was part of the secret commission organized in 1969 to view the Shroud and make recommendations for further scientific study. Anthony Sava, an American physician, studied the Shroud for many years and was involved in some of the medical studies in the 1970s.

In the late 70s and 80s, the most prominent medical specialist to investigate the Shroud was pathologist Robert Bucklin. In 1978 he served on the Shroud of Turin Research Project.

Current Shroud Pathology: An Overview

Death by crucifixion is a complicated medical puzzle, especially when it has been preceded by scourging, a crown of thorns, and other mistreatment, as in the case of Jesus. Accordingly, isolating a single cause of death is difficult.[3]

Most medical experts postulate that asphyxiation plays a major role in a crucifixion death—perhaps the major role. As the suspension of the body's weight from the wrists places intense pressure on the pectoral and intercostal muscles of the chest, breathing becomes increasingly diffi-cult. Moedder found that all his volunteers—regardless of age, stamina, and physical condition—lost consciousness in a maximum of twelve minutes.[4]

Studies have indicated that trying to relieve the tension

in his chest by standing up on the nails driven through his feet, the victim of an actual crucifixion freed his lungs somewhat but suffered great pain. Breaking the ankles or legs caused the victim, now severely weakened, to hang "low" on the cross. Death often followed swiftly.

This rather simplistic description shows how asphyxiation is a major factor in death by crucifixion. But such a terrible death is also complicated by shock and congestive heart failure. In spite of a rather amazing general consensus, details may differ from scholar to scholar.

An additional question of much interest concerns the nature of the spear wound recorded in the Gospel of John (19:31–34) and also found on the Shroud image. The aforementioned medical experts agree that the man in the Shroud was dead when the spear struck his side as is evidenced by both the body in the Shroud clearly being in a state of rigor mortis and by the postmortem nature of the blood flow from the chest wound. Yet once again details differ on the exact nature of the wound.

Some medical experts follow Barbet, who held that the blood came from the right side of the heart while the water came from the pericardium, a thin sac that surrounds the heart and holds some watery fluid.[5] On the other hand, Sava postulated that the scourging was so severe that it caused chest hemorrhaging. Then the pleural cavity (in particular the membrane sacs that enclose the lungs on each side of the chest) filled with blood from the lower portion of the pleural cavity and lighter-weight fluid from the upper portion. This view thus involves pleural effusion: the "bloody fluid collects between the outer surface of the lung and the inner lining of the chest wall."[6]

Actually, each view contains a degree of truth. The spear probably pierced both Jesus' pleural cavity and His heart, thereby causing blood to flow from both places. The watery fluid could have come from the cavity and the pericardial sac.

But Jesus was already dead when this occurred. Moedder, Willis, and Bucklin accept this scenario.[7]

From this rather simplistic summary, I may proceed to consider new research of the 80s, including the conclusions of another expert, Frederick Zugibe, whose results appeared in 1982.

Further Debate

On October 10–11, 1981, in New London, Connecticut, STURP held a semipublic press conference and series of lectures on the scientific research since the October 1978 investigation of the Shroud in Turin, Italy. Representing the medical side of these studies (pathology and forensic pathology) were Joseph Gambescia and Robert Bucklin.

STURP's official press release told the public, among other things, that the Shroud had made contact with a body and that it was "a real human form of a scourged, crucified man."[8] In the later words of John Heller, "It was evident from the physical, mathematical, medical, and chemical evidence that there must have been a crucified man in the shroud. If I followed the principle of Occam's razor, I could draw no other conclusion."[9] These two statements are quite important, especially in terms of my opening assertion that if the Shroud wrapped the body of a crucified man, then we can still perhaps learn much about what happened to Jesus, even if it was not His garment.

In some ways this STURP conference was both the end and the beginning of further studies, including medical research. The most rigorous study of a "religious relic" in history was supposedly winding down. At the same time, however, other experts were publicly presenting their conclusions. One of these was Frederick Zugibe in *The Cross and the Shroud*.[10]

In Cullen Murphy's well-publicized Harper's article, Zugibe was practically portrayed as the chief disputer of Robert Bucklin's claims.[11] As adjunct associate professor of

pathology at Columbia University and chief medical examiner of Rockland County, New York, Zugibe brought an array of medical talents to more than twenty-five years of Shroud studies. He had also participated in the Second International Scientific Conference of Sindonology on October 7–8, 1978, immediately before the STURP testing.[12]

In experimental testing of the crucifixion process, Zugibe suspended volunteers between twenty and thirty-five years of age from an actual cross, strapping gauntlets around their hands and seat belts around their feet. Then he monitored their heart rates with an EKG and kept close tabs on their blood oxygen (with an ear oximeter) and blood pressure.

He noted that with their arms stretched out at an angle of sixty to seventy degrees, their bodies hardly touched the cross. Rather, during their frequent shifting to relieve cramps and other pains, the victims often arched their bodies outward, away from the cross itself. Their most frequent complaint was pain in their limbs. Zugibe observed, however, that none of the volunteers had difficulty breathing. In fact, oxygen level increased. Other observations included moderate rises in blood pressure and heartbeat, pronounced sweating, and muscle twitching.[13]

Zugibe's findings on the absence of breathing difficulties mark a crucial disagreement with the established medical studies of crucifixion. The reason for Zugibe's disagreement may lie with his understanding (or lack thereof) of the angle of Jesus' execution, an area I will explore later. But while Zugibe noted this and several other points of disagreement with the medical consensus, he also held that the Shroud is probably the authentic burial garment of Jesus, that Jesus was definitely dead, and that we have much medical evidence to establish the means of His death.[14] As I focus on the points of his interaction with other medical experts, I will evaluate the strengths and weaknesses of his case.

Pre-Crucifixion Suffering

One aspect of Jesus' passion that is well known but much underplayed is pain. Few realize that Jesus actually experienced two types of capital punishment: the preliminary scourging, crown of thorns, and beating; and crucifixion itself. Of the preliminary abuses, Zugibe wrote:

> Jesus was bent over and tied to a low pillar, where He was flogged across the back, chest, and legs with a multifaceted flagrum with bits of metal on the ends. Over and over again the metal tips dug deep into the flesh, ripping small vessels, nerves, muscles and skin. He writhed, rolled, wrenched and His body became distorted with pain, causing Him to fall to the ground, only to be jerked up again. Seizure-like activities occurred, followed by tremors, vomiting, and cold sweats. . . . Unfortunately, the scourging was initiated by the Romans so that the Deuteronomic limit of forty lashes less one was not followed.[15]

There are few disagreements on the scourging and other pre-crucifixion abuses of Jesus. Most researchers have counted between 100 and 120 scourge wounds on the Shroud, perhaps more than the 40 lashes allowed by the Jews (Deut. 26:3; 1 Cor. 11:24). But since there were more than one dumbbell-shaped pieces of metal on the Roman flagrum, it is difficult to convert the number of scourge wounds to the number of lashes. Still, I assume that there were more scourge marks on the burnt (and therefore now indiscernible) image of portions of the shoulders and that there may have been lashes that did not break the skin and therefore would probably not be visible at all.

The crown—or more properly, cap-of-thorns—was apparently placed on the man's head. Some experts agree that the most likely plants for this use were either *Zizphus spina* or *Paliuris spina*, both members of the buckthorn family, with thin, inch-long thorns. The scalp is a sensitive area,

especially with regard to the nerves. When the small blood vessels are lacerated, significant bleeding results. In our modern culture, we too often ignore the pain involved in this aspect of the punishment alone.[16]

In addition, on the cross the nails in the wrist area pushed against the median nerve, causing a continual burning pain; the nails in the feet were pressed by the body weight against the plantar nerves, causing similar pain. And perhaps worst of all was the terrible pain in the shoulders, wrists, knees, and feet, the muscle twitching, numbness, and cramping. Bucklin noted that when he once suspended himself on a cross for a short time, "the pain suffered by a suspension of the wrists alone is all but unbearable, with the tensions and strains being directed to the deltoid and pectoral muscles. These muscles promptly ensure a state of spasm."[17] The complications from thirst have been described as the worst agony of all.[18]

We must never lose sight of the suffering that Jesus Christ, who Scripture says was an innocent victim, underwent to pay the penalty for humankind's sin. Regardless of the status of the Shroud's authenticity, His suffering and sin payment were real.

The Positions of the Nails

One point of disagreement between Zugibe and most other researchers is the position of the nails. Zugibe listed three possible positions: the palm of the hand; the wrists; and the lower arm area. But instead of placing the nails in the wrists as virtually all other researchers do, he placed them in the lower palm area, just above the wrists. He suggested finding the spot by touching the little finger with the thumb. He thought that the nail was placed in the lower portion of the resulting gully, the thenar furrow.[19] This places the nail, not in the center of the palm, but only about one inch from the wrist, where it was driven in at an angle, exiting in the back near the wrist, as is indicated on the Shroud. Thus, this disagreement is not as profound as some might think.

Since Zugibe realized that the New Testament word for hand can mean anything from the fingers through the lower arm, he gave six reasons for selecting the lower palm. Two, the most subjective, are that the palm is the area most people accept and that stigmata have occurred in the palm, reportedly corresponding to Jesus' wounds. These arguments seem superfluous. While Christian tradition may clarify some issues, it is finally subordinate to the facts. So, too, an argument from stigmata cases is questionable because of the very nature of such manifestations. To resolve the question of where the nails were placed, we must rely on the available data.

Zugibe's other reasons rely more substantially on medical research. He believes that the palm closely corresponds to the location of the wound on the Shroud, which exits on the radial (thumb) side of the hand. By contrast, Destot's space in the wrist, made famous by Barbet's research and favored by many, exits on the ulnar (little finger) side. A nail there would easily hold the human body on a cross without breaking any bones and would explain the apparent lengthening of fingers observed on the Shroud.

This argument holds no difficulty for those who postulated that the nails pierced the wrists, especially since, as Bucklin notes, the position does not need to be Destot's space.[20] The wrist can also sustain the weight of the human body without necessarily breaking bones. And Zugibe's assertion that positioning the nail in the palm explains the lengthening of the fingers makes sense only if it is the sole explanation. If the finger length can be explained by other means, there is no need to locate the nail in the lower palm area.

But this is not to say that Zugibe is wrong here. The exact location of the nails is difficult to determine with absolute certainty. Since there is only about one inch difference in front and virtually no difference in back, such a determination may, in fact, be unnecessary.

Another issue is the reason the thumbs are not immediately visible on the Shroud. Barbet's popular answer, supported by experimental results, was that when a nail was driven through Destot's space, it touched the median nerve, causing the thumb to draw inward to the palm. Disagreeing, Zugibe objected that the position of the drawn-in thumbs in front of the index finger "is a relatively natural postmortem position frequently observed at the medical examiner's office."[21] At this point, the drawn-in thumbs are difficult to explain, but this is a minor point.

Concerning the nailing of the feet, executioners appear not to have used one prominent method. The skeleton of Yohanan, found in Jerusalem in 1967, shows that he was nailed through both heel bones by a single seven-inch Roman spike. Some researchers have maintained that the feet were crossed, left over right, with two nails holding them together. Others have suggested that after the right foot was nailed, the left was crossed over and a second nail was driven through both feet.[22] The most common theories are that both feet were crossed and affixed with one nail or that the feet were placed side by side with a single nail in each. Noting that the Shroud evidence is ambiguous, Zugibe objected to the one-nail theory because it was more difficult to perform; he favored the view that the feet were placed side by side, with each fixed by a single nail.[23]

Zugibe's arguments on this point are quite weak. The fact that it is easier to nail this way is irrelevant. The question is how the executioners did it. That Yohanan's crucifixion apparently dates from the first century A.D. provides some evidence for a one-nail theory. And the Shroud reveals that the left foot slants inward, possibly from rigor mortis fixing it in the position it may have occupied before death—over the right foot. Zugibe's argument that the slant is accounted for by a fold in the cloth[24] is possible but not substantiated. If Gambescia and Bucklin's suggestion is valid, the crossed feet may even have been affixed by two nails, thus answering

Zugibe's concern with the "easier" method.[25] At any rate, the skeleton of Yohanan, the location of the wound on the Shroud, and the slant of the left foot all support the crossed-feet view, with most researchers favoring the use of one nail.

Cause of Death

With its theological significance for the Christian Gospel, perhaps the single most crucial physical element in the study of the crucifixion is the assurance of Jesus' physical death. Hence, signs of the cause of this death are important.

Bucklin listed the cause of Jesus' death as "Postoral asphyxia related to failure of the cardiovascular system from shock and pain." For Zugibe, the cause was "cardiac and respiratory arrest due to cardiogenic, traumatic, and hypovolemic shock due to crucifixion."[26] Thus both pathologists included cardiovascular failure, particularly the heart. Bucklin stressed congestive heart failure due to excessive blood in the heart while Zugibe stressed cardiogenic shock, shock of the heart. Bucklin also noted shock and, like Zugibe, identified Jesus' suffering and crucifixion as the root cause of death.

But the importance of asphyxiation in Jesus' death is a matter of serious disagreement. Bucklin followed the majority opinion in his conclusion that asphyxiation was crucial.[27] Zugibe did not find this to be a contributing cause in any of his experiments and called it a priori hypothesis. But Bucklin spent a brief time on a model cross and reported that the deltoid and pectoral muscles "promptly assume a state of spasm, and the victim so suspended is physically unable to make use of his thoracic muscles of respiration,"[28] a statement that has been experimentally confirmed by Moedder, Barbet, and others. Thus Bucklin's conclusion was not a priori as Zugibe claimed.

Critiquing Barbet's three major arguments for the asphyxiation theory, Zugibe held first that the bifurcated blood flow on the wrist was postmortem and thus not due to

breathing difficulties, a point I will return to later. Second, he argued that crucifragium (breaking of legs) was a common procedure that did not contribute to asphyxiation. And finally he said that Barbet's evidence from German concentration camps does not apply to first-century crucifixion methods because the camp victims' hands were suspended directly above their heads, which was not the case in Jesus' crucifixion.[29]

In fact, Zugibe appears to have indulged in circular reasoning when he assumed but did not substantiate that sixty to seventy degrees was the arm angle of a first-century crucifixion victim. Although his subjects experienced no breathing difficulties, Zugibe admitted that at different arm angles asphyxiation *will* result.[30] William Meacham and Robert Bucklin had noted that a measurement of the blood flow argues for an arm angle of approximately fifty-five to sixty-five degrees.[31]

Other evidence points to the strength of the asphyxiation theory. The skeleton of Yohanan showed that the nails were driven through the lower arms, between the radius and ulna. One radius was both scratched and worn smooth from constant friction. Although an up-and-down movement to relieve leg pain may explain this, most researchers believe the wear on the bone evidences a frantic effort to breathe.

Second, Yohanan had suffered crucifragium, in keeping with the testimony of John 19:31-36 and other sources. Zugibe, not believing that this practice contributed to asphyxiation, postulated shock as the desired result,[32] an unconvincing explanation since blows to other parts of the body might do the same. That legs were the target is evidence for asphyxiation. Crucifragium kept the victim from moving up and down, thereby inducing death.[33]

Third, Meacham judged from the state of rigor mortis that the man in the Shroud suffered asphyxiation:

It has frozen in an attitude of death while hanging by the arms; the rib cage is abnormally expanded, the

large pectoral muscles are in an attitude of extreme inspiration (enlarged and drawn up toward the collarbone and arms), the lower abdomen is distended, and the epigastrio hollow is drawn in sharply. The protrusion of the femoral quadriceps and hip muscles is consistent with slow death by hanging, during which the victim must raise his body by excertion of the legs in order to exhale.[34]

Notably, a study in the prestigious *Journal of the American Medical Association* (*JAMA*) has reached a similar conclusion. After studying the relevant literature, the authors noted the primary cause of Jesus' death on the cross as "hypovolemic shock and exhaustion asphyxia." The "major pathophysiologic effect of crucifixion was an interference with normal respirations." Other possible contributory factors included dehydration, congestive heart failure, or cardiac rupture, accenting "acute heart failure." So while death on the cross was "multifactorial," stressing asphyxiation, "Clearly, the weight of historical and medical science indicates that Jesus was dead before the wound to His side was inflicted. . . . Accordingly, interpretations based on the assumption that Jesus did not die on the cross appear to be at odds with modern medical knowledge."[35]

Therefore, although other causes, like shock or orthostatic collapse (in which blood collects in the lower portions of the body) have been presented as primary contributors to crucifixion deaths, the evidence favors asphyxiation. More importantly, however, researchers agree that the man in the Shroud was dead.

The Spear in the Side

Bucklin's view on the chest wound was that the Roman lance entered the dead body between the fifth and sixth ribs, drawing out the postmortem blood flow.[36] Like Moedder and Willis, he further postulated that the lance pierced the pleural cavity, the pericardium, and the right side of the

heart. Most of the water came from pleural effusion (not of Sava's variety) while most of the blood proceeded from the right side of the heart.[37] Heller also holds that the blood flow from the chest was postmortem.[38]

Generally, agreeing about the location of the wound, Zugibe also places it about six inches from the center of the chest. On the nature of the wound, he entertained several options. Contrary to some medical theories, mostly older ones, he held that Jesus' heart did not rupture for four reasons: Jesus' comparative youth, the rarity of heart attacks in first-century Palestine, the absence of any record of heart attack earlier in His life, and the insufficient time between scourging and crucifixion.

Zugibe then listed eleven hypothetical causes of the flow of blood and water. Of the eleven, some of which differ only in fairly minor details, eight postulate that the lance entered the chest cavity, the pericardium, and the heart. Dismissing Barbet's experiments and theory of the water coming from the pericardium and the blood from the heart on the grounds that the two would be mixed, Zugibe chose two possible theories. One is Sava's, discussed earlier, but Zugibe found it weak because, again, blood and water might be mixed.

The view that Zugibe proposed as better is like that of Willis, Moedder, and Bucklin: the "right atrium of the heart pierced by spear (blood) and pleural effusion from scourging and/or congestive failure."[39] Since the man in the Shroud was dead, his wound yielded a postmortem flow of blood and water. But even had he been alive, the wound would have killed him. Its very purpose was to make sure he was dead. Zugibe and the others seem generally agreed about the spear wound in the chest.

Signs of Death

Zugibe stated his theory on the wound in the side in virtually the same words as Willis, Moedder, and Bucklin, all of whom agree that the wound was post-mortem. The authors of the

JAMA article also conclude, "The spear, thrust between his right ribs, probably perforated not only the right lung but also the pericardium and the heart and thereby ensured his death. . . ."[40]

There are at least signs on the Shroud that Jesus was dead when He was buried. First, the body of the man in the Shroud is in a state of rigor mortis, in which the muscles stiffen, keeping the body in the position the person occupied just prior to death. Such a state is complete in about twelve hours after death, begins to wear off in twenty-four hours, and disappears in thirty-six to forty hours. Of course, these times are variable and imprecise, and therefore somewhat unreliable. Closely related to rigor mortis is a state called cadaveric spasm, an immediate stiffening, a rather sudden contraction of the muscles that occurs quickly after some violent deaths.

Rigor mortis is observable on the Shroud in several places. The head was bent forward, the feet were somewhat drawn up, and the left leg in particular had moved back toward its position on the cross. Especially visible in the three-dimensional image analysis of the Shroud are the retracted thumbs and the "frozen" posture of the chest and abdomen. As was also noted by Bucklin, the entire body was quite rigid and stiff, occupying some of the positions it did on the cross.[41]

The second evidence of death in the man of the Shroud is the post-mortem blood flow, especially from the chest wound. If the heart had been beating after burial, the blood literally would have been shot out onto the cloth. But the blood oozed out instead. Also, a comparatively small quantity of blood flowed, and there was no swelling around the wound. Finally, the blood from chest, left wrist, and feet separated into clots and serum and was much thicker and of much deeper color than it would have been prior to death.[42]

Zugibe also mentioned a third piece of evidence based on his medical experience. If Jesus had been alive after the spear wound, the soldiers and others at the site would have heard

a loud sucking sound caused by breath being inhaled past the chest wound. Zugibe related that when answering a distress call after a man had been stabbed in the chest, he heard the loud inhaling of the unconscious man all the way across the room. He saw this phenomenon as "a direct refutation of the theory that Christ was alive after being taken down from the cross."[43]

Washing the Body

One of the most interesting pathological issues is whether or not the body in the Shroud had been washed. A case could be made for either view (see "The Unwashed Body" on page 100).

Bolstering this idea, some pathologists in the 80s raised valid questions on the washing of the body. Since Jesus was alive for much of His time on the cross, His body would literally have been covered with blood. Even small wounds bleed profusely when the heart is beating. So how could the wounds and blood flows on the Shroud be so perfectly outlined? How was the blood kept from smearing during burial? Or if it was washed first, did the dead body bleed, even from smaller wounds? And even if all the blood stains occurred after His body was washed, why does some of the blood flow uphill if Jesus was buried on His back?

Some researchers view several of these questions not as evidence that the Shroud is a fake but as indications that Jesus' body was washed before burial.[44] This thesis generally contends that Jesus' body was washed and that the blood on the Shroud is made up of postmortem flows that came from wrapping and moving His body after the washing. In fact, Zugibe asserted that this is the only possible view in light of the phenomena on the Shroud.[45]

Contrary to popular opinion, dead bodies do bleed, especially in cases of violent death. But even after nonviolent, natural deaths, blood usually remains unclotted for about the first eight hours. Much bleeding or oozing can occur,

even the next day, when the body is moved about. This is true even of some smaller, fairly superficial wounds, especially if a blood vessel has been cut. Zugibe held that since the body in the Shroud otherwise would have been covered with blood, the clearness of the wounds on the Shroud can only be explained by post-mortem flow after washing.

The post-mortem blood flows can account for just the types of stains present on the Shroud. The blood did not flow "uphill" but, according to Zugibe probably flowed when the body was being wrapped and carried at various angles to the tomb after the washing.[46]

As was just shown, there are plausible arguments favoring both the washing and the nonwashing of the body. Either view appears tenable, and fortunately a resolution is not crucial to understanding the nature of Jesus' suffering and death.

Marfan's Syndrome

One last issue is Zugibe's contention that Jesus may have had Marfan's syndrome, a condition that Abraham Lincoln also may have had. A person who suffers from Marfan's is usually tall and thin, has a combined arm span greater than his height, is longer from the groin to the soles of the feet than from the groin to the top of the head, and has long fingers and a narrow face. The usual cause of death is a ruptured aorta near the heart. One study showed that the average age of death is thirty-two. According to Zugibe, if Jesus had this disorder, it would have no effect on any theology and would not have been detrimental to Jesus' ministry. And, indeed, Abraham Lincoln's career can be taken as an indicator that Marfan's is not debilitating.

But it cannot be known for certain that the man in the Shroud had this condition.[47] Actually, the evidence indicates that this was not the case. The man in the Shroud, at approximately 5 ft. 11 in. and 175 pounds, was neither extremely tall or thin. Zugibe's case is built on the assumption

that the average height of a first-century male would have been 5 ft. 4 in., so the man in the Shroud would have been about seven inches above average.[48] However, the average height of adult male skeletons found in a recent excavation of a first-century Jewish grave site was approximately 5 ft. 10 in.,[49] which would make the man in the Shroud of only average height. Meacham observed that Talmudic interpretation also confirms the taller average height.[50] The man in the Shroud was also well built and rather muscular, as if accustomed to physical labor.[51]

The fingers of the man in the Shroud do appear long, but Zugibe has already argued that the nail wounds in the lower palms explain the length.[52] So at least he need not appeal to Marfan's to explain this phenomenon. Besides, the elongated fingers may simply be a result of image resolution on the cloth. The claim that the man's face is narrow is also problematical because a face cloth apparent on the Shroud would make the face look slender.[53] Also, the gaps at the sides of the face are from the weave of the cloth, not the man's physical features.

Finally, the claims that the cause of death among those with Marfan's syndrome is often rupture of the aorta and that the average age of death is thirty-two cannot be said to parallel Jesus' death. In Jesus' case, rupture of the aorta cannot be proven; even Zugibe appears to rate it as only a possibility.[54] Even though Jesus was near thirty-two, He did not simply die but was a victim of capital punishment.

There is no persuasive evidence that Jesus had Marfan's syndrome. Zugibe admits that he has only offered "scientific speculation" and that a definitive diagnosis cannot be made from the Shroud. Granted, such a conclusion would not affect theological claims,[55] but, as Bucklin asserts, any claim that the man in the Shroud had Marfan's syndrome is illegitimate. The observed facts do not support Zugibe's thesis.[56]

Conclusion

Not all physicians agree on all the details of the exact nature of Jesus' suffering and death.[57] Yet even among those with the strongest disagreements, there is little dispute over Jesus' death by crucifixion. The researchers discussed above largely agree about the pre-crucifixion abuse—beating, scourging, the crown of thorns; the general outline of the type of crucifixion; the fact of Jesus' death—postmortem blood flow, rigor mortis, and other indicators; and most of the elements of burial. The fact of this medical agreement on major issues should not be clouded by disputes over the exact placement of nails, the position of the thumbs, more minute details of the cause of death, and washing. Besides, even on these minor issues, scholarly concensus can be shown.

With the pathologists' views in the background, the central fact of Jesus' crucifixion now commands our attention. In *The Cross and the Shroud*, Frederick Zugibe summarizes that event:

> He was almost totally exhausted and in severe pain. Sweat poured over his entire body, drenching him, and his face assumed a yellowish-ashen color. . . . The burning, exquisite pains from the nails, the lancinating lightning bolts across the face from the irritation by the crown of thorns, the burning wounds from the scourging, the severe pull on the shoulders, the intense cramps in the knees, and the severe thirst together composed a symphony of unrelenting pain. Then he lifted his head up to heaven and cried out in a loud voice, "It is consummated." Jesus was dead.[58]

Whether the Shroud of Turin is or is not the actual burial garment of Jesus, it accurately and movingly portrays Jesus' suffering for each of us. We willingly remind ourselves of that suffering, not for the sake of morbid speculation, but

that we might more deeply appreciate Jesus' love and self-sacrifice for us.

10

Evidence for the Cause of the Image

We have seen that Jesus was dead when He was buried. While medical views differ on some of the details regarding His death, it is agreed that He did not survive crucifixion.

In this chapter we will consider evidence for the cause of the image on the Shroud, especially the testimony since 1981. The cause of the image, the real crux of the controversy, is the issue that has created the most heat. Why? In a sense, everything depends not only on whose image it is, but on the data it reveals.

In *Verdict on the Shroud,* I reported scientific treatments of hypotheses that seek to explain the Shroud's image in terms of fraud or natural processes.[1] I included a detailed appendix (also included as Appendix B in *The Shroud and the Controversy*), that lists the objections to such views.[2] Although I will not repeat that discussion here, I will investigate whether scientific statements still verify it.

Before I actually begin my treatment, it must be carefully noted that the views contained in this chapter were expressed

before the 1988 carbon dating results were released. Therefore these persons might not say the same today. Even so, there are at least two reasons for including these data. First, one of the purposes of this volume is to note results from Shroud research since 1989, and the views expressed here are certainly part of the story. Second, in any discussion of the Shroud image, the question of how the image was caused is still important, whatever one concludes on the subject of dating.

So even if the Shroud turns out to be a medieval artifact, it need not be simply a human work of art. In fact, many have responded to the dating efforts of the 80s by commenting that the formation process is still a major issue. Some now believe that this question has been intensified by the dating process. And if the dating was possibly incorrect, this subject is even more significant.

Hypotheses Involving Fakery

First I will explore the validity of hypotheses suggesting fakery as the cause of the image. Could the image have been created by an application of some sort of foreign material to the linen? A number of scientists have testified that before their investigations they believed the Shroud was a fake. "Give me twenty minutes and I'll have this thing shot full of holes," testified STURP chemist Ray Rogers.[3] Bill Mottern of Sandia Laboratory, another STURP scientist, said, "I went in as a doubting Thomas."[4] Heller reported that, "For numerous reasons, Adler and I had been assuming all along that the Shroud was a forgery."[5] Testimonies like these could be multiplied. Many STURP scientists thought that the Shroud was simply a fake to be exposed by scientific testing.

But in the 1981 meeting at New London, Connecticut, the scientists reported: "No pigments, paints, dyes or stains have been found on the fibrils. X-ray fluorescence and microchemistry on the fibrils preclude the possibility of paint

being used as a method for creating the image. Ultraviolet and infrared evaluation confirm these studies."[6]

Even since then, several STURP scientists have continued to report that forgery could not be the cause of the Shroud's image.[7] Heller notes: "At the end of months of work, I had pretty well eliminated all paints, pigments, dyes, and stains . . . the images were not the result of any colorant that had been added."[8] Heller points out that fraud can be checked by at least two scientific methods—chemistry and physics. Concerning the first means, he said, "Adler and I had reached the conclusion that the image could not have been made by artistic endeavor."[9] The second method revealed no forgery either: "The conclusion of the physical scientists was that the Shroud could not be the result of eye/brain/hand."[10]

During these studies, a number of published reports appeared which detailed the work of Walter McCrone, a former STURP member. A world-renowned micro-analyst, McCrone announced that he had discovered red ocher (iron oxide and Vermillion) and gelatin or collagen tempera (he frequently changes his mind) on the Shroud, which he believed indicated that the Shroud's image was either painted or at least touched up by this substance.[11] His claim directly opposed the findings and stand of STURP and other reports, such as Heller's. Consequently, one report challenged Heller and Adler to publish their findings in response to McCrone.[12]

So although STURP scientists found no pigments, paints, dyes, or stains on the Shroud,[13] several of them began work on McCrone's specific challenge. Heller and Adler, who did some of the main work, reported that "There was not enough iron oxide or vermillion to account for one painted drop of blood, let alone all the gore on the Shroud."[14] STURP scientists tested and rejected McCrone's claims.

The stage was set for a debate, and one was planned for the 1981 meeting of the Canadian Society of Forensic Sciences. McCrone, Heller, and Adler were invited and hoped that the

issue would be resolved. But McCrone did not go, so the confrontation did not occur.[15]

Later McCrone was quoted as saying, "I believe the shroud is a fake, but I cannot prove it."[16] At any rate, STURP objected to his findings.[17] Even one nonteam physicist who appeared sympathetic to McCrone's findings still admitted that "STURP unanimously rejects McCrone's interpretations."[18]

One other well-publicized set of attempts to show how the image may have been faked came from artist Joe Nickell. His chief example involved applying a dry powder mixture of myrrh and aloes to a damp cloth which had been carefully fitted around a bas-relief face. The result is also an image of the face, created by the powder, which, to an untrained eye, resembles the face on the Shroud.[19]

Nickell's methods have been analyzed frequently, especially since his work was first publicized in 1978. He has changed his methods over the years, but his various attempts (as well as similar ones) have all been tested with the devastating results to Nickell's claims. The absence of powder on the Shroud and the disproving of any artistic process by both chemical and physical testing wielded death blows to Nickell's theories. Also, Nickell's models failed the 3-D test and were badly distorted when checked by the VP-8 image analyzer, as pointed out by John Jackson. Problems with shading and the fact that Nickell's model is not superficial (despite his claims to the contrary) led to the assessment that it was "unacceptable."[20] Heller likewise listed as a major failure of both bas-reliefs and block prints the fact that they do not reproduce a 3-D image, as the Shroud does.[21] He also pointed out that no such bas-reliefs or artistic method existed in medieval times.

Don Lynn and Jean Lorre of the Jet Propulsion Laboratory discovered that the Shroud's image is nondirectional; it has no linear direction. In other words, the image was apparently not caused by any movement of a hand across cloth, which

"would not be consistent with hand application"[22]—the crux of Nickell's theories. This poses a big problem, not only for Nickell, but for anyone who suggests that hand artistry caused the image. Many other problems could be mentioned,[23] but as Heller asserted, bas-reliefs were "examined and rejected because they could be ruled out—both theoretically and experimentally."[24] STURP scientists tested many different models and rejected all of them.

Another suggested method of fakery given considerable attention was "acid-painting," a chemical alteration of a linen cloth to produce an image. But STURP's tests with acid also failed to create a viable image. Achieving uniform density like that in the Shroud's image was a problem for this method, as was the presence of capillarity and even the destruction of the cloth itself.[25] For these and other reasons, acid-painting was rejected as a viable cause.[26]

Other fakery hypotheses were concerned with producing contact images, whereby an object with some substance on it is transferred to the linen by contact, apart from any painting methods. One of the more clever attempts involved coating a plaster bust with phosphorescent paint and then dipping the bust into black ink. But this method failed both chemically and physically.[27]

Another attempt at producing a contact image came from draping a cloth over a statue or bas-relief. Although scientists used various designs, their attempts failed to account for the image. In the words of Ron London, "You can scorch cloth. . . . You just can't make it look like what we see [on the Shroud]."[28] Numerous problems, such as the lack of 3-D information, plague these theories involving heated images. Heller noted that these hypotheses are "seriously flawed" with regard to this distance information.[29] Another problem is the inability of heat to cause a resolute image because heat diffuses.[30] STURP also discovered that when the heat was high enough for the contact areas to mark the

linen, the contact areas "burned through the cloth,"[31] which again fails to match the characteristics of the Shroud's image.

Consequently, STURP rejected all these theses.[32] In Rogers' words, "The image is too sharp and too uniform for any of the hot statue theories."[33] Heller rejected them on both theoretical and experimental grounds.[34] Even Mueller, skeptical of the Shroud's authenticity, recognized their failure at this point.[35]

For such reasons as these, fakery theories have been ruled out by STURP. The testing revealed no pigments, paints, dyes, or stains on the linen fibrils. As the STURP statement released at New London in 1981 proclaims, "[The image] is not the product of an artist."[36] To quote John Heller again, the Shroud's image "could not have been made by artistic endeavor. . . . The Shroud could not be the result of eye/brain/hand."[37] This conclusion rests on thousands of hours of tests, many of the results of which are not even presented here.[38]

Natural Hypotheses

Now I will turn to natural hypotheses to see if they can explain the image on the Shroud. None of the options in this category are based on fakery; rather, they point to natural causation.[39] The basic tenet of these models is that perhaps some natural relationship between the cloth and the body buried in it can account for the image. Maybe the image was caused by gases coming from the body or by contact.

In 1902 biologist Paul Vignon hypothesized that the body under the cloth was the source of chemical gases caused by the presence of sweat, ammonia, blood, and burial spices. These gases supposedly diffused upward toward the cloth and account for its image.[40]

Vignon's thesis was fairly popular from its appearance in 1902 until about the 70s. But further scientific investigations revealed numerous problems with his supposition. Robert Wilcox reviewed several of these problems. Summarizing,

he said, "As far as chemicals being able to make such an image, lab tests have shown that chemicals diffuse and 'run' through linen fibers, and thus produce a blurry, and certainly non-3D image."[41] Chemicals do not travel in straight lines upward, as Vignon's theory requires; rather, they diffuse in the air and lack any clear image, which creates resolution problems. Also, such chemicals cause capillary flow (run) on the cloth, a phenomenon absent from the Shroud. And, as Wilson noted, a chemically-induced vaporgraphic image is not three dimensional.

Mueller pointed out two other problems with Vignon's view. Both concern the superficiality and lack of saturation on the Shroud.[42] The Shroud's image is on the surface fibers only, but vaporgraphs permeate cloth. Furthermore, unlike the characteristics present with vapor transfer, the image is not saturated and contains no plateaus. Also, STURP's studies revealed "no evidence of any spices, oils, or any biochemicals known to be produced by the body in life or in death."[43] The very chemicals needed to create the image, according to Vignon, were not present on the cloth. For reasons such as these, the vaporgraph theory fell from popularity in recent years.[44]

Another natural hypothesis suggests that the Shroud's image was created by the contact between the cloth and the body wrapped in it. Obviously, at least parts of the image, such as the bloodstains, were caused by contact, so the supposition that the whole image could be accounted for by natural contact between the Shroud and the body does not seem farfetched—at least at first. But further research on this hypothesis has revealed that, by itself, contact cannot explain any of the observed phenomena on the Shroud.

One of the major problems for contact theses is that they cannot explain the portions of the image that did not contact the body. As Wilcox pointed out in one of his 1982 articles, areas of the body that apparently did not touch the cloth, such as the ribs, the sides of the nose, the eye recesses, and

part of the neck, are still shown on the image. This is a major problem for any direct contact theory.[45]

Another significant problem is that a contact thesis seems to require the image's back side to be more saturated than its front because of the weight of the body laid to rest in a tomb. Also, pressure from the contact should theoretically cause a different density in the dorsal and frontal images. But the fact is that the back side of the Shroud is neither more saturated nor any more dense than its front side. In short, a contact mechanism requires pressure, but the cause of the Shroud's image is pressure independent.[46]

Still another problem was pointed out by Ray Rogers. Mass spectrometry tests performed at the University of Nebraska revealed that there were no aloes, myrrh, oils, or other substances that could create a contact image on the Shroud.[47] If these or similar substances were not on the cloth, it is very difficult to see how any type of contact image could have resulted. The sensitizing material is just not there.

Mueller noted two additional problems for contact theories. The superficiality of the Shroud's image is a major objection, for even if there were sensitizing chemicals on the cloth, they would not remain superficial but would soak into the fibrils. The Shroud shows no evidence of this ever having occurred. Also, the Shroud's image has no saturation points, as would most likely occur with contact chemicals.[48]

A rather ingenious form of the contact thesis deserves some special attention. Samuel Pellicori of the Santa Barbara Research Center and John German of the Air Force Weapons Lab, both members of STURP, postulated that the Shroud's image might have been caused by direct contact through the transference of bodily chemicals to the cloth, producing the image over a long period of time, with the help of either heat or the linen's natural aging process. This "latent image" theory has some interesting twists, such as the belief that the dampness of the tomb might have caused an originally stiff shroud to droop over some previously untouched areas. The

darker aspects of the image would have been caused by the portions of the cloth that contacted the "higher" points of the body for the longest period of time.[49]

Although this hypothesis makes several improvements on the older versions of the contact thesis, it still suffers from numerous problems, some of which have already been mentioned. The Pellicori-German model is still pressure dependent and, if true, would lead to a darker dorsal image and a lighter frontal one. But the Shroud's pressure independent image does not reveal density differences between the back and front of the image. The absence of sensitizing chemicals on the Shroud is another major obstacle since they are, according to this model, the agents responsible for the image. Moreover, the superficiality and lack of saturation of the Shroud's image are still not accounted for on the Pellicori-German hypothesis.

Perhaps the major problem for the latent hypothesis is still the 3-D nature of the Shroud's image. Heller explained it this way: "The recessed areas of the face could not have been in contact with the cloth, as proved by the VP-8 images and the Shroud-body distance data. Pellicori agreed that that was still a problem for his hypothesis. It was not a problem, but rather the problem."[50]

Some of the scientists, including Heller, also thought that they had observed capillarity on the samples developed by Pellicori, which is another difference from the Shroud's image.[51] Other problems with this theory could be cited,[52] but we will mention only one more here. If this type of body-on-cloth action is natural, why are there no other burial garments that have images of the person buried in them? Surely more than one burial cloth with a contact image on it would have been discovered. But so far as I know, the Shroud is unique in this regard. And even if another burial garment with an image caused by natural contact with a dead body were found, the image would still have to display the

characteristics of the Shroud's image, which has been shown to be highly unlikely.

Hence, serious flaws in contact theories disallow them, at least at present, as likely explanations for the cause of the Shroud's image. STURP concluded: "It is clear that there has been a direct contact of the Shroud with the body, which explains certain features such as the scourge marks, as well as the blood. However, while this type of contact might explain some of the features of the torso, it is totally incapable of explaining the image of the face with the high resolution which has been amply demonstrated by photography."[53]

For these and other reasons,[54] the contact thesis must be rejected as a viable image-producing mechanism. As Heller remarked, "Any hypothesis based on contact between the Shroud and body chemicals had to be ruled out, because the physics of the images seemed to preclude it."[55]

In conclusion, natural hypotheses have failed to explain the Shroud's image and are untenable at this time. Schafersman even referred to such alternatives as "absurd."[56] Thus, neither fakery nor natural hypotheses are viable. Murphy remarked in 1981 that "it is STURP's conclusion that none of the forgery theories is tenable. Neither are any of the 'natural phenomenon' hypotheses."[57]

The Scorch Theory

At this point, science is unable to explain the Shroud's image completely.[58] On scientific grounds, the cause of the image is an enigma. In the words of the STURP report delivered at New London, "The answer to the question of how the image was produced, or what produced the image, remains now, as in the past, a mystery."[59] As Heller asserted, 100 thousand to 150 thousand scientific man-hours have been spent "studying the Shroud, utilizing the best scientific instruments, and yet the image still remains a mystery."[60]

In spite of this conclusion, by the early to mid 1980s numerous scientists had indicated their view that the image

was best explained by a scorch theory of some sort. Even Mueller, a critic of the Shroud, pointed out in 1982: "Nation-wide, at least, most members still seem to regard the dehydrated-cellulose image as a probable low-temperature scorch, and the image as having been somehow 'projected' across space onto the cloth. This is, of course, the old radiation-scorch hypothesis in thin semantic disguise."[61]

Wilcox's 1982 article series, largely based on his interviews with twenty-six scientists from the 1978 investigation, confirmed some of Mueller's suspicions. Noting that possibly the most important single finding of STURP was the oxidized, dehydrated, and conjugated nature of the linen fibrils,[62] Wilcox decided to ask the scientists he interviewed what they believed to be the cause of the image. Only seven ventured a specific answer. Two of them, Pellicori and German, favored the latent-image version of the contact theory[63] even though STURP declared that contact theories are "totally incapable" of explaining crucial portions of the image.[64] The other five scientists who answered Wilcox's query indicated their view that the image was a scorch.[65]

Even though a sample of seven scientists is admittedly very small (about 27 percent of those questioned), it is nonetheless quite significant that those who did answer believed the scorch hypothesis fit the facts better than any other. However, the interesting question here is, how can a dead body under a cloth produce such a scorch on linen? Although no completely scientific answer to this question has been given, some of the scientists who accepted the scorch hypothesis cited data in its favor. I will turn now to consider some evidence for this theory.

Questions about the Scorch Theory

According to Mueller, John Jackson led an influential group of STURP scientists who accepted the scorch theory or a similar view. One major argument they cited was the three-dimensional data.[66]

Roger Gilbert of the Oriel Corporation was one of the scientists who believed that the image was caused by a scorch. He was also involved in one of the tests—visible spectral reflectance—which appeared to indicate this conclusion. The test revealed that the molecular properties of the image were very similar to those of the scorch marks inflicted in the fire of 1532. This provides evidence that characteristics of the fire burns were likely the same as these of the Shroud's image, although those who held the scorch theory generally believed that the scorch was caused by a mild emanation of heat or light at moderate temperatures and not by a burst of intense heat or light. Gilbert, on the other hand, was not prepared to explain how a body might "glow" in order to cause the image.[67]

An important question concerned the fact that testing revealed that the 1532 scorch (fire) marks fluoresced while the image did not, which is evidence against the two types of scorches being caused by a similar action. Answering this result, Gilbert explained, "I think this is due to the physical differences in the two targets, not their inherent natures. The Shroud's image is superficial, for instance, while the 1532 scorch marks extend to the reverse side of the cloth."[68]

Alan Adler was another STURP scientist who reportedly favored the scorch theory. Like Gilbert, he believed this scorch was produced by mild heat intensity, which would account for the oxidation, dehydration, and conjugation of the fibrils observed on the Shroud. But again, the issue was how a body or bodily form, especially a lifeless one, could have been the source of such a scorch.[69]

One question concerning the scorch theory was how heat or light could have caused the high resolution of the image. But Roger Morris, a Los Alamos scientist who also favored the scorch hypothesis, pointed out that heat rays can travel in straight lines, depending on the angle from which they are projected,[70] which is consistent with what scientists have discovered about the Shroud's image.

In Murphy's 1981 interview with Ray Rogers, this chemist also stated his preference for the scorch theory: "A scorch seems a bit more promising. If a scorch is produced at moderate temperatures, the predominant result is creation of conjugated double bonds, which is what we have. . . . I incline toward the idea of a scorch, but I can't think how it was done. At this point you either keep looking for the mechanism or start getting mystical."[71]

In his book on the Shroud, John Heller also appeared to give the slightest hint that the scorch theory just might possibly be the correct view: "If it turns out that some form of molecular transport I have not been able to fathom is the method whereby the images of the scourged, crucified man were transferred to the linen, I shall have only solved another little micropart of the puzzle."[72]

Some non-STURP scholars have also defended the scorch theory since the 1978 scientific studies were conducted.[73] Perhaps the scholar who had received the most attention was Giles Carter, professor of chemistry at Eastern Michigan University, who had specialized in x-ray fluorescence analysis for fifteen years. Carter felt the Shroud's image was caused by low-energy x-rays of a secondary nature, which were emitted by the body under the cloth.[74] Carter based his research on STURP photographs supplied by Vernon Miller, chief photographer for the team. After studying them, Carter thought that he could detect the effects of x-rays, taking some hints from what he believed was evidence of knuckles, of some of the backbone, and even of teeth on the Shroud. From this, Carter developed his theory, which proposed that strong x-rays actually proceeded from within the bones and teeth of the dead man and then reacted with dust, dirt, and chemicals on the skin, such as those caused by perspiration. The result was that the elements on the skin fluoresced, thereby producing secondary x-rays and causing the image. In other words, the initial, stronger x-rays were the cause of the secondary, low-energy x-rays. The latter resulted from

the fluorescing dirt and other chemicals on the body and then produced the image over the distance between the body and the cloth.

Carter experimented with his method in the laboratory and had some reasonably good results, even claiming that his model could account for the three-dimensional data on the Shroud. He presented a paper explaining his findings at the September 1982 meeting of the American Chemical Society.[75]

Carter sent copies of his work to Shroud specialists, including several members of STURP. When interviewed, Adler responded that Carter's theory was "great physically, great chemically, but absolutely bizarre biologically. Anyone who was that radioactive would be dead long before he was crucified."[76] In 1983 Carter concluded, "I'm more optimistic because time has gone by and my theory hasn't been disproved."[77]

Another researcher, Jerome Goldblatt, who had been close to Shroud studies in the 80s, also espoused a scorch theory, favoring the postulation that a burst of radiant energy from the body projected onto the cloth. On the other hand, he allowed as possibilities the other varieties of the scorch hypothesis: "in the final analysis . . . whether I call the image on the Shroud a scorch, a quasiphotograph, a thermogram, a Kirlian aura, or a hologram is only a matter of semantics."[78]

But the scientific tendency, to the extent to which a scorch was a possible option, was away from high-intensity radiation to the concept of a moderate-temperature scorch (less than 280°C).[79] Of course, the question regarding how such heat could emanate from a live or dead human body has no purely scientific answer. But the scorch theory did seem to account for more data than any other theory that had been proposed.

Conclusion

The scorch thesis was not without problems to be solved if it was to be viable. Yet a scorch could exhibit many of the characteristics present on the Shroud, such as oxidation, dehydration, and conjugation of linen fibrils, superficiality, the absence of saturation or image plateaus, and thermal and water stability and coloration.[80] In other words, a scorch explains such phenomena as the conditions of the image fibrils themselves, the fact that this image is on the surface fibrils only, and that there are no points at which the image soaks into the cloth (except for the blood stains). A scorch can also account for the coloring and the resistance of the image to changes brought about by heat or water.

Hence, just as the scorch theory was probably the most popular thesis before the 1978 scientific investigation,[81] so some form of it appeared to be the most popular option in the 80s, at least until the carbon dating results were revealed. Granted, comparatively few of the scientists answered this critical issue publicly. Instead, many of them labeled the image a mystery. Nonetheless, several scientists professed their view, and most of those espoused some form of scorch thesis.[82] And yet, even for those who postulate a scorch, they may not know its cause. Such a scorch could have a known or unknown origin.

But could the scorch theory still possibly be true? If so, what could account for the emanation of heat or light? That's the question I will address in the next chapter. For those who do not think that carbon dating has eliminated the chance that the Shroud could be the burial garment of Jesus, this may, in fact, be the most important question of all.

11

New Evidence for Jesus' Resurrection

I have been building a post-carbon-dating case for the possibility that Jesus was the one buried in the Shroud. Medical knowledge has confirmed that Jesus died from the rigors of crucifixion. And concerning the cause of the Shroud's image, there has been no scientific consensus, except that the image is a mystery.

Now we turn to the most controversial subject of the whole debate—Jesus' resurrection. Is there any support for this event from the Shroud of Turin? Could any scientific evidence from the ancient linen cloth add to the strong independent historical evidence for the resurrection of Christ? Now, of course, for those who believe that the results of the carbon dating are authoritative, this question is misplaced. But for those with doubts about the tests, the issue is still important.

Scientific Opinion in the 80s

From 1978 to 1988 the scorch hypothesis appeared to be most popular among scientists who expressed their views on the cause of the image. However, it must be carefully noted that the question of whether the Shroud provides evidence for Jesus' resurrection is not dependent on whether the image was caused by a scorch. The Shroud appears to be unique at this point, even if a natural explanation for the image is found.[1] As Wilcox pointed out: "But even if [researchers] come up with some "natural" process, the failure, so far, to find anything like the shroud amongst the world's body of cloth and artifacts leaves them with the further problem of why the process occurred only once in the history of the world, so far as is yet known."[2]

In fact, Wilcox even observed from his 1982 study that the thirteen scientists who indicated their belief that the Shroud was the actual burial garment of Jesus also thought that a natural cause for the image would be consistent with the Christian belief in Jesus' resurrection:

> While all 13 indicated they thought a "natural explanation" (meaning one that can be explained by science) for the cloth's images will eventually be found, they also indicated they believe the Shroud's uniqueness (nothing like it has yet been found on earth) will remain, thus keeping it, in their view, consistent with the Christian belief in Jesus' death and resurrection.[3]

John Heller has also commented on the Shroud's uniqueness: "I do know, however, that there are thousands on thousands of pieces of itinerary linen going back to millennia before Christ, and another huge number of linens of Coptic Christian burials. On none of these is there any image of any kind."[4]

Therefore, even if a natural hypothesis for the Shroud's image is discovered, it would not discount the image as

evidence for Jesus' resurrection. In fact, a natural thesis could even produce evidence for this historical event, since scientific phenomena such as those described later in this chapter still exist.

Some of those who have studied the Shroud have related its revelations to Jesus' resurrection. STURP pathologist Robert Bucklin, who did not support the scorch theory, still believed that the Shroud provided evidence for the resurrection:

> It was inevitable that the question of the resurrection would come up in relation to the Shroud studies. . . . While the majority of the scientists have been reluctant to take a stand on this matter, a few of us have openly expressed our opinions that there is support for the resurrection in the things we see on the Shroud of Turin.[5]

Elaborating, Bucklin proclaims: "The medical data from the Shroud supports the resurrection. When this medical information is combined with the physical, chemical and historical facts, there is strong evidence for Jesus' resurrection."[6]

Giles Carter's thesis postulates that the body in the Shroud emitted x-rays, which caused surface dirt and chemicals on the body to fluoresce and produce secondary, low-energy x-rays. These, he argued, passed over the distance from the body to the cloth and created the image on the Shroud.

But how did a dead body wrapped in a burial cloth emit strong x-rays? Carter suggested three options. Perhaps the person buried in the Shroud had lived in a cave that had radioactive walls due to the effects of certain materials. Or maybe this person had eaten food that was grown in naturally radioactive soil. Or, according to Carter, "There is a possibility of the unknown, a supernatural cause, if in fact this is the burial shroud of Jesus Christ."[7]

Concerning the likelihood of the last option, Carter held that if the Shroud turned out to date from Jesus' time, this would "provide proof of the resurrection: which would make some atheists awfully mad."[8]

As was pointed out earlier, Alan Adler's initial response to Carter's thesis was that it was "great physically, [and] great chemically." But in regard to Carter's first two options, Adler concluded they are "absolutely bizarre biologically. Anyone who was that radioactive would be dead long before he was crucified."[9] Now if Carter's thesis was otherwise "great" on both physical and chemical grounds and yet his first two explanations for the image were "bizarre" and physically unexplainable, does this make the supernatural option possible? Several pieces of evidence provide support for this thesis.

Jerome Goldblatt found strong evidence for the resurrection on the Shroud of Turin. Although not a scientist, Goldblatt is an informed researcher on this subject. He noted that the man buried in the Shroud was in a state of rigor mortis and definitely dead. Yet absolutely no decomposition is observed on the Shroud, indicating that the body apparently left the cloth during the period of rigor mortis, twenty-four to forty-eight hours after death. Neither does the body appear to have been removed by any human agency because the blood stains are not smeared or otherwise marred and no known damage to the image fibrils exists. This entire process is unique. Saying, "Precedents are not only elusive, they are nonexistent," Goldblatt related each of these evidences to the resurrection of Jesus.[10]

Wilcox's report that thirteen of the twenty-six STURP members were willing to identify the Shroud as the actual burial garment of Jesus was startling, especially since these thirteen also believed that the Shroud was consistent with Jesus' death and resurrection.[11] Some researchers have even contended that the Shroud is evidence for Jesus' resurrection. What case could be made for this conclusion? Let's see.

The Evidence

By combining the New Testament record with the scientific, medical, archeological, and other historical information concerning the Shroud of Turin, an argument can be made. The detailed agreement between the beating and execution of Jesus and that of the man buried in the Shroud, especially in the crucifixion anomalies, indicates that the man in the Shroud may still possibly be Jesus.[12] Then the witness of the Gospels to Jesus' bodily resurrection from the dead provides the possible explanation for the scientific evidence pointing to the strange disappearance of Jesus' body from the Shroud. Any other Shroud data could present additional evidence for His resurrection. And I believe, along with numerous other researchers and scientists, that the Shroud does exhibit some additional evidence for this event.[13]

First of all, that the Shroud contains no hint of bodily decomposition indicates a hasty bodily departure. If the body had remained in the cloth, it would have been seriously decomposed after a very few days. The fact that the body was still in rigor mortis indicates that it may have left the cloth before the forty hours or so that the condition generally lasts.

Second, according to Bucklin, the blood stains indicate that the body left the Shroud without disturbing it. Since the cloth was loosely attached to the body from the dried blood, any attempt to remove it probably would have damaged the stains. Yet these blood stains are anatomically correct, even down to their precisely outlined borders. Moreover, I noted earlier that the scientific tests failed to reveal any evidence of damage done to the image fibers, again evidence that no physical separation between the body and the Shroud occurred. Bucklin takes this as further evidence that the body was not unwrapped.[14]

Third, my theory that the Shroud's image was caused by a scorch from a dead body certainly reveals a mystery surrounding the death of the man buried in it and his subsequent departure from it.

But what sorts of theories could account for such a strange disappearance of a dead body? The possible theories are three: (1) naturalistic, which must utilize explanations that proceed solely from the normal operations of nature; (2) supernaturalistic, which require that ultimate explanations derive from a work of God or another agent with powers beyond those of nature; and (3) unknown origin; which either fail or refuse to provide a causal explanation for the phenomena in question. But the current evidence suggests that the naturalistic alternatives are mistaken.

Naturalistic hypotheses that would account for the Shroud must explain at least (a) the absence of decomposition, (b) the fact that the body was apparently not unwrapped when it separated from the cloth, and (c) a very possible light or heat scorch from (d) a dead body in a state of rigor mortis. Theories involving an unwrapped, rewrapped, or stolen body are confounded by (b) and (c). Those claiming that the person in question never died are disproved by (b), (c), and (d). Most other naturalistic theories are refuted by one or more of these phenomena.

Some people might prefer to wait for a yet unknown or future naturalistic hypothesis. And to be honest, there is some warrant for such attitudes in light of the carbon dating, for this is a serious objection. On the other hand, no known alternative thesis can presently explain the image, the results of the dating notwithstanding. In addition, given the significant problems with the 1988 dating procedures, the possibility that the Shroud is authentic is increased, in which case it could still have some relevance to the issue of the resurrection.

Therefore I conclude that the Shroud does provide some new evidence for Jesus' resurrection. In addition to the absence of viable naturalistic theories, other features of the Shroud support Jesus' resurrection:

- The physics and mechanics of the light/heat image

strongly imply the mechanics of bodily separation from the cloth, which is independent of other data.

- Most of the facts about the Shroud image, such as three-dimensionality, superficiality, and nondirectionality, are empirical and repeatable, certainly a new type of evidence for the resurrection.
- The image may actually be a quasiphotograph of the process of separation, again a new phenomenon.
- That the man was clearly in a state of rigor mortis shows that whatever else occurred, it was not a near-death experience or a resuscitation.

While it is true that none of these conditions proves a resurrection, it is also true that they present more than just a strange occurrence. Indications such as a quasiphotographic image caused by heat or light and having the unique empirical and repeatable characteristics of three-dimensionality, superficiality, and nondirectionality, all proceeding from a completely dead body, and that the body apparently exited from the cloth without being unwrapped, produce strong considerations for Jesus' resurrection. Of course, the Shroud's image could have a different cause, and this evidence does not amount to a proof for this event. But there is certainly some evidence here for the cause being Jesus' resurrection. And when it is combined with the Gospel records and other historical evidence, the man imaged in the Shroud is still possibly none other than Jesus. In and of themselves, the Gospels' eyewitness testimony to Jesus' resurrection lends reliable historical support to that event. But I conclude that the Shroud adds some further empirical evidence.

Consider the analogy of a court case. Even if there is enough evidence to convict a person of a crime, extra evidence could reinforce the conviction. Similarly, the independently reliable Gospels confirm the historicity of

Jesus and His resurrection. The Shroud may add some new empirical evidence, strengthening an already strong case.

At any rate, one could either accept this preliminary Shroud apologetic as providing some evidence for the Resurrection, or one could reject it in light of the current data. But when the scientific evidence is combined with the previously and independently validated Gospels, the result may be more than the possible identification of Jesus with the man of the Shroud. The Gospels also record Jesus' resurrection from the dead.[15] The Shroud could add some new, empirical evidence for this event, thereby providing a possible explanation for the scientific mystery that is at least partially generated by the strange disappearance of a dead body from the cloth.[16]

I am not stating that the Shroud supplies any proof for the resurrection. However, that does not rule out the possibility for there being some evidence on it for the resurrection. And yet I must be cautious about evidence from the Shroud of Turin. This cloth still might turn out to reveal something different from what I have envisioned, and, of course, Christianity neither rises nor falls on the nature of the Shroud. On the other hand, the Shroud may give some added testimony to that of the early church: "Christ died for our sins according to the Scriptures, and . . . He was buried, and . . . He rose again on the third day according to the Scriptures" (I Cor. 15:3–4).

An important concern needs to be voiced here, however. What if the Shroud turns out, in the end, not to be that of Jesus? What would such a conclusion say about resurrection? Would someone else have been raised? Here it should be remarked that there are at least two differences between the identification of Jesus and that of some unknown victim of crucifixion. First, if it is known for sure that the Shroud is a medieval garment, then an alternative theory of some sort does become a much more likely candidate simply by the fact that its origin has thereby been explained otherwise than was

previously thought. If I have been wrong in my previous assessment, then all of my conclusions suffer. Second, the resurrection of an unknown individual would not have the additional and independent backing of either the New Testament or historical data, as Jesus' resurrection does. The evidence would not be sufficient to conclude that a resurrection had occurred to an unknown individual.

A Brief Apologetic for the Resurrection

At this point, an additional issue needs to be addressed: the relationship between the Shroud and a defense of the resurrection itself. The writings of Gary Habermas on this subject have stressed the existence of independent historical arguments for the resurrection which are based on either a reliable New Testament or historically demonstrable facts acceptable even to critical scholars who reject the New Testament's reliability.

In other words, these two independent arguments could either proceed in a rather straightforward manner from the trustworthy New Testament to its testimony concerning the resurrection or, conversely, I could utilize known and critically accepted historical facts which can be separately confirmed on the basis of the available data. These facts are sufficient to prove the historicity of the resurrection, even for those who do not believe that the Scriptures are trustworthy. In short, I can reason to the resurrection either from the overall nature of the New Testament text or from separate facts that are independently demonstrable.

I could pursue the first approach, which begins with the New Testament, by employing evidence regarding authorship, eyewitness testimony, dating, extrabiblical and archeological sources, as well as manuscript support. Then I would have to ascertain what these sources report concerning Jesus' resurrection.

On the second approach, facts that are verifiable on separate grounds (beyond the trustworthiness of the New

Testament) are utilized to both disprove alternate, naturalistic attempts to dismiss the resurrection and to provide numerous positive evidences for this event. In particular, these minimal facts (which are accepted by virtually all critical scholars who study this subject) especially affirm the nature of the eyewitness claims to have seen the glorified body of Jesus. And, to repeat, these appearances have not been explained away by naturalistic means.[17]

Another evidence has already been presented in this chapter. It uses both the independently verified Gospels and the new evidence for the resurrection from the Shroud.

Some new twists can be added to this second approach. For instance, even the German liberal scholars of the nineteenth century decimated each other's naturalistic and critical theories, revealing many weaknesses in each of their views. Furthermore, these theories are generally rejected wholesale by twentieth-century critics. Hence, numerous nonsupernaturalistic theories of the resurrection have fallen on bad times—and for many reasons.

But the strongest aspect of the second type of apologetic asserts that a minimum number of facts accepted as historical by virtually all scholars who study this subject can provide enough evidence to demonstrate the historicity of Jesus' resurrection. Having accepted these minimal facts, which are established by strict historical and critical methods accepted even by contemporary skeptical scholars, they cannot properly reject the conclusion of the bodily resurrection of Jesus whatever their doubts on other areas of Scripture. Therefore, the resurrection event is established by the minimal amount of historically validated and accepted facts.[18]

A third approach has already been presented in this chapter. It uses both the independently verified Gospels and the new evidence from the Shroud for the resurrection of Jesus.

It is not the purpose of this chapter to present the

previous historical arguments in any detail; the interested reader can pursue them elsewhere. The second argument, in particular, differs from the approach in this chapter in that all of the arguments contained in the former apologetic are built on demonstrated historical facts accepted almost unanimously even by more radical critics who reject the reliability of the New Testament. The present approach, however, uses the trustworthiness of the Gospels and any possible scientific corroboration from the Shroud.

A Miracle?

If the image of the Shroud of Turin is a scorch, what significance might it have? Mueller, a critic of the Shroud, surprisingly concludes:

> The celebrated interpretation that the Shroud image is a scorch formed by a burst of radiation emitted by the corpse obviously requires nothing less than a miracle. Not only would the source of radiation be unprecedented, but the radiation emanating vertically from every element of the body surface would somehow have . . . properties totally unknown to science.[19]

He makes a similar point in a reference to my earlier work on this subject: "Stevenson and Habermas in their book [*Verdict on the Shroud*] regard the radiation-scorch as proved. . . . They fully realize that it clearly implies supernatural intervention."[20]

Beside the fact that I do not believe either the "burst" form of this thesis or that the scorch theory has been proven (but only that a form of it is possible), Mueller has clearly recognized the possibly miraculous nature of the Shroud image, although he does not believe it is a likely option: "The point is that there are really only two possibilities for the origin of the shroud: either it was made by an artist or it is a miraculous reproduction of the image of Jesus Christ."[21]

We have already seen that both the scientists have found artistry to be a highly unlikely hypothesis and that some scholars have accepted the scorch theory. However, not all would agree that a scorch would indicate a miracle. In some current philosophical discussions, an argument for a resurrection is not necessarily an argument for a miracle. To determine if a miracle has actually occurred, we need criteria beyond the event itself. Regardless of whether the Shroud is the actual burial garment of Jesus, I do have such criteria for recognizing a miracle in the historical case for Jesus' resurrection.

Reproducing the evidence for this last point would take us far beyond the scope of this chapter. So what I will do here is outline only the conclusions of two sets of arguments for the identification of Jesus' resurrection as a miracle caused by God.[22]

A Philosophical Case

In *The Shroud and the Controversy*, Gary Habermas asserted with good reason that he lived in a theistic universe. He referred to theism in a specific way: it entails a universe where God exists and in which He is involved to some extent with man in the process of history. God reveals Himself to human beings in various ways, and they are to respond through prayer and worship. The meaningfulness of history is also shown by moral and other values present in this existence as well as in life after death. In such a universe, we therefore have an important indication of the identity of the power that caused Jesus' resurrection. In other words, the truthfulness of theistic argumentation, including many of the attributes of God and the orderliness of the universe, best identifies the resurrection as an orderly event brought about by God's power, consistent with His attributes, in order to validate Jesus' truth-claims. Therefore, proceeding from true theistic arguments, God's attributes, and the order and purpose in the universe, the historical resurrection of Jesus

should be seen as an orderly theistic event which verifies His theistic message. This evidence agrees with Jesus' theistic worldview much more than with the notion that the resurrection had some unknown natural cause.

A Theological Case

The second argument combines the claims of Jesus with His literal resurrection as further verification for His teachings and worldview. Jesus' claims to be deity, God's chosen messenger, and His agent of personal salvation; Jesus' views on His corroborating miracles; and His having predicted His own resurrection all point to His theistic worldview.[23] The resurrection was a planned and orderly historical occurrence, and Jesus was in the best position to interpret it. Jesus taught that the resurrection validated His message and claims.[24] And the only time that a resurrection is known to have happened,[25] it occurred to the only person who made these extraordinary claims concerning Himself and God. The combination of this unique historical event with the unique message of Jesus further verifies this theistic worldview.

In other words, if just anyone had been raised from the dead, the cause might be hard to ascertain. But since it was Jesus who was raised, I must take very seriously His claims to be deity and God's special messenger and agent of personal salvation, as well as His belief that His miracles and bodily resurrection validated His claims. Since these unique claims were coupled with the unique resurrection event, I judge that Jesus' theistic worldview was validated.

Conclusion

We have seen that prior to the 1988 carbon dating, numerous scholars involved in investigations on the Shroud had indicated their belief that it was Jesus' actual burial garment. Furthermore, most of a small sample of scientists who responded to the question favored the scorch theory as the cause of the Shroud image. A number of scientists and

scholars have also stated that the Shroud image is either consistent with the resurrection of Jesus or evidence for it.

Next I pointed out some evidence on the Shroud for the resurrection. The Gospels provide the very possible identification of the man of the Shroud as Jesus and record His literal resurrection. The Shroud of Turin adds some new, empirical, and repeatable evidence for the resurrection as the best explanation for such data as the strange bodily disappearance, the absence of decomposition, the lack of unwrapping, and the quasiphotographic image caused by a probable scorch from the dead body. We must look not only to the mere strangeness of these conditions but beyond it to ascertain a cause. The improbability of alternative theses and the suggestive new information reveal some evidence for Jesus' resurrection.

More important and independent of the Shroud, I also presented summarized arguments for both the historicity of the resurrection and for the miraculous nature of this event as an act of God which provides further verification of Jesus' theistic claims. The Shroud may or may not provide additional evidence for Jesus' resurrection, but the event itself and the claims of Jesus' theistic worldview are validated completely apart from it.

Jesus' call to salvation in the kingdom of God was His central teaching, as is recognized by virtually all scholars today. His chief message was a challenge concerning a personal decision with one's eternal destiny hanging in the balance.[26] According to Jesus' primary message, all people are sinners by their very nature, the remedy for which is repentance (Luke 13:3, 6) and forgiveness of sins (Luke 24:47). Faith in Jesus and His payment for sin through His death (I Cor. 16:1–4) allow one to gain entrance into the Kingdom of God and receive eternal life (Mark 1:15; John 3:16–16). The Christian's response to Jesus should be total surrender (Luke 14:25–35).[27]

Since this was Jesus' central message, it is the portion of

Jesus' claims and theistic worldview which would most be validated by the resurrection and other evidences from His life. To ignore this message is to ignore the only entrance to eternal life. Faith is not to be placed in the Shroud but in Jesus, who died for the sins of humankind and was raised by the power of God.

PART 3

Into the Millennium

12

Shroud Studies in the 90s

Larry A. Schwalbe presented an interesting paper in 1990 called, *Scientific Issues and Shroud Research in the 1990s.*[1] In his paper, he outlined a list of tasks related to Shroud research and he put together a timetable for carrying out those tasks. His timetable extended to the year 2000, which is upon us now. He outlined three major categories he felt were crucial in Shroud studies:
- Conservation, preservation, and archiving issues
- Image formation studies
- Provenience studies (Shroud origin)

Let's take a look at his proposed categories and see if there have been any significant progress in those areas.

Conservation and Preservation

With the report of a fire heavily damaging the cathedral housing the Shroud of Turin early one Saturday in April 1997, the question of conservation and preservation was again raised.

"The linen is intact. It's a miracle," said Turin Archbishop Giovanni Saldarini, who is the keeper of the Shroud on behalf

of the pope and the Vatican. Firefighter Mario Trematore used a hammer to break through four layers of bulletproof glass protecting the urn that contained the 14-foot-long linen Shroud, while other firefighters poured water on the vessel to keep it cool. In total, it took about 200 firefighters more than four hours to extinguish the blaze.

The Shroud had been enshrined in the Guarini Chapel of the cathedral since 1578. Because of the restoration project in that chapel, the Shroud had been moved into the Cathedral of Turin. Firefighters said that if it had been in its traditional place in the chapel, it would not have survived.

The Guarini's Capel of the Shroud and a wing of the Royal Palace were seriously damaged posing a major risk to the preservation of the Shroud itself. Shortly after the fire, a meeting was called to discuss the preservation of the Shroud and how the Italgas Society had decided to take charge of finance. A generous sum of money was set aside to study preservation conditions, the construction of a large glass reliquary, and a security system to protect the Shroud.

In the Fall of 1991, a qualified international commission composed of professionals of different scientific disciplines was formed for the explicit purpose of Shroud preservation. In September of 1992, the commission examined the Shroud and documented the condition of the cloth. In 1996, the commission drafted a report describing new preservation requirements.[2] Physical, chemical, and biological processes had to be considered when formulating a conservation and preservation program.[3] Differences in opinion on how the image was formed (that is, some think the Shroud is a 14th century painting, while others believe the image was formed by some other process), have lead to delays in formulating preservation plans. Carefully identifying how the image was formed becomes imperative in determining just how to preserve the cloth. A summary of the 1996 report and the new conservation requirements follow:[4]

- The Shroud will be kept in an extended and horizontal position.
- The Shroud will be kept in a reliquary with waterproof, bullet-proof glass. It will have inert gas and no air. The reliquary will be protected from light and a constant climate will be maintained.
- To protect against excessive handling, the reliquary will be used when the Shroud is publicly exhibited. Note that the next exhibition is scheduled for the year 2000, which will commemorate the Jubilee anniversary of the birth of Jesus. Saturday, August 26, to Sunday, October 22, 2000 are the planned dates for that exhibition.

By observing the points outlined in the commission's report, Shroud conservation radically changed. In particular, the Shroud will be laid out horizontally rather than rolled up on a cylinder. To date, the unresolved issue of image formation curtails preservation techniques. For example, until definitive studies are completed on image formation, the possibility of destroying the Shroud by disinfestation from bacteria, fungi, and parasitic microorganisms exists. Because the risk is too great, these types of preservation techniques must be put on hold.

On Friday, April 17, 1998 the Shroud was inserted in its new case. The cost of 800 million liras to produce the case was sponsored by "Italgas." The case weighed three tons (size 4.64 × 1.38 m) and was formed of two 5 mm bulletproof steel plates separated by a thin inner tube, while the inside part was of stainless steel. The Shroud was covered by a special glass, 7 cm thick, bulletproof and UV protected. Inside the case there is a mixture of inert gas (argon) and steam; the quantity of oxygen is continuously controlled since it must not exceed 0.01 ÷ 0.1%. The temperature is controlled at around 18°C. The case was placed in the cathedral at almost the same position in which the Shroud was shown in 1978.

On Saturday morning, April 18, the first visitors were allowed to view the Shroud in its new reliquary.

Archiving

On September 13th and 14th, 1997, an Archiving Meeting was held in Kaufman, Texas. A large group of individual Shroud researchers attended this meeting to discuss possible ways that scattered Shroud resources (housed in individual collections all over the world) could be archived and made available to everyone.

Conventional and digital archiving methods for the new millennium were discussed. The first step in long-term preservation was to create an alphabetical master catalog of world-wide Shroud collections and data. Everyone at the meeting agreed to add to this list with the hope that others would be encouraged to do the same. Once the master catalog is created, the intention is to make it present on the Internet so that it is available for research and can be updated regularly with any new collections.

Image Formation: What's New?

Just how was the image on the Shroud formed? This is a serious question that has been long debated in the past and will continue to be debated into the millennium. Image formation on the Shroud continues to baffle scientists even with our advanced scientific methodologies and, to date, no definitive answer has been found. Even though the Shroud was declared a fake after the 1988 C-14 testing, the question of how the image got there still remains a mystery to those still seeking answers.

Several studies have revealed the physical and chemical distribution of the image. These studies have revealed how the image was not formed. (See Chapter 10 for more information about image formation.) Perhaps the newest and most controversial theory about image formation comes from Dr. Garza-Valdes concerning DNA studies. He states,

"as of now, I have no reason to believe the Shroud of Turin is not the burial cloth of Jesus Christ."[5] Dr. Garza-Valdes believes that the blood on the Shroud is of a human male and is ancient.

In the early 1990s, Dr. Garza-Valdes and Victor Tyron, (director of the Center for Advanced DNA Technologies of the University of Texas Health Science Center at San Antonio) worked together to determine the organisms they believed were present in the Shroud samples. They used a technique that enabled them to make millions of copies of the extremely small segments of DNA contained in "sticky-tape" samples of the Shroud.

After the tests were performed, Tryon said, "All I can tell you is that DNA contamination is present and that the DNA belonged either to a human or another higher primate. I have no idea who or where the DNA signal came from, nor how long its been there." Tryon says it is not necessarily the remains of blood. He believed that DNA signals were left by anyone who touched the Shroud. Not long after the tests were completed Tryon left the project citing "zealotry in science" as one of the reasons. [6]

Alan Adler, a chemist, has doubts that the oxidation was humanly induced. One reason he believes this is that the image is only one fiber deep. He says, "If you lift a crossing fiber, you won't find any discoloration below." He believes the "fiber-by-microscopic-fiber gradations," even in a single thread defy a human hand if it were engaged in either the application of acid or a rubbing process. Adler, who is a recognized expert on certain molecules found in blood, states emphatically of the crimson stains and rivulets that ornament the Shroud, "The blood is blood, and it came from a man who died a traumatic death." He says, "both chemical analyses and a telltale yellow-green fluorescence under ultraviolet light indicate the presence of remains of a slightly different substance: the fluid exuded from blood clots." Because that substance is invisible to the naked eye and was

only discovered in the 20th century, he believes that if a medieval artist created the image, "he must have been a genius."

Provenience Studies

1994 Fire Simulating Laboratory Model

Further studies have been done to try to determine Shroud origin. Dr. Dmitri A. Kouznetsov of the Biopolymer Laboratory developed a laboratory model in 1994 to simulate conditions of the 1532 Chambery fire. Major changes in the radiocarbon date were noted when linen samples were exposed to even modest levels of heat. What is of great interest in Dr. Kouznetsov's research is that during the fire of 1532, the Shroud was exposed to fire, scorching and burning, leaving the entire cloth yellowed. A logical conclusion would be that the Chambrey fire altered the radiocarbon date of the Shroud. The interaction of carbon dioxide in the air produces a chemical enrichment of the sample with the radiocarbon isotope.[7] If true, this would tend to produce a younger date.

The Russian experiments were tested by the University of Arizona (original carbon daters of the Shroud) and they were unable to confirm Dr. Kouznetsov's experiment. However, the Turin Shroud Center of Colorado performed studies indicating that conditions of the Arizona experiment could have caused any enrichment in C-14 to dissipate before the end of their experiment. This was seen in Dr. Kouznetsov's data but at a much slower rate.

The Biological Fractionation Theory

Russian physicist Dr. Dmitri Kouznetsov has presented yet another theory. His new theory is called the "biological fractionation of carbon isotopes." He points out that living green plants, such as flax, can fractionate or redistribute different varieties of carbon atoms (isotopes) between the different classes of biomolecules contained within the plant's cellular structure.

As a result, more than 60 percent of all C-14 atoms can be concentrated within the cellulose part of the flax plant. He notes that "during the manufacturing process of linen production, cellulose is removed from the flax and that gives the linen textile an enriched amount of C-14 relative to the total flax plant." Kouznetsov points out that this important detail was not taken into account during the 1988 radiocarbon dating of the Shroud.

They mistakenly measured the amount of C-14 in the linen as an indicator of the age of the Shroud. In fact, the C-14 was redistributed by the flax plant so that it was concentrated in the cellulose (used to make the linen). This factor distorted the C-14 testing and made the Shroud appear younger. Factoring in a correction for biological fractionation makes the Shroud much older than the 1988 C-14 date.

Bio-Plastic Coating Theory

A 1995 team lead by Leoncio A. Garza-Valdes, MD and Stephen J. Mattingly, PhD (of the University of Arizona) after months of examining microscopic samples came to the conclusion that the Shroud was centuries older than its carbon date.[8]

Dr. Garza-Valdes concluded that fibers on the Shroud were coated with centuries-old bacteria and fungi and a bioplastic (lacquer-like) coating. Because this coating cannot be removed by conventional cleaning methods used in most radiocarbon labs (Dr. Garza-Valdes devised a special method for cleaning the cloth), the carbon dating had included the contaminants as well as the cellulose of the fibers. Therefore, the linen itself was not dated. Even though the sample that Dr. Garza-Valdes used was given to him by Giovanni Riggi di Numana (who took the official Shroud samples for the 1988 C-14 dating), the Catholic church has not sanctioned the fibers as an official sample. Because of this, Dr. Garza-Valdes' findings have not been published in a scientific journal.

Dr. Garza-Valdes' hypothesis is also being taken seriously by microbiologists, archeologists, and others close to carbon dating issues. This is because his conclusions can mean the difference of up to 1,000 years. Keeping all this in mind, the University of Arizona in Tucson is preparing to test Dr. Garza-Valdes' theory by testing an ibis bird mummy that dates back to approximately 330–30 B.C.[9] Dr. Garza-Valdes' breakthrough find could help with understanding the ancient world and determining the authenticity of museum artifacts such as Egyptian mummies.

Moving the Shroud's origin back several centuries would place it near the time of Jesus' death, adding fuel to the debate of whether the Shroud is real or a hoax. But, there still exists the question of whether Drs. Garza-Valdes and Mattingly have real Shroud fibers. Even Cardinal Giovanni Salarini publicly questioned the sample. Although the final outcome of Dr. Garza-Valdes' team remains to be seen, their research and methods will enhance the accuracy of carbon dating. Archeologists also have a new tool for evaluating artifacts.

Conclusion

To sum up this chapter—yes, there has been serious ongoing research during the 90s and even the formulation of some new theories. But, still at the dawn of the millennium, no one can say they know without a doubt how the image on the cloth was formed. I am reminded of the following Bible verse:

> But God chose the foolish things of the world to shame the wise; . . .
>
> 1 Corinthians 1:27 (NIV)

Who is wiser than all the scientists who have been baffled by this wondrous mystery for centuries now? With all of our technology and computer genius, why can't we solve this puzzle? Will 21st century technology perhaps provide the answers, or will the cloth remain silent?

PART 4

Significance of the Shroud

13

The Image That Won't Go Away

When D. James Kennedy, one of the finest scholar-pastors, read *Verdict on the Shroud,* he was inspired to write a message and a booklet called *Save the Wrappings*. When Norman Geisler, now the Dean of the Liberty Center for Research and Scholarship at Liberty University in Lynchburg, Virginia, was asked to review the book, he went from certainty of fraud to near certainty of authenticity calling it the "best evidence in the 20th century for a 1st century miracle."[1] These are just two of the many remarkable responses to the evidence from the Shroud in 1981. In conservative scholars of their caliber, the reversal in position carries additional weight.

Historically, the Shroud image has been the focus of hotly contested battle lines, shared at times by the most bizarre of "bedfellows." For example, it is not unusual to see an evangelical Christian like Josh McDowell align himself with an atheistic opponent of the Shroud like Marvin Mueller. On the other side of the war zone, you might find Jewish Shroud experts like Barrie Schwortz and Alan Adler in

agreement with such Shroud proponents as former agnostic Dee German. Some researchers just as ardently avoid the obvious religious implications of sindonology. More importantly, they actually expect people to regress to their purported position of "noncommittal scientific curiosity." Almost no one remains neutral.

What is the public to believe? Is the Shroud of Turin really a burial garment, or is it a pious fraud? Does the scientific research completed thus far give us any reliable conclusions? If in fact it is the Shroud of Jesus Christ, what role does it play in Christianity? What message does it give to the world at large? Where do I go from here? From peer review and discussion, what conclusions can finally be drawn? Is the evidence as strong as I felt it was when I wrote *Verdict on the Shroud* and *The Shroud and the Controversy*, or should I tone down the enthusiasm that earned me everything from skepticism and outright scorn by opponents to hearty approval? These are the major issues for the conclusion of this book.

A Historical Perspective

Perhaps the single most frustrating thing to me in the entire Shroud saga is the near hysteria that originally greeted *Verdict on the Shroud*. Amazingly, the worst of it came from brothers in Christ, who even went to the extent of leveling false charges at me, the co-author, and the book. One critic began an address before IEEE by stating that I claimed "that the Shroud exhibits proof of the resurrection of Jesus," which is patently untrue.[2] Nowhere in *Verdict* or in public lectures or interviews have I made such a wild claim. In fact, I say in the conclusion of *Verdict on the Shroud:*

> Throughout this work I have tried not only to present the known facts, but also to be cautious in my evaluation of them. . . .
>
> Even though hypotheses involving fakery and

natural explanations have failed to explain the known data, I did not therefore assert that the Shroud gives evidence for a supernatural occurrence. . . .

Thus the facts point strongly to the two conclusions that the Shroud is an actual archeological artifact, and that it is Jesus' burial garment.

. . . it is also probable that the cause of the image *corresponds* to the historical report that Jesus rose from the dead. . . .

Science can only go part of the way; it *cannot prove* irrefutably that the man of the Shroud is Jesus Christ. . . .

We must remember that *the Shroud proves nothing* [emphasis not in original].[3]

After line upon line of caveats and disclaimers throughout *Verdict on the Shroud*, to end on such a note is far from "proving" anything, much less something as significant as the resurrection. Nor did my personal opinions on the resurrection require approval by STURP members. Perhaps the real cause for alarm was that I understood the facts too well and drew from them a probability that some were not willing to accept.

Some of the scientists would say that the "proof" of the resurrection and the "proof" of the identity of Jesus do not belong in their studies. Their consistent argument is that to answer such questions lies outside the realm of science. For the "nth time" let me state clearly, I most emphatically agree! "Proof" of either the resurrection or of the identity of Jesus cannot come from science alone. However, let me make it clear that while the proof itself may be outside of their bailiwick, evidence is not, hypotheses are not, the connection is not, and most certainly the issue is not!

While all of those hostile to the Shroud question have no problem making the connection between Jesus, His

resurrection, and the Shroud, and while they even go so far as to use it as an offensive weapon against the scientists, some of the key people providing the most positive evidence for authenticity tend to hide behind the cloak of scientific objectivity. Consider the comments of Professor Gonella given at the Hong Kong Symposium in 1986:

> The operation also showed the difficulties of communicating scientific results and problems to the public and humanistic colleagues. Both the media and scholars of the related humanistic fields seem to make little or no difference between reasoned scientific conclusions by professional scientists and wild hypotheses by amateurs, between measured results and mere opinions. Thus the field is still cluttered by misinformation and thoroughly confuted theories. The media showed an uncanny ability in pushing the wildest news and overlooking the solid results ... because too many Shroud enthusiasts (pro and con) choose to address the mass-media instead of scientific journals. The media interest, fostered by the emotional attachment in the public, brought about too many misquotations of those who walk on the narrow path of scientific rigour [sic] and publication in referenced journals. They were often judged by such misquotation, and often accused of "religious fanaticism" only because they were studying an object of obvious religious connection; they were therefore compelled to lean over backward in their statements to an extent unheard of in normal research, under the weight of a psychological pressure that constitutes an effective limitation to the freedom of reseach.[4]

Throughout his report Gonella had made reference to the "obvious religious connection" and in nearly the same breath attempted to sever that connection. STURP members were

well aware of the nature of the problem they were attacking in sindonology. We discussed it among ourselves on more than one occasion, including the overwhelming media interest that would unquestionably follow our work. As one who primarily handled press relations for STURP from its inception, I often stressed the increasing need to address the general public, but my pleas generally fell on deaf ears. After three long years of silence and secrecy except for the excellent June 1980 *National Geographic* article and a smattering of others, the leaders of STURP were content to make the public wait. Unfortunately, men like Nickell and McCrone were quick to provide answers—answers that sounded good but were plagued with inaccuracies and loopholes.

Also from a personal perspective, I frequently argued for the inclusion of other disciplines, including Scripture experts, but these were considered "unscientific" by STURP. Even Father Rinaldi admonished us all, "When you take up the cause of the Shroud, you take up the cross."[5]

Now it seems that because we failed to find the "missing link" of sindonology—the image formation process—there is an overwhelming desire to remove all connection with Jesus of Nazareth. Let me state emphatically that *if it were not for the Gospel of Jesus Christ, the Shroud would be no more than a scientific oddity, a museum piece, a mere curiosity.* Anyone who is honest must concede that point or accede to intellectual dishonesty.

Also, to deny public access to the data because of "media misquotations" or an inability of the public to distinguish between facts and opinions strikes me as a form of intellectual snobbery. Is the problem that we, the public, may not understand the scientific theories? Certainly a reasonably accurate report could be prepared for public consumption without scientific compromise. After all, such has been done many times before—the *National Geographic* and *Current Anthropology* articles on the Shroud are cases in point.[6]

One letter expressed this feeling very well: "It does seem

to me that ever since the American scientists—seemingly great numbers of them—came on the scene with all their manifold scientific tests (which never seem to provide an answer!) the whole conception of the truth of the Shroud has come to a sort of shuddering stop. It seems to me also that I was much better off before the tests were embarked upon. I do wonder if other people think the same, or is mine an uninformed viewpoint?"

Humorous, perhaps. Uninformed? Decidedly not! Nor can the scientists expect us truly to believe that the media and public pressure is too great when they knew in advance what to expect. More importantly, how long do they expect to limit Shroud knowledge to a privileged few, a sindonology club for members only? Not all the scientists acted or responded this way, but personal opinions and conclusions have elicited quite volatile responses, especially from those who feel their work is misunderstood.

Skeptical Antagonism

First, to address the issue of whether or not the concerns of some STURP members were actually justified, let's examine the "misinformation" problem as it really exists. Are science and religion truly at war?

Delage's 1902 comment seems particularly relevant in dealing with such a touchy issue, for he manages to separate science from religion without separating the Shroud from Jesus:

> A religious question has been injected into a problem which is in itself purely scientific with the result that feelings have run high, and reason has been led astray. If, instead of Christ, there were a question of some person like a Sargon, an Achilles, or one of the Pharoahs, no one would have thought of making any objection. . . . I have been faithful to the true spirit of science in treating this question, intent only on the truth, not concerned in the least whether it would

affect the interests of any religious party. . . . I recognize Christ as a historical personage and I see no reason why anyone should be scandalized that there still exist material traces of his earthly life.[7]

What we actually characteristically face in dealing with most of the Shroud opponents is an oversimplification of the technical qualities of the image, which then allows an easy solution but actually one that does not exist.

As *Chemical & Engineering News* correctly points out, we're now faced with a serious problem: "These differences are difficult to reconcile. Neither side hesitates to question the scientific objectivity of the other."[8] Both proponents and opponents of authenticity justifiably claim scientific expertise, yet both can't be correct. How do I break the tie—if one really exists? Most Shroud opponents seem to have a special ax to grind. For example, Nickell and Schafersman make much ado about Jesus Himself or the narratives concerning the miraculous events of His life being mythical, topics certainly not at issue here nor within their expertise.

In *Current Anthropology* Schafersman states, "Meacham's painstaking rendition of this ritual [that the image on the Shroud represents Jesus Christ] is therefore characteristic and only serves to reveal his dogged belief in the authenticity of the Shroud of Turin and of Jesus Christ, a personage best considered by available evidence to be mythical."[9] If that were not strong enough, he clarifies his position in the *Skeptical Inquirer* (a self-appointed watchdog publication of the supernatural): ". . . there are serious doubts that, if he [Jesus] existed, he was crucified; that there are serious doubts that, if he was crucified, he died; and there are serious doubts (to say the least) that, if he died, he was resurrected."[10] Nickell even claimed to be writing a book that concludes Jesus was simply a magician, obviously intending to imply

that Christ's miracles recorded in the Gospels were simply sleight of hand.[11] Does that mean that Jesus' walk on water was done with mirrors à la David Copperfield?

McCrone and Mueller have another ax to grind. They seem bent on demonstrating STURP to be a clique of religious zealots out to prove a point. According to Mueller, "Shroud investigators have usually been characterized by their pro-authenticity enthusiasm and markedly religious interpretations. About this there can be little disagreement."[12] Certainly many of the members of STURP would not agree with such a harsh blanket statement by Dr. Mueller and would in fact disagree wholeheartedly. Mueller offers a further caustic comment:

> ... it would be surprising to find in these times a fairly large, well-funded, well-organized program of experimentation with predominately theological motivations. . . . Yet, for several years now, such an enterprise has been subjecting a most famous relic, the so-called Shroud of Turin, to an impressive panoply of scientific tests. . . . Concluding that the Shroud is the work of an artist would dash the hope of changing the prevalent scientific world-view. Also the strong religious inclination of nearly all of the STURP membership doubtless plays a role here![13]

To the evangelical Christian, if no one else, warning bells should be sounding at this point. The issue at hand is not Christianity nor the historical existence of Jesus Christ. The issue is not the particular religious bent of the individual scientists who happened to be among the privileged few selected to study this enigmatic cloth—although that has been badly misrepresented in much of the literature opposing the Shroud. Nor is the issue some supposed agenda to change the prevailing scientific view of the "cosmos." The issue is what does the scientific evidence say concerning the possible authenticity of the Shroud.

Oddly enough, the Shroud opponents have actually helped to make the case. Certainly the need to resort to a denigration of the scientists on the basis of their religious preferences shows a decided bias on their part. In addition, if critics feel the need to declare Jesus a myth, are they not actually suggesting that the Shroud evidence indeed matches the Gospel narratives of Christ's passion and death? At least a few of them are willing to admit this in print. For example, Schafersman states, "Stevenson and Habermas even calculate the odds as 1 in 83 million that the man of the shroud is not Jesus Christ . . . a very conservative estimate. I agree with them on all of this. If the shroud is authentic, the image is that of Jesus. Otherwise, it's an artist's representation. . . ."[14]

The bottom line then is that either the image is that of Jesus of Nazareth, or it was intended by its creator to portray Jesus. Since we've ruled out human artifice, am I unscholarly or unscientific to suggest the image is likely that of Jesus?

Most of the misinformation available is clearly attributable to hostile sources and can be easily refuted by the facts. Therefore, we're squarely back to the main issue: I know what the image is, but not how it got there. The known characteristics can't be accounted for by any natural chemistry known so far, nor do they match any known "scorching" mechanism.

In the movies situations like this are called Mexican standoffs. Neither of the primary research directions concerning the image-formation process has resulted in a lab-reproducible product that matches all of the known characteristics of the Shroud image. The easy out for all involved is to state that the Shroud is a mystery, wipe the sweat from their brows, and head off into the sunset. I would readily do this, if only the Shroud existed in a vacuum. But it does not.

The Testimony of the New Testament

Let's see where the facts lead. Assuming that the Shroud is in fact a burial garment, assuming that the most likely person to have been wrapped in that burial garment was Jesus of Nazareth, then there is a reliable record to give us additional input—the Bible.

When I accepted Christ and began to read the Bible to understand my new relationship with Him, I did not reject rational thought as some might assume. Nor did I, because I began to believe the claims of the Bible, forfeit or trash all my years of higher education. On the contrary, things that I had never before understood concerning this universe and all of the good and bad connected with it began suddenly to make sense as I found a totally reliable central reference point. Science-versus-Bible debates have long been heated and led to inflamed emotions. The Shroud story is no different. Some would deny us even the liberty to discuss what the Bible says concerning the resurrection of Jesus but given our still extant laws of freedom of speech/press I will have a go at it. After writing fifty verses of a letter to the Corinthian church developing the following facts: (1) Jesus Christ did rise from the dead; (2) His resurrection was both the type and assurance of our promised resurrection; (3) the resurrection of Jesus demanded a moral change in His followers; (4) the resurrected body was different from the mortal body; the apostle Paul said concerning the unknown process of resurrection, "Behold I tell you a mystery: we shall not all sleep, but we shall all be changed—in a moment, in the twinkling of an eye, at the last trumpet. For the trumpet will sound, and the dead will be raised incorruptible, and we shall be changed. For this corruptible must put on incorruption, and this mortal must put on immortality" (I Cor. 15:51–53).

Paul was a formerly hostile antagonist to the Gospel whose dramatic resurrection encounter led not only to his own life change, but to his authoring 60 percent of the New

Testament and changing millions of lives. The key words in this passage that pertain to the Shroud are, in order: (1) mystery: *musterion*—secret, something hidden or not fully manifest, unknown to human reason, known only by revelation from God; (2) sleep: *koima*—to put to sleep, to decease, to be dead; (3) changed: *allasso*—to change, transform, exchange; (4) twinkling of an eye: *rhipe*—a jerk of the eye, an instant; (5) incorruptible; *aphthartos*—not capable of corruption, exempt from wear, waste, or deterioration; (6) immortality: *athanasia*—without death, rendered immortality, glorified body, resurrection body.[15]

In common English, Paul, the protégé of the famous Rabbi Gamliel, says that we will partake of the same type of resurrection Jesus had and that as a result, our dying mortal bodies will "metamorphosize" in a split second into a body that can never die, a body that according to the Gospel accounts has incredible powers and abilities and yet is touchable and even partakes of food (Jesus was not a ghost).

When I asked chemist Alan Adler if such an event could bridge the gap between what I know of the image and its still elusive formation process, his answer was, "Yes, but if such an event took place in which that much matter was exchanged, you'd still have an incredibly huge crater where the Middle East used to be."[16] However, I'm not sure I agree. As my dear friend Dr. Richard Eby recorded in *Caught Up into Paradise*, when Jesus changed the water into wine, there had to be a tremendous energy release, and yet it was contained in a stone jug. If Adler's supposition were to hold true across the board, then the changing of water into wine should have also blown Cana off the map. In actuality, Dr. Eby's father wed the knowledge of that incredible energy exchange to design a bushing to serve as an insulator to contain the energy of the Boulder Dam project.[17] Are bodies described in Scripture as earthen jugs? Perhaps there are yet a few "secrets" or "mysteries" that I don't understand concerning these earthen jugs. As Sam Pellicori said concerning his

image-formation thesis, "The current incompleteness of the hypothesis is not cause to disregard it, especially in the absence of a valid (i.e., verifiable) replacement."[18]

Certainly if that logic holds for his theory, it will hold for mine. After all, does anyone really know what happens in a resurrection?

One final consideration about the resurrection connection has been raised by the pathological evidence. If indeed the image was caused by the resurrection, why does it show a dead body in rigor mortis instead of a wakening body? Certainly this is a difficult question. However, one theory that was never fully developed that is in harmony with this concern was first proposed by Joe Accetta. He was a member of STURP during the 1978 research effort. While in Turin with the team, he produced some fascinating infrared photography that showed the image, not as a negative, but as a positive. At the time, some of us believed that Accetta had supplied a critical key to the image-formation process. Unfortunately, however, his work was given short-shrift by others on the team.

Recognizing that Scripture states that Joseph of Arimathea bought a large quantity of aloes, which are known to be photosensitive, to use in Jesus' burial, Accetta derived an equation for image formation based on the known properties of radiant light. He felt that if the light source came from outside the cloth, the weave pattern would act as a sort of focusing mechanism, giving us the excellent resolution and the three-dimensional effect on the cloth. As with many other turns in sindonology, Accetta may have provided a key to further research into image formation and its connection to the resurrection regardless of what his personal beliefs may be.

Throughout Scripture there are references to the "glory of God" being revealed as an incredible light. Moses had to cover his face with a veil against the strength of the light of God's glory revealed on Mt. Sinai. Jesus, who was

transfigured on the Mount of Olives revealed to the disciples His "glory." If in fact the Resurrection of Christ is involved, perhaps what truly happened is that the "glory of God" enveloped the body of Jesus as He lay in the tomb. The Hebrew and Greek words involved in these specific passages are exactly what I initially thought concerning the image-formation properties of the Shroud: "glory": *kabod/doxa*—glory, brilliance, reflecting brightness, giving off beams of light; "shine" "shone": *qaran/lampo*—shoot out rays of light, radiance as the sun; "transfigured": *metamorphoo*—metamorphosed, a change denoted by brilliance. Certainly if it was a process such as this, it would have to display a corpse and yet would still imply the resurrection process was occurring.

On the other hand, on a purely logical basis, if a completely natural process caused the Shroud, why are there no others known in the entire world—especially since the Egyptians left us so many burial linens? Numerous sindonologists who believe in a natural process are troubled by this fact. And if the response is that because it was Jesus' cloth, the disciples chose to retain it, why would they go against the biblical injunctions which were so built into them that it required several books of the New Testament for God to change their hearts? After all, a Jewish believer would have destroyed any burial garment, much less one with an image on it, because of the Mosaic injunctions against uncleanliness and idolatry (Lev. 22:4; Num. 9:6–10; Deut. 5:8–9). It is interesting to note that even after Jesus' earthly ministry, the early church still struggled with a legalistic understanding of such scriptural commands. Peter and numerous other Jewish believers had to be convinced that associating with Gentiles and eating foods previously considered unclean were now kosher (Acts 10:9-11:18). At one point, Paul even had to rebuke Peter publicly over the issue of eating with a Gentile, which was thought to be an unclean practice (Gal. 2:11–21).

Admittedly we are dealing with evidence from outside

the realm of modern science, but the source has been demonstrated to be extremely reliable, especially in the singularly most related scientific field of Shroud study—archeology! The biblical accounts concerning the cities of Sodom and Gomorrah, Jericho, Ur, Ninevah, and Babylon have all been confirmed by the archeologist's shovel.

Perhaps Paul waxed prophetic when he warned Timothy to avoid "the profane and vain babblings and contradictions of what is falsely called knowledge" (I Tim. 6:20). Furthermore, if scientists are to be considered more objective auditors of the facts, then we have too soon forgotten the scientific frauds of the Piltdown man, Neanderthal man, Hesperopithecus haroldcookii (Western ape-man), Pithecanthropus erectus, and even australopithicines, *all* of which were touted as the "missing link" necessary to support the theory of evolution and which have been determined (by truly objective researchers) to be respectively: a man-made fraud, a man with rickets, an extinct pig, a large gibbon, and apes. Moreover, most of these frauds were admitted to in the end by the very perpetrators themselves.[20] Perhaps those "scientists" (I do not include all scientists in that category but merely those who have gone to any length against the evidence to "prove" their pet theories) should consider the statements of two of the leading spokesmen for evolutionary theory, Aldous and Sir Julian Huxley. By their own admission, these two men denied the existence of a Creator for self-serving reasons. Aldous Huxley, leading atheist and evolutionist said,

> I had motives for not wanting the world to have meaning; consequently assumed that it had none, and was able without any difficulty to find satisfying reasons for this assumption. . . . For myself, as no doubt, for most of my contemporaries, the philosophy of meaninglessness is an instrument of liberation. The liberation I desired was simul-

taneously liberation from a certain political and economic system [capitalism] and liberation from a certain system of morality. We objected to the morality because it interfered with our sexual freedom.[19]

In the late 80s, Sir Julian Huxley, a famous evolutionary biologist, admitted on a television talk show, "We all jumped at the Origin [Darwin's Origin of the Species] because the idea of God interfered with our sexual mores."[20] Perhaps some of Paul's comments in his letter to the Romans are appropriate here:

For the wrath of God is revealed from heaven against all ungodliness and unrighteousness of men, who suppress the truth in unrighteousness, because what may be known of God is manifest in them, for God has shown it to them. For since the creation of the world His invisible attributes are clearly seen, being understood by the things that are made, even His eternal power and God-head, so that they are without excuse, because, although they knew God, they did not glorify Him as God, nor were thankful, but became futile in their thoughts, and their foolish hearts were darkened. Professing to be wise, they became fools. (Romans 1:18–22)

Though obviously evolution is not the issue in this particular work, I believe it is more than germane to the issue. Historically, the leading scientific theorists of past centuries were men whose belief in the Bible did not in any way hamper their objectivity nor their scientific excellence. A partial list of them would include: bacteriology, Louis Pasteur; calculus and dynamics, Sir Isaac Newton; anatomy, Georges Cuvier; surgery, Joseph Lister; chemistry and gas dynamics, Robert Boyle; electromagnetics and field theory, Michael Faraday; genetics, George Mendel; galactic astronomy, Sir William Herschel; computer science, Charles

Babbage; dimensional analysis and model analysis, Lord Rayleigh; energetics, Lord Kelvin; entomology, Henri Fabre; electrodynamics, James Maxwell; geology and ichthyology, Louis Agassiz; fluid mechanics, George Stokes; hydrostatics, Blaise Pascale.[21] The list could go on. On the other hand, when two leading theorists of modern evolutionary thought, Dr. Stephen Jay Gould and Dr. Nils Eldredge, admit that the "trade secret" of paleontologists has been that transitional forms do not exist and then leap to a totally bizarre theory of punctuated equilibria, which requires the first bird to hatch from a lizard's egg, could I not suggest intellectual bias of the worst order? Bias is especially possible since both men are by their own admission atheists as well as Marxists.[22]

If the Shroud could indeed be demonstrated to be authentic (just for sake of argument! I in no way mean to imply that the case has been made), would it not also require a considered decision on the part of all concerned? After all if Jesus did indeed rise from the dead and there were evidence to that effect, then I must consider the claims of Christ. Some of the researchers call any religious conclusions about the Shroud "blind faith" but fail to acknowledge that belief in any unproven theory requires faith. For whatever reason, many sindonologists want nothing to do with the possibility that the image formation process involves Jesus' resurrection. Some, like McCrone, Mueller, Nickell, and Schafersman, have "altered" the facts to suit their own interpretations of the existent data. McCrone, in his textbook on microscopy, even suggests that data be altered to achieve the desired result.[23] Others seem reluctant to voice the possibility that the image could be Christ for fear of what people may think of them.

Certainly I cannot prove that this cloth held Jesus Christ's body. Nor indeed can I prove that the image was a direct result of His resurrection from the dead. But there is almost no basis for the incredible histrionics that follow comments such as the following: "To assume it's a painting would be a

greater miracle than the resurrection."[24] When Jewish chemist Alan Adler makes such a statement, he does so without emotion exactly because to his studied eye, that is the fact. And yet the scoffing from many quarters that follows such a statement is deafening.

When I have made the statement that the image formation process was probably some form of "scorch" that most likely occurred at the moment of resurrection, it was simply my best shot at describing the facts as they were then known and understood. As late as 1986, Luigi Gonella, who serves as a scientific advisor in Shroud testing to the Archbishop of Turin, put it this way:

> The "3-D characteristic" brought forward the hypothesis of a radiation burst among the image-formation mechanisms to be investigated. This hypothesis, vastly misunderstood, elicited much attention from the media and has often been dubbed "miracolistic," though it was nothing of the kind. Rather it is the obvious reaction of a physicist faced with the structural features of the Shroud image: the agent acting at a distance with decreasing intensity is, almost by definition, radiation. The limitation of the cloth darkening to the outermost surface pointed to a non-penetrating, non-diffusing agent, like radiant energy; the absence of plateaus pointed to an effect limited by the exposure time (hence a "burst") and not by saturation of the receiving material; whatever the mechanism might be, it must be such to yield effects as if it were a burst of collimated radiant energy.[25]

The only thing that has changed since this statement was made is that it has been demonstrated that any known or heretofore postulated form of "scorching" mechanism will not match all the known Shroud image characteristics. The image does not fluoresce, burn through, damage the fibrils, or blur as all known methods of scorching do. I readily admit

all of these facts and still stand by my original judgment because it still best fits the known facts. The Shroud does not exist in a vacuum. On the contrary, if the medical and scientific evidence confirms the biblical record in every other detail, I conclude that the only remaining detail is also accurate: Jesus Christ rose from the dead and the image on this cloth is in some as-yet-unknown way connected with that event. Whether it was the effect of body chemicals over a period of time, an effect that has escaped our duplication attempts, or some high-energy, high voltage transformation for which I lack both name and knowledge, that historical episode—the resurrection of Jesus Christ—is the single most feasible explanation for the image on the Shroud.

The scientists of STURP even conclude the following concerning the image formation process:

> The cause, then, of the yellowing in chemically altered cellulose consisting of structures formed by dehydration, oxidation, and conjugation products of the linen itself. . . . This conclusion is supported by laboratory simulations using controlled accelerated aging processes that produce the same spectral reflectance curves as the body-only image areas and the background areas on the Shroud. . . . It is important to note that this chemistry is similar to the chemistry that causes the yellowing of linen with age. The fact that we see the body image tells us that the body image is due to a more advanced [cloth] decomposition process than the normal aging rate of the background linen itself. For this reason, we will from this point on refer to the chemistry of the body-only image as advanced (cloth) decomposition.[26]

The STURP scientists go on to state:

> The Shroud's mapping relationship, however, poses the strongest objection to a contact mechanism. Contact mechanisms have not been able to produce a

convincing cloth-body distance relationship. In fact, taken alone, this mapping function seems to suggest some kind of "projection" mechanism, because there seems to be an image present even where it does not appear to have been possible that the cloth was in contact with the body, we are left to identify what kind of "projection" mechanism, and this we have been unable to do. Simple molecular diffusion and "radiation" models, for example, fail to account for the apparent resolution of the image as I understand it. . . . I really do not have a satisfactory, simple explanation for how the body image got on the cloth. I think this fact is underscored by the fact that to our knowledge no other image on any cloth—grave cloth or art form—like the body image on the Shroud is known to exist today. If another example were to exist, our task of identifying the origin of the body image would be much simplified.[27]

Immediately following that remark, the members of STURP began a discussion of whether or not the Shroud might be Jesus':

To put all of the above in common English, they conclude that the Shroud image is caused by an unknown form of "advanced decomposition" of the cloth, which seemed to "project" from body to cloth—a process which has thus far eluded all attempts at duplication. The image is unlike any art form and also has no natural counterpart. Again recall that the lab-induced "advanced decomposition" was accomplished by "baking" linen in an oven. I clearly recall asking Sam Pellicori if we could induce "shroud-like" characteristics by baking the linen, what was so hard to accept about an unknown process that might have occurred in a split second of time two thousand years ago in Jesus' garden tomb? Sam had no answer.[28]

Nor is it necessary for science to have an answer. Human beings are not limited to science for answers. Would you choose a spouse because his/her genes are scientifically perfect or because of your love for that person? If you answered "love" could you give a scientific definition for love and demonstrate how to reproduce it in the laboratory? Surely I know many of the chemical reactions involved in the human body when love is in action, but can I reproduce it in a pill or in the lab? Not at all. Why then do human scientists cringe when Christians talk about the resurrection? One of the most notable intellectual scholars and skeptics of his day, the late John A. T. Robinson wrote, "The quest for the Shroud can lead only to the quest for Christ."[29] Considering that his initial intent was to disprove the Shroud, this statement is highly significant—especially in view of the fact that he professed faith in Christ before his death.

A Scientist's Conviction

I believe the case for the authenticity of the Shroud of Turin would hold up in any court in the land. Furthermore, I believe the case for the resurrection can be made beyond a "reasonable doubt." More importantly, it is my firm conviction that the Shroud does have a role to play in Christianity. Indeed, though I by no means consider these things to be "proven" if what I believe about the Shroud is accurate, then its purpose is as follows:

After all is said and done, the Gospel of Jesus Christ neither rises nor falls because of the Shroud of Turin. Certainly if more evidence were found to buttress a medieval date, the case for authenticity would be much more questionable. On the other hand, even if a first-century date were scientifically confirmed, the Shroud is not now, nor indeed should it be, an article of faith.

What the Shroud does best is to provide an extremely accurate window back in time to the passion of Jesus Christ. As medical doctors from Barbet to Bucklin have discovered,

the Shroud allows a virtual autopsy of Calvary. Historians and biblical scholars alike have marveled at the accuracy and level of detail on the cloth of that brutal death. Perhaps the Shroud even allows the modern-day doubter to put his or her finger in His hands and side. Most impressive is the life-changing impact that an open, objective study of the facts can cause. Over and over during the years since *Verdict on the Shroud* and *The Shroud and the Controversy* were published, people have told me that the straightforward presentation of the facts was responsible for a new direction in life. These people did not become rabid, fanatical, or somehow lose touch with reality. They merely chose to believe in Jesus. The Shroud was only a catalyst to their conversions based on the claims of the Gospels.

Decide for Yourself

My question to you is, what will you decide about the Shroud? You have heard the evidence pro and con. The final decision for or against authenticity rests squarely with you.

Beyond the issue of the cloth itself, what have you learned about the man who may have been wrapped in the cloth 2,000 years ago? The one who in love predicted His own death, burial, and resurrection. It has been well stated that the Shroud is "God's love letter in linen to all mankind."[30] What better evidence could God offer of His love to a technical generation than something that has stumped some of the best technical minds of their day, while at the same time revealing a depth of love few could even imagine?

For the scientist in you, I close with these words of Oswald Scheuerman:

> It seems as if physics and chemistry (would have) provided better explanations of the formation of the image nowadays . . . and yet, the genuine arrangement of simultaneous and successive causal steps that formed this expressive and informative image cannot be attributed to a series of coincidences.

Neither was it possible for human beings to produce such an image. . . . Consequently, one cannot help reaching the following conclusion:

"A Dead Man Rose from the Dead and Left Behind His Image as an Evidence for Posterity."[31]

Afterword

Dear Reader,

It is my prayer that everyone receiving this word will make a determination from this day forward to seize the Kingdom of God; to lay hold of it. To be those who would walk in the principles of the Kingdom of God. Not as those who would only live in the past, remembering only old victories, nor as those who would stretch so far out into the future that all they could see is heaven. But, rather as a people who would dwell in the earth, demonstrating God's Kingdom and power to a lost and dying generation. My prayer is that the truth and the Word of the living God spoken in these pages sinks deeply into the hearts of all those who are ready to receive.

If what you have read in this book has touched your heart, the following prayer can be used as a guide to help you pray to God, according to His Word.

"Help me, Lord Jesus to walk on a Kingdom level of living. Help me to reject going back to fleshly things; things of my mind and my emotions; the things of the world. Help me, Lord, to be discontented with the way I used to live in the past. Father God, I desire today that Your fullness dwell in me bodily; manifested in and through me bodily. That I be conformed to the image of Your Dear Son, Jesus and that

when I begin to go and do, I will be able to honestly say, "It is no longer me that does the work, but it is Christ in me." Father, I pray that Your Word be secured and manifested in and through my life today. Father God, I praise and thank You that Your Spirit rules, reigns, and has the pre-eminence in my life. I am unwilling to allow my flesh to dictate to me any longer. Father, I confess that Jesus Christ is LORD. I want my whole confession to be that You are Messiah; King of kings and LORD of lords in all that I say and do. Equip and strengthen me on the basis of Your Word, for I ask it in the Name of Jesus. Amen."

If you have read this book and you do not truly know Jesus, have never made that intimate connection with the true and living God in a relationship; if you have never publicly or even privately confessed Jesus as your personal Lord and Savior; if you are uncertain as to where you will spend eternity, God's hand is still stretched out to you. If you were born-again, but have been back-slidden, not serving Him, not walking uprightly before Him, if the world has been drawing and attracting you, know that God is still reaching out to you, even now. God's Word declares that He is not willing for any to perish but for all to come to a knowledge of repentance.

God is sovereignly calling you today. There is a spirit trying to destroy this generation and God wants you right with Him. You can be part of the Kingdom of God if you will receive the Word that has been given to you. It's not about a church, a denomination, the color of your skin, or any such thing. It's a spiritual thing. It's God saying to you, "The door is open."

If you do not know Jesus in the ways described in this book and you have never made a full commitment to Him; if you have been straddling the fence and the truth of God proclaimed in this book has been touching your heart, know that you can make it right with God right where you are. Don't allow anything to keep you from Him. This moment,

as you read these words, may be a divine appointment for you today. We are not promised tomorrow on this earth. You may be able to fool other people, but no one can fool the Person of the Holy Spirit, Almighty God. You can allow Jesus to become real in your own heart and life through prayer spoken in sincerity.

"Lord Jesus, I come to You as a sinner in need of a Savior, and I ask You to come into my heart. Forgive me of my sins and cleanse me of all unrighteousness. By an act of my will, I repent and turn away from the world, satan, even my own flesh; and I turn to You, the true and living God. I believe that You died for me. I believe that You rose again, and I believe that You are coming back. I give You full control of my life. Fill me with Your Holy Spirit so that I may have power to live before You. In Jesus' Name, I pray. Amen and Amen."

Welcome to the family of God! Hallelujah! As a new believer in Christ it is vitally important that you communicate with God through prayer and get to know Him through the reading of His Word, the Holy Bible, on a daily basis. The Bible is God's love letter to you and if you are uncertain as to where to begin reading, the Gospel of John is a great place to start. It is also extremely important that you pray and seek God for a church home; that is, a local assembly where you will be taught the Word of God and where you can begin to fellowship with the other Christian believers.

If you have any questions or are in need of prayer, you may call or write to us at:

Everlasting Covenant Church
445 Main Street
Beacon, New York 12508
914-831-ECCE
Email address: EvCov7@worldnet.att.net
Visit our website for more information about the Shroud and Everlasting Covenant Church:
www.everlasting.org

APPENDIX

Timetable for Recent Shroud Studies and Events (1988–2000)

Year	Who/What/Where	Research/Conclusion/Description
1988	Oxford University, University of Arizona, and Swiss Federal Institute of Technology	Shroud samples have a 95% probability of dating between 1260–1390 A.D. This dating indicates that the Shroud is not authentic, thereby causing research to decline.
1989	Dr. T. Phillips	Purposed a theory of neutron bombardment, which predicts isotopic conversion of C-13 into C-14. This process could easily cause misdating of the Shroud or any other object exposed to neutrons in this manner.
1990	Turin, Italy (The Royal Chapel)	Stone crashes to the floor from the roof ninety-eight feet above in the Royal Chapel. The Chapel is closed and a temporary canopy erected over its altar.

Year	Who/What/Where	Research/Conclusion/Description
1990	Monsignor Giovanni Saldarini, Archbishop of Turin	Chosen Pontifical Custodian for the Shroud.
1991	St. Louis University	A task force to formulate an American position on conservation and further testing of the Shroud was formed. A second meeting for this purpose is held several months later, but with little impact on sindonology.
1992	International Shroud Commission (September)	The commission was allowed to examine the Shroud and a first report about the state of the cloth was drafted.
1993	Royal Chapel (Turin, Italy)	The Shroud is removed from its normal shrine in the Royal Chapel and transferred to a specially designed but temporary plate glass display case behind the High Altar, in the main body of Turin Cathedral.
1993	Rebecca Jackson	Historical research indicates that the Shroud may have also been the tablecloth used at the Last Supper. The Shroud cloth meets all the requirements for a Jewish burial garment (Tachrichim) and is the right size to cover the table for a Passover supper for 13 people.
1994	Dr. Alan Whanger	Using very sensitive multi-frequency polarized optical analysis techniques, Dr. Whanger claims evidence of objects which include a crucifixion nail, a Roman spear, a sponge on a stick, a crown of thorns, a "titulus" (a Roman title board), a Tiberian amulet, two scourges, a large hammer, a pair of pliers, and two desecrated Jewish phylacteries or prayer boxes. All are consistent with first century objects and with Roman crucifixions of Jews.

Year	Who/What/Where	Research/Conclusion/Description
1994	Drs. D. Kouznetsov and A. Ivanov	Stated that carbon exchange between carbon in the combustion products from a fire and Shroud linen carbon during the fire of 1532, aided by the catalytic action of molten silver and steam, shifted the mix of surface carbon atoms by 20% to 40% thus yielding errors in C-14 measurement. Their experiments yielded a Shroud date "not less than 1,800 years old." Biofractionalization in flax also contributes to faulty C-14 results since flax plants absorb carbon isotopes at differing rates depending on the chemical constituent of the flax involved.
1995	Cardinal Saldarini	A statement was issued declaring any Shroud samples in circulation unauthorized (with the exception of those taken with official permission for the tests of 1978).
1995	Drs. S. Mattingly and L.Garza-Valdes	Subjected small residual Shroud samples to infrared and mass spectroscopic analysis. They find samples coated with biogenic varnishes which would materially alter results in C-14 testing making the Shroud appear much younger than it really is. This would occur if the biogenic varnishes were not removed prior to carbon dating procedures.
1995	Dr. Victor Tryon	Isolated signals from three different human male genes using polymerase chain reaction techniques. The samples were take from "blood globs" found on the Shroud.

Year	Who/What/Where	Research/Conclusion/Description
1995	Dr. Allan Mills	Proposed "single oxygen theory" to account for the Shroud Image mechanism. In his research paper, published in *Interdisciplinary Science Reviews*, Vol 20, no. 4, Dec. 1995, he states that some mechanism must be at work that can take into account all of the following facts which have been developed from analyzing the Shroud.
1996	Italgas Society	The Society intervenes with financial support for conservation requirements.
1996	Drs. Mattingly and Garza-Valdes	Concluded that the carbon dating of the Shroud done in 1988 may be erroneous because the Shroud samples do not appear to have been appropriately treated to remove biogenic varnishes. The varnish effect they describe is valid for all carbon dating on textiles of ancient origin.
1997	Fire (April 11th)	A fire breaks out in the Royal Chapel in Turin, housing the bullet-proof case holding the Shroud. Firefighter Mario Trematore breaks open the case and moves the Shroud to safety in Cardinal Saldarini's house.
1997	Shroud Inspection (April 14th)	The Shroud was carefully inspected and was found to be totally unaffected by the fire.
1998	Shroud Exposition	The Shroud was exhibited in commemoration of the centenary of the discovery by Secondo Pia of its hidden negative image.
1999	Conference Planned (June)	A conference is planned for June 17th–20th by The Shroud of Turin Research Center in Richmond, Virginia. Details were unavailable prior to the printing of this book.
2000	Shroud Exposition (August–October)	The Shroud will be exhibited again to commemorate the jubilee anniversary of the birth of Christ.

Notes

Chapter 2: History of the Shroud

1. Edward A. Wuenschel, *Self-Portrait of Christ: The Holy Shroud of Turin* (Esopus, New York, 1954).

2. Ian Wilson, *The Shroud of Turin* (New York: Doubleday, 1979) 104–105.

3. Ian Wilson, "The Shroud's History Before the 14th Century," *Proceedings of the 1977 United States Conference on the Shroud of Turin*, ed. Kenneth E. Stevenson (Bronx: Holy Shroud Guild, 1977) 31–49.

4. Wilson, *The Shroud of Turin* (New York: Doubleday, 1979) Appendix C. Cf. Eusebius, *Ecclesiastical History*, Chapter xiii.

5. Maurus Green, "Enshrouded in Silence," *Ampleforth Journal* (1969): 319–45.

6. Steven Runciman, "Some Reflections on the Image of Edessa," *Cambridge Historical Journal* (1931): 238–52.

7. Wilson 172–91.

8. Wilson 187.

9. Edward A. Wuenschel, "The Holy Shroud of Turin: Eloquent Record of the Passion," *American Ecclesiastical Review* (1935): 441–72.

10. Wilson 166–70.

11. John Jackson, "Color Analysis of the Turin Shroud: A Preliminary Study," rpt. in Stevenson 190–95.

12. Wilson Appendix C.

13. Wilson 106–12.

14. Wilson 293–98.

15. Gilbert Raes, "Examination of the 'Sindone," *Report of the Turin Commission on the Holy Shroud* (London, Screenpro Films) 79–83.

16. Silvio Curto, "The Turin Shroud: Archeological Observations Concerning, the Material and the Image," *Report of the Turin Commission on the Holy Shroud* (London, Screenpro Films) 59–73.

17. John Jackson, et al., "The Three-Dimensional Image on Jesus' Burial Cloth," rpt. in Stevenson 90.

18. Francis L. Filas, "The Dating of the Shroud of Turin from Coins of Pontius Pilate," private monograph, 1980.

19. Rachel Hachilili, "Ancient Burial Customs Preserved in Jericho Hills," *Biblical Archaeology Review* July/August 1979: 28–35.

20. "Memorandum of Pierre D'Arcis," trans. Herbert Thurston, rpt. in Wilson Appendix B.

21. Thomas Humber, *The Sacred Shroud* (New York: Pocket Books, 1978) 100.

Chapter 3: Fraud and the Shroud

1. Herbert Thurston, "The Holy Shroud and the Verdict of History," *The Month CT* (1903): 19. cited in Wilson 53.

2. Joe Nickell, "The Turin Shroud: Fake? Fact? Photograph," *Popular Photography* Nov. 1979: 99, 147.

3. Robert Wilcox, *Shroud* (New York: Macmillan, 1977) 131–32.

Chapter 4: Back to the 80s

1. *Associated Press* reports, 28 Sept. 1988.

2. *Associated Press* reports, 13 Oct. 1988.

3. Kenneth E. Stevenson and Gary R. Habermas, *Verdict on the Shroud: Evidence for the Death and Resurrection of Jesus* (Ann

Arbor: Servant Books, 1981). This book will be referred to as *Verdict* in the rest of the notes.

4. Although this section of Chapter I was written well before any rumors circulated about the C-14 dating, the release of the results did not affect my willingness to reconsider some former positions.

5. David Graf, review of *Verdict* First Edition Oct. 1981: 46–47.

6. Stevenson and Habermas 6-7, 179–86.

7. Gary Habermas, letter to the editor, *Biblical Archaeology Review* 10 July-Aug. 1984: 24–26.

8. Stevenson and Habermas Chapter 9.

9. Stevenson and Habermas 121.

10. For example, what was earlier identified as a pigtail (*Verdict*, 35–36, photo 9) is dismissed by some researchers today as a peculiarity of the photographs.

11. Steven Schaferamen, "Comment," *Current Anthropology* 24 (June 1983): 301.

12. John Cole, Ibid., 296.

13. Gordon Stein, review of *Verdict*, *The American Rationalist* Jan.–Feb. 1982: 76–78.

14. William Meacham, "The Authentication of the Turin Shroud: An Issue in Archeological Epistemology," *Current Anthropology* 24 (June 1983): 306.

15. Kenneth Stevenson, ed., *Proceedings of the 1977 United States Conference of Research on the Shroud of Turin* 23-24 (March 1977).

16. See Gary R. Habermas, *The Resurrection of Jesus, A Rational Inquiry* (Ann Arbor: University Microfilms, 1976); *The Resurrection of Jesus: An Apologetic* (Lanham: University Press of America, 1984); *The Verdict of History: Conclusion Evidence for the Life of Jesus* (Nashville: Thomas Nelson, 1984); Antony Flew, *Did Jesus Rise from the Dead? The Resurrection Debate*, ed. Terry Miethe (San Francisco: Harper and Row, 1987).

17. Meacham, "Authentication," 289, 307.

18. *Verdict* 6–7, 179–86.

19. Brigid Elson, review of *Verdict*, *Queen's Quarterly* 90:2 (1983): 570.

20. William Meacham, "The Authentication of the Turin Shroud: An Issue in Archaeological Epistemology," *Current Anthropology"* (June 1983): 308.

21. John P. Jackson and William R. Ercoline, "The Three Dimensional Characteristics of the Shroud Image," *IEEE 1982 Proceedings of the International Conference on Cybernetics and Society* #0360-8913/82/0000-0559 (Oct. 1982): 573.

22. William Meacham, "The Authentication of the Turin Shroud: An Issue in Archaeological Epistemology," *Current Anthropology"* (June 1983): 308.

23. Ibid., 299.

24. John P. Jackson and William R. Ercoline, "The Three Dimensional Characteristics," 575.

25. Robert A. Wild, SJ., "The Shroud of Turin: Probably the Work of a 14th-Century Artist or Forger," *Biblical Archaeology Review*, 10:2 (Mar./Apr. 1984): 46.

26. L. A. Schwalbe and R. N. Rogers, "Physics and Chemistry of the Shroud of Turin: A Summary of the 1978 Investigation" (Amsterdam: Elsevier Scientific Publishing Co., n.d.), 28.

27. Joseph Lambert, ed., "Of the Various Stains and Images on the Shroud of Turin, American Chemical Society: #205, 470.

28. W. R. Ercoline, R. C. Downs, Jr., and John P. Jackson, "Examination of the Turin Shroud for Image Distortions," *IEEE 1982 Proceedings of the International Conference on Cybernetics and Society*, #0360-8913/82/0000-0576 (Oct. 1982): 579.

29. Alan Whanger and Mary Whanger, "Findings on the Shroud of Turin" (Raleigh Durham, NC: Mar. 1986).

30. Mary Whanger, interview with Kenneth Stevenson, July 1988.

31. Kenneth Weaver, *National Geographic* staff member, speaking in Data Reduction Meeting, Los Alamos, NM.

32. Robert Haralick, *Analysis of Digital Images of the Shroud of Turin* (Blacksburg, VA: Spatial Data Analysis Laboratory, Virginia Polytechnic Institute and State University, 1983): 2.

33. Alan Whanger and Mary Whanger, "Polarized Image Overlay Technique: A New Image Comparison Method and Its Applications," *Applied Optics*, 24 (Mar. 1985): 771.

34. Max Frei, "Nine Years of Palynological Studies on the Shroud," *Shroud Spectrum International* (June 1982): 7.

35. William Meacham, "The Authentication of the Turin Shroud: An Issue in Archaeological Epistemology," *Current Anthropology* (June 1983): 307.

36. William Meacham, interview with Kenneth Stevenson in Tarrytown, NY, 15 July 1988.

37. L. A. Schwalbe and R. N. Rogers, "Physics and Chemistry of the Shroud of Turin: A Summary of the 1978 Investigation" (Amsterdam: Elsevier Scientific Publishing Co., n.d.), *ACA*, 1982. 45.

38. Eric J. Jumper, et al., "A Comprehensive Examination of Various Stains and Images on the Shroud of Turin," *ACS Advances in Chemistry, No. 205, Archaeological Chemistry III,* ed. Joseph B. Lambert (1984): 456.

39. Ibid., 467.

40. Ibid.

41. Ibid.

42. Alan Adler, interview with Kenneth Stevenson, July 15, 1988.

43. Alan Adler quoted in Zurer, "Archaeological Chemistry," 35.

44. Oswald Scheuermann, "Shroud of Turin–Image Formation: New Biblical Basis" (8501 Behringersdorf, Nurnberg, West Germany, June 1986): 67.

45. Alan Adler, interview, July 15, 1988.

46. Oswald Scheuermann, "Shroud" (West Germany: June 1986): Al, 5, 7.

47. Ray Rogers, quoted in Walter C. McCrone, "How the Shroud Was Created," *The Microscope*, 30:3 (1982): 234.

Chapter 5: The New Testament and the Shroud

1. Edmund Wilson, *The Scrolls from the Dead Sea* (London: Fontana, 1955) 50–51.

2. "Laws of Mourning," *Code of Jewish Law*, Chapter 364, trans. Rabbi Revkir.

3. See *Code of Jewish Law*, Ibid. See also Giulio Ricci, "Historical, Medical, and Physical Study of the Holy Shroud," in Stevenson 60.

4. For comparisons of these different words, see William F. Arndt and F. Wilbur Gingrich, A *Greek-English Lexicon of the New Testament and Other Early Christian Literature* (Chicago: University of Chicago Press, 1979) 177, 264, 270. Cf. John A. T. Robinson, "The Shroud of Turin and the Grave-Clothes of the Gospels," in Stevenson 24.

5. Josh McDowell and Don Stewart, *Answers to Tough Questions Skeptics Ask About the Christian Faith* (San Bernardino: Here's Life, 1980) 165–66.

6. Edward A. Wuenschel, "The Shroud of Turin and the Burial of Christ," *Catholic Biblical Quarterly* 7 (1945), and 8 (1946).

7. For an authoritative discussion, see John A.T. Robinson, in Stevenson 23–30.

8. "Laws of Mourning," *Code of Jewish Law*, Chapters 351–352.

9. Arndt and Gingrich 270, 646.

10. John Jackson, et al., "The Three-Dimensional Image on Jesus' Burial Cloth," in Stevenson 91.

11. Robinson, rpt. in Stevenson 25.

12. "Laws of Mourning," *Code of Jewish Law*, Chapter 364.

13. Robinson, rpt. in Stevenson 23.

Chapter 6: Carbon 14: Is the Shroud a Medieval Object?

1. According to the gas-counter method of dating, C-14 measurements are made on the gas products of a material's ionization and carbonization. This method of dating is viewed by scientists as able to give more accurate results because residual gas can be redated, allowing for multiple testing on only one sample.

2. Bill McClellan, "Secrets of the Shroud," *St. Louis Dispatch* 15 May 1988: C1, 16.

3. Alan Adler, personal interview, 1990.

4. William Meacham, in a paper delivered at the Hong Kong Symposium on the Turin Shroud, March 1986.

5. "Wrapped in Mystery," *Los Angeles Times* 29 May 1988.

6. Ibid., italics added.

7. McClellan C1, 16.

8. Meacham, 1986 Hong Kong Symposium.

9. Ibid.

10. "Radiocarbon dating," *McGraw Hill Encyclopedia of Science and Technology*, 6th ed. italics added.

11. Ibid., 125, italics added.

12. Ibid., 126.

13. Ibid., 123.

14. Ibid., 128, italics added.

15. Michael Tite, "An Inter Comparison of Some AMS and Small Gas Counter Laboratories," *Radiocarbon* 28 (1986): 575.

16. Ibid., 576.

17. Ibid.

18. Willy Wolfi, *Nuclear Instruments and Methods in Physics Research*, B29 (1987): 1–13.

19. William Meacham, "Comments on the British Museum's Involvement in Carbon Dating the Turin Shroud," Hong Kong Symposium on the Turin Shroud, Nov. 1988, 2.

20. William Meacham, personal interview, 15 July 1988.

21. Wolfi 1–13, emphasis added.

22. Leoncio A. Garza-Valdes, *The DNA of God* (New York: Doubleday Books, 1999).

23. Ibid., 34.

24. Ibid., 34.

25. Ibid., 35.

26. Ibid., 64–66.

27. Ian Wilson, *The Blood And The Shroud* (London: Weidenfeld & Nicholson, 1998) p.229.

28. Meacham, personal interview, 15 July 1988.

Chapter 7:
Other Tests for Age: Their Reliability and Their Results

1. Gilbert Raes, "Rapport d'Analise," La S. Sindone supplement to Rivista diocesana torinese, *Turin Commission on the Holy Shroud*, January 1976: 83.

2. Werner Bulst, "The Pollen Grains on the Shroud of Turin," *Shroud Spectrum* 10 (1984).

3. Ibid.

4. Ibid.

5. Post-Testing Meeting, Santa Barbara, California, 24–25 Mar. 1979.

6. Eric Jumper, Kenneth Stevenson, Jr., and John Jackson, "Images of Coins on a Burial Cloth?" *The Numismatist*, official publication of the American Numismatic Association, July 1978: 1356.

7. Josh McDowell and Don Stewart, *Answers to Tough Questions Skeptics Ask About the Christian Faith* (San Bernardino: Here's Life, 1980) 168.

8. Robert Haralick, "Analysis of Digital Images of the Shroud of Turin," *Virginia Polytechnic University Paper* (1983): 34.

9. Eleazor Erbach, personal interview, April 1978.

10. Meacham, personal interview, 15 July 1988.

11. Noel Currer-Briggs, *The Shroud and the Grail* (London: Weidenfeld & Nicholson, 1987) 241. Reviewed in British Society for the *Turin Shroud Newsletter* May 1987: 13.

12. John Tyrer, "Looking at the Turin Shroud as a Textile," *Shroud Spectrum* 6 (1983): 38.

13. Ibid., 43.

14. Ibid., 39.

15. Rex Morgan, *The Holy Shroud and the Earliest Paintings of Christ* (Manly: Runciman Press, 1986) 121–22, italics added.

16. Rex Morgan, telephone conversation with Ken Stevenson, Oct. 1988.

17. See note 15.

18. Currier-Briggs, *The Holy Gail and the Shroud of Christ* (Middlesex: ARA Publications, 1984) 156.

19. Ian Wilson, *The Mysterious Shroud* (Garden City: Doubleday and Co., 1986) 82.

Chapter 8: The Burial Cloth of Jesus?

1. See *Verdict* especially Chapters 8 and 9 for details in the movement from reliability of the Scriptures to the question of the identity of the man buried in the Shroud as being Jesus.

2. Giulio Ricci, "Historical, Medical and Physical Study of the Holy Shroud," in *Proceedings*, ed. Stevenson 60.

3. Dr. David Willis concluded that the marks on the back of the head were "caused by independent puncture wounds of the scalp." Quoted in Wilson, *The Shroud of Turin* 23; cf., 36–37.

4. Questions about the relationship between the burial of Jesus and that of the man in the Shroud are common. For a full treatment, see *Verdict*, Chapter 4 and Appendix C.

5. Francis Filas, interview, "Inquiry into the Shroud of Turin," *CBN University*, 4 April 1980.

6. Vincent J. Donovan, "The Shroud and the Laws of Probability," *The Catholic Digest* Apr. 1980: 51–52.

7. Ibid., 51.

8. Ibid.

9. Alan Whanger, Mary Whanger, Avinoam Danin, Uri Baruch, "Flora of the Shroud of Turin" (Missouri Botanical Garden Press, 1999).

10. Ibid.

11. Ibid.

12. Ibid.

13. Ibid.

14. Philip McNair, "The Shroud and History: Fantasy, Fake or Fact?" *Face to Face with the Turin Shroud*, ed. Peter Jennings (Oxford: Mowbray, 1978) 35.

15. Wilcox, *Shroud* (New York: Macmillan, 1977).

16. Wilcox, "The Shroud: What Does Science Say About the Ancient Cloth of Turin?" *The Voice* 26 Feb. 1982: 12.

17. Ibid. 2.

18. For Jackson's statement, see Cullen Murphy, "Shreds of Evidence," *Harper's* Nov. 1981: 61.

19. Robert Bucklin, cited in Richard Lewis, "Pathologist at Calvary: Examination of Turin Shroud Provides Crucifixion Details," *American Medical News* 13 Apr. 1979: 21.

20. John H. Heller, *Report on the Shroud of Turin* (Boston: Houghton Mifflin, 1983) 217.

21. Ibid., 219–20.

22. Donald Lynn, personal interview, 1984.

23. Quoted in Murphy, "Shreds," 47.

24. "The Shroud; It's Even Changed the Lives of Scientists Studying It," *Globe* 22 Sept. 1981: 26.

25. Ibid.

26. Ibid.

27. Concerning problems with dating, see also Charles Foley, "Carbon Dating and the Holy Shroud," *Shroud Spectrum* 1:1:25–27. See also Meacham, "Authentication," 289.

28. Robert Wilcox, "Fake or Not, Shroud Leaves Mark on Scientists," *The Voice* 19 Mar. 1982: 12.

Chapter 9: Death by Crucifixion: The Discoveries and Disputes of Pathology

1. Heller 17.

2. For background information, see *Verdict* Chapter 5.

3. For summaries, including sources, see Wilson, *The Shroud of Turin*, Chapter 3; Wilcox, *Shroud*, 23-25, 72–73; *Verdict*, Chapter 10.

4. Wilcox, *Shroud* 161; cf. 23-25.

5. See Pierre Barbet, *A Doctor at Calvary* (New York: Doubleday, 1953).

6. See Sava, in *Proceedings*, ed. Stevenson 50–57.

7. See Wilson, *The Shroud of Turin* 29; Wilcox, *Shroud* 72–73.

8. The Shroud of Turin Research Project (STURP) press release

was marked "Text" and dated 8 October 1981. Future references will be noted as STURP, "Text."

9. Heller 210.

10. Frederick T. Zugibe, *The Cross and the Shroud* (New York: Angelus Books, 1982).

11. For this confrontation, see Murphy, "Shreds," 66–57.

12. Zugibe 138–40, 199.

13. Zugibe 96–115.

14. Zugibe 138.

15. Zugibe 195–96.

16. See Robert Bucklin, "The Legal and Medical Aspects of the Trial and Death of Christ," *Medicine, Science and the Law* Jan. 1970: 25; Bucklin, cited in Lewis, "Pathologist at Calvary," 21; Zugibe 24–36.

17. Bucklin, cited in Lewis, "Pathologist at Calvary," 21.

18. Zugibe 77, 85–88, 105–9, 117–18, 195–99.

19. Zugibe 56–79, 87.

20. Robert Bucklin, interview with Gary Habermas, 15 March 1984.

21. Zugibe 159–60.

22. Joseph Gambescia and Robert Bucklin, "Pathology and Forensic Pathology," STURP Conference, New London, CT, 10 October 1981.

23. Zugibe 79–88.

24. Zugibe 80, 85.

25. Bucklin, cited in Lewis, "Pathologist at Calvary," 21. Gambescia agrees with Bucklin's assessment. See Reginald W Rhein, Jr., "The Shroud of Turin: Medical Examiners Disagree," *Medical World News* 22 Dec. 1980: 47.

26. Zugibe 136; cf. 132–37.

27. Zugibe 89–90.

28. See Bucklin, "Legal and Medical Aspects," 24; "The Shroud of Turin: A Pathologist's Viewpoint," in *Legal Medicine* (Philadelphia: W. B. Saunders, 1982) 37, 39. Cf. "Medical

Aspects of the Crucifixion of Christ," *Linacre Quarterly* Feb. 1958: 1–9, rpt in Sindon 7 (1961): 6.

29. Zugibe 89–95.

30. Zugibe 68–70, 94–95, 105.

31. Meacham, "Authentication," 285; Robert Bucklin, in the film *Silent Witness.*

32. Zugibe 92.

33. See *Verdict* 116–17. Cf. Nicu Hass, "Anthropological Observations on the Skeletal Remains from Giv' at ha-Mivtar," *Israeli Exploration Journal* 20 (1970): 38–59.

34. Meacham 285.

35. William D. Edwards, Wesley J. Gabel, and Floyd E. Hosmer, "On the Physical Death of Jesus Christ," *Journal of the American Medical Association* 255 (1986): 1455, 1461, 1463.

36. Bucklin 8.

37. Bucklin, "Shroud," 25–26; interview, 5 and 30 May 1981.

38. Heller 217.

39. Zugibe 118–31, 162, 171.

40. Edwards, Gabel, and Hosmer, "On the Physical Death," 1463. For Bucklin's proposed combination of the views of Barbet and Sava on this point, see "Medical Aspects, 25–26; "Shroud," 38–39; interview 30 Apr. and 5 May 1981; Zugibe 127, 130.

41. On the issue of rigor mortis, see Zugibe 148–50,152; Meacham 285; John P. Jackson, Eric Jumper and R. William Mottern, "The Three-Dimensional Image," in *Proceedings*, ed. Stevenson 92; Bucklin, "Legal and Medical Aspects," 22, 24; Bucklin, "Shroud," 36.

42. Cf. Zugibe 165, with the more detailed reports in Bucklin, "Legal and Medical Aspects," 25; "Shroud," 25; Heller 217; Meacham 286.

43. Zugibe 165.

44. For questions such an these, see Robert A. Wild, "Shroud of Turin," *Biblical Archaeology Review* Mar.–Apr. 1984: 40; Frank C. Tribbe, *Portrait of Jesus? The Illustrated Story of the Shroud of Turin* (New York: Stein and Day, 1983) 90-93; Zugibe 91, 151–52.

45. See Tribbe, ibid., and Zugibe, ibid. Wild prefers the view

that the Shroud is a forgery but admits he does not know what kind (ibid., 30, 45). Numerous other problems in his article are answered in this present book, especially in Chapter 8. Cf. Gary Habermas, "To the Editor," *Biblical Archeology Review* July–Aug. 1984: 24–25.

46. Zugibe 151–52. 49.

47. Zugibe 91, 125, 150–52, 157, 159–63.

48. Zugibe 192.

49. Zugibe 42.

50. Haas, "Anthropological Observations," 38–59.

51. Meacham 291.

52. Cf. Wilson 21.

53. Zugibe 65–66, 160.

54. *Verdict* 49–51, 202.

55. Zugibe 125–27, 189.

56. Robert Bucklin, interview with Gary Habermas, 15 March 1984.

57. Some have used the testimony of Michael Baden, deputy chief medical examiner of New York, Queens County, against the "traditional" views of pathologists who have investigated the Shroud. Baden was quoted as disputing most of their pathological conclusions. Bucklin points out, however, that Baden's testimony is somewhat muted by such factors as his making no personal examination of the Shroud and not spending much time studying it. Baden himself admits, "In no way do I hold myself out as an expert on the shroud. . . ." Bucklin, a friend of Baden, asserted that if he [Bucklin] and others "could sit down with him for a few hours, we could get him to change his mind." See Rhein, "The Shroud of Turin," especially 40, 49–50, for this discussion. Meacham is a bit more direct:

> Baden . . . is a lone sniper laying siege to a fortified city. Regardless of his prestige, his opinions appear off the cuff. He has not seen the Shroud, nor does he appear to be familiar with the vast medical literature or to have been in contact with other scholars; he has not published on the subject; he is said to be "something of an iconoclast" [quoting Bucklin in Rhein, 50]; his opinions were given on

the basis of magazine photographs. . . . This is not to say that Baden may not have something useful to contribute to Shroud studies, but the fact that skeptics quote him at this stage demonstrates their desperation in the medical arena. ("Authentication," 307–8).

58. Zugibe 199.

Chapter 10: Evidence for the Cause of the Image

1. See *Verdict* Chapters 5 and 6.

2. Ibid., 191-197.

3. Ray Rogers, cited in Murphy, "Shreds," 44.

4. R. William Mottern, cited in Murphy, "Shreds," 47.

5. Heller 201.

6. STURP, "Text" 1.

7. See Murphy, "Shreds," 47, 61–62, including comments by Jackson and Jumper. For the same view see Zugibe 192.

8. Heller 198.

9. Heller 207.

10. Heller 209.

11. For one report on McCrone's work, see Angier, "Unraveling," 54–60. For a technical discussion by McCrone, see *The Microscope* 28 (Mar.–Apr.): 105–15.

12. See Schafersman, "Science, the Public, and the Shroud," 49.

13. STURP, "Text" 1; Murphy 56.

14. Heller 194.

15. Heller 205, 213,

16. McCrone, cited in Murphy 54–56.

17. Murphy 55; Meacham 289, 308. See also Jackson, Jumper, and Ercoline, "Three-Dimensional Characteristics," 566–69.

18. Mueller, "Shroud," 29. For a further critique, see *Verdict* 191–92.

19. Joe Nickell, "The Turin Shroud: Fake? Fact? Photograph?" *Popular Photography* Nov. 1979: 99, 147. Nickell has published other works on the Shroud, including articles in *The Humanist*

Jan. and June 1978, and a book, *Inquest on the Shroud of Turin* (Buffalo: Prometheus Books, 1983).

20. Jackson, cited in Murphy, "Shreds," 58, 60-61; Jackson, Jumper, and Ercoline, "Three-Dimensional Characteristics," 573.

21. Heller 208.

22. Don Lynn and Jean Lorre, cited in Murphy 55.

23. Zugibe 180.

24. Heller 203. Cf. *Verdict* 191–93.

25. Heller 203; Murphy 55.

26. STURP, "Text," 2. Cf. *Verdict* 193.

27. Heller 207–8, 211.

28. Ron London, cited in Murphy 56,

29. Heller 203, 208, 211.

30. Heller 203.

31. Heller 211.

32. STURP, "Text," 2.

33. Rogers, cited in Murphy 65.

34. Heller Chapter 14.

35. Mueller 27.

36. STURP, "Text," 1–2. Cf. Jackson, Jumper, and Ercoline 559, 569, 575.

37. Heller 207–9.

38. See *Verdict* 191–93.

39. One might, for instance, speak of heated statues and bas-reliefs in this category, but we have already discussed these options.

40. Paul Vignon, *The Shroud of Christ* (New Hyde Park: University Books, 1970).

41. Wilcox, "What Caused Shroud Images?" *The Voice*, 12 Mar. 1982: 10. Cf. Jackson, Jumper, and Ercoline 569.

42. Mueller 27.

43. STURP, "Text," 1.

44. For other problems with this view, see *Verdict* 193–94.

45. Wilcox, "Half of Shroud Scientists Say Image Is Authentic," *The Voice* 5 Mar. 1982: 12.

46. Cf. Heller 209.

47. Rogers, cited in Murphy 65.

48. Mueller 27.

49. Schwalbe and Rogers, "Physics and Chemistry," 35–36, 43–45.

50. Heller 210.

51. Heller 209.

52. *Verdict* 195–96.

53. STURP, "Text," 1.

54. See *Verdict* 194–95.

55. Heller 201.

56. Schafersman, "Science, the Public, and the Shroud," 42.

57. Murphy 47. See the conclusions of Jackson, Jumper, and Ercoline 559, 575.

58. STURP, "Text," 1; Murphy 47.

59. STURP, "Text," 2.

60. Heller 218–20.

61. Mueller 28.

62. Wilcox, "Half," 12.

63. Wilcox, "What Caused Shroud Images?" 11.

64. STURP, "Text," 1.

65. Wilcox, "Shroud: Real or Fake?" 14, 11.

66. Mueller 23.

67. Cf. Wilcox, "What Caused Shroud Images?" 10–11; Murphy 65.

68. Wilcox, ibid.

69. Wilcox, "Shroud; Real or Fake?" 13–14.

70. Wilcox, "Scientists," 11.

71. Rogers, cited in Murphy 65.

72. Heller 220; interview with Gary Habermas, 19 May 1980.

73. See *Verdict*, Chapter 6.

74. Zurer, "Archaeological Chemistry," 35.

75. Giles Carter, quoted in Emma Jackson, "Prof Thinks X-Rays Caused Shroud Image," *Christian Herald*, Feb. 1983: Al, 5. For a technical discussion, see Giles F. Carter, "Formation of the Image on the Shroud of Turin by X-rays: A New Hypothesis," *Archaeological Chemistry* 3 (1984): 425–46.

76. Zurer 35.

77. Jackson A5.

78. Jerome Goldblatt, "The Shroud," *National Review* 16 Apr. 1982: 419.

79. Schwalbe and Rogers, "Physics and Chemistry," 333.

80. Ibid.

81. For instance, see suggestions by Ray Rogers, "Chemical Considerations Concerning the Shroud of Turin," in *Proceedings*, ed. Stevenson 188; Wilson, *The Shroud of Turin* 207–12; Wilcox, *Shroud*, 171–73.

82. STURP, "Text," 2.

Chapter 11: New Evidence for Jesus' Resurrection?

1. Of the three categories of image explanations—artificial (fakery), natural, and unknown-source scorch theories—the artificial hypotheses are most problematical in terms of the facts. They remain possible explanations but are not likely. Still, if the Shroud is medieval in origin, it of course cannot offer any evidence for Jesus' resurrection.

2. Wilcox, "Half," 13.

3. Wilcox, "Shroud: Real or Fake?" 12.

4. Heller 220.

5. Bucklin, "Afterward," *Verdict* 190.

6. Bucklin, interview with Gary Habermas, 30 April 1981. See also *Verdict* 155–57.

7. Jackson A5.

8. Ibid.

9. Zurer 35.

10. Goldblatt, "Shroud," 418-19. See also *Verdict* 155–57.

11. Wilcox, "Shroud: Real or Fake?" 12–14.

12. See *Verdict* Chapters 1-9, and p. 158 for a summary of this argument. If a person was simply crucified to copy Jesus' death, then one must still explain the Shroud phenomena listed in this present volume.

13. For this argument in greater detail, see Gary R. Habermas, "The Shroud of Turin: A Rejoinder to Basinger and Basinger," *Journal of the Evangelical Theological Society* 25 (June 1982): 219–27.

14. Bucklin, interview, 30 April 1981.

15. See Habermas, "Shroud," 220–22, for further support of the reliability of the Gospels.

16. For further detail and a similarly worded argument, see ibid., 224–25.

17. For an abbreviated form of this argument, see Habermas, "Shroud," 225-26. More details are provided in Habermas, *The Verdict of History and The Resurrection of Jesus.*

18. See especially Habermas, *The Verdict of History.*

19. Mueller 17.

20. Ibid., 29.

21. Schafersman, "Science, the Public, and the Shroud," 43.

22. For a brief treatment, see *Verdict* 163–73. For the actual argument, see Habermas, *The Resurrection of Jesus*, Chapters 2–3. The next two paragraphs in the text of this book are a fairly close rendering of material in *Verdict* 168–170.

23. For examples of such claims by Jesus, see Matt. 11:27; 19:28–29; Mark 2:1–12, 17; 8:34–38; 9:31; 10:33–34, 45; 14:61–63; Luke 24:46–47; John 10:30; 14:6; cf. 5:18.

24. For Jesus' view of the corroborating nature of both His resurrection and His miracles in general, see Matt. 11:1–6; 12:22–28, 38–40; John 5:36–37; 10:36–38.

25. We are, of course, differentiating here between Jesus' resurrection in a glorified body and a miraculous return to one's mortal body, as in the case of Lazarus. For an investigation of the charge that other religious figures were actually raised from the dead, see Gary Habermas, "Resurrection Claims in Non-Christian Religions," *Religious Studies*, forthcoming.

26. Habermas, *The Resurrection of Jesus*, Chapters 4–5.

27. See also Habermas, *Verdict* 171–72.

Chapter 12: Shroud Studies in the 90s

1. Larry A. Schwalbe, "Scientific Issues and Shroud Research in the 1990s," *Shroud Spectrum International* 35/36 (June/Sept. 1990).

2. Professor Piero Savario, "The Shroud Preservation," *Shroud Press Conference* 10 June 1997.

3. Alan D. Adler and Larry A. Schwalbe, "Conservation of the Shroud of Turin," *Shroud Spectrum International* 42 (December 1993).

4. Shroud Press Conference, Turin, Italy, 10 June 1997.

5. *Time Magazine*, 20 April, 1998, Volume 151 No 15.

6. Ibid.

7. Dr. Dimitri Kouznetsov reported in the *Journal of Archeological Science* 23 (1996).

8. Jim Barret, "Science & the Shroud, Microbiology meets archaeology in a renewed quest for answers," Spring 1996.

9. Ibid.

Chapter 13: The Image that Won't Go Away

1. Norman Geisler, Songtime radio interview, Oct. 1981.

2. Eric Jumper, "An Overview of the Testing Performed by STURP with a Summary of Results," *IEEE* Oct. 1982: 535.

3. *Verdict* 176, 177, 179, 186.

4. Luigi Gonella, "Scientific Investigation of the Shroud of Turin: Problems, Results, and Methodological Lessons," paper delivered at the 1986 Hong Kong Symposium, 39.

5. Peter Rinaldi, S.J., STURP meeting, 1978.

6. See the "Select Bibliography" in *The Shroud and the Controversy* for them and other sources.

7. Yves Delage, quoted in Wilson, *The Shroud of Turin*, 20.

8. *Chemical and Engineering News* 21 Feb. 1983: 35.

9. Schafersman, "Comments," *Current Anthropology* 24:3 (1983): 302.

10. Ibid.

11. Joseph Nickell, personal letter to Ken Stevenson, 1977.

12. Mueller, "Comments," *Current Anthropology* 24:3 (1983): 299.

13. Mueller, "Shroud of Turin: A Critical Appraisal," *Skeptical Inquirer*, B Edition (1982): 16.

14. Schafersman, "Science, the Public, and the Shroud," *Skeptical Inquirer*, B Edition (1982): 41.

15. Spiros Zodhiates, "Lexicon," *The Hebrew-Greek Key Study Bible* (Grand Rapids: Baker Book House, 1984) 1659.

16. Alan Adler, personal interview, 15 July 1988.

17. Richard E. Eby, *Caught Up into Paradise* (Old Tappan: Revell, 1978) 99.

18. Sam Pellicori, letter to Ken Stevenson, 5 Oct. 1988.

19. Aldous Huxley, as quoted by D. James Kennedy in pamphlet "The Crumbling of Evolution."

20. Sir Julian Huxley, ibid.

21. Kennedy, "The Crumbling of Evolution."

22. Ibid.

23. Walter McCrone, *Methods in Chemical Microscopy*.

24. Alan Adler, "Archaeological Chemistry," *Chemical and Engineering News*: 35.

25. Gonella, "Scientific Investigation," 31.

26. STURP, Analytica Chemica Acta.

27. Ibid.

28. Ibid.

29. Robinson, *Proceedings of the 1977 Conference of Research on the Shroud of Turin*, ed. Stevenson (Bronx: Holy Shroud Guild, 1977).

30. Kim Dreisbach, "Behold the Man" TV documentary, produced by Ken Stevenson, Good Friday 1985.

31. Oswald Scheuerman, "Shroud" (West Germany, June 1986).

Index

A

Adler, Alan 87, 196, 204, 223, 229, 239, 245, 278

archeology 70, 125, 150, 242, 277

Archbishop Ballestrero 109, 111

Archbishop of Turin 49, 112, 245

archiving 219, 222

art authenticity of 19, 31, 32, 33, 35, 36, 42, 52, 56, 65, 78, 125, 127, 133, 134, 135, 146, 156, 157, 186, 217, 227, 247

art history 36, 69, 73, 75, 76, 77, 81, 91, 132, 147, 148, 149, 153, 157, 160, 167, 169, 171, 174, 175, 176, 177, 178, 179, 180, 182, 187, 190, 194, 199, 204, 205

asphyxiation 95, 166, 167, 174, 175, 176

B

Barbaris, Bruno 151

Barbet 166, 167, 173, 174, 177, 248, 268, 270

bas-relief sculptures 79

Bensen, Igor 88

Bio-Plastic Coating Theory 225

Biological Fractionation Theory 224

Bucklin, Robert 160, 162, 166, 168, 175, 203, 268, 269, 270, 271

building a new reliquary 41, 49, 58, 128, 220, 221, 222

burial cloth 23, 29, 36, 96, 101, 161, 193, 203, 223

burial customs 52, 91, 130, 158

burial garment 22, 23, 24, 26, 27, 29, 30, 33, 36, 40, 47, 49, 55, 67, 70, 81, 86, 91, 93, 142, 145, 146, 150, 151, 154, 157, 158, 159, 160, 161, 162, 163, 165, 169, 182, 193, 199, 202, 204, 212, 213, 230, 231, 238, 241, 256

Byzantine 31, 32, 33, 35, 36, 38, 40, 42

C

cap-of-thorns 170

carbon-14, dating 16, 91, 108, 140, 158

Carter, Giles 87, 203

cellulose 72, 73, 75, 85, 86, 87, 91, 141, 225, 246

chemical characteristics 75, 78, 85, 88

Christian art 32, 33, 56, 157

coin studies
Pontius Pilate 44, 82, 83, 88, 91, 130, 131, 132

conservation 219, 220, 221, 256, 258

Constantinople 33, 35, 36, 37, 40, 41, 42, 129, 133

contact image 189, 192, 193

contact theories 192, 194, 195

contaminants 91, 113, 119, 141, 225

Coon, Carleton 152

crucifixion 21, 24, 36, 40, 50, 56, 62, 68, 93, 94, 95, 104, 132, 146, 147, 148, 149, 150, 151, 152, 153, 154, 157, 158, 160, 162, 163, 165, 166, 167, 169, 170, 173, 174, 175, 176, 177, 182, 185, 201, 205, 208, 256

crucifixion technique 166

crucifragium 175

Currer-Briggs 133, 134, 135

D

Damon, Paul 110, 112

d'Arcis, Bishop Pierre 135

de Charny 30, 39, 45, 47, 48

de Clari, Robert 33, 37

de Molay 39

de Vergy, Jeanne 30, 45

Delage, Yves 23, 161, 166, 277

DeVries effect 113, 114

Donovan, Vincent 151

E

Eby, Dr. Richard 239

Edessa 33, 34, 35, 36, 40, 41, 42, 129, 134, 259

Edessan image 33

Egyptian mummy 98, 130

electrostatic imaging 79

Emperor Justinian 35

energy transfers 87

Essene burial customs 104

F

fibers 43, 57, 72, 75, 77, 119, 126, 128, 141, 191, 205, 225, 226

Filas, Francis 44, 83, 125, 151, 267

fire 41, 49, 59, 60, 67, 118, 141, 196, 219, 220, 224, 257, 258

flagrum 94, 147, 148, 170

fluorescence 75, 80, 85, 186, 197, 223

forgery 30, 31, 45, 46, 47, 48, 50, 52, 55, 56, 57, 61, 62, 107, 116, 119, 127, 132, 135, 157, 186, 187, 194, 271

fraud 24, 44, 46, 55, 56, 59, 62, 84, 117, 146, 187, 229, 230, 242

Frei, Max 43, 82, 125, 127, 156

G

Garza-Valdes, Dr. Leoncio 222

gas counter method 110

Goldblatt, Jerome 198, 204, 275

Gonello, Luigi 109

Gospel of John 99, 101, 149, 153, 167

Gove, Dr. Harry 108

grave clothes 99, 100, 101, 105

Green, Maurus 31, 259

Guarini Chapel 220

H

Habermas, Gary 136, 209, 212

Haralick, Robert 83

history 16, 27, 29, 33, 34, 35, 36,
40, 42, 43, 45, 50, 51, 52, 56, 59,
62, 67, 118, 123, 125, 126, 127,
128, 129, 133, 134, 142, 156,
159, 168, 202, 212

Holy Mandylion 33, 36, 37, 42

hot bas-relief 79

hot statues 79

House of Savoy 30, 48, 49

I

icon 42, 82, 83

iconographic theory 31

iconography 83, 134, 135

iron oxide 57, 58, 72, 75, 76, 187

iron particles and protein 76

Italgas Society 220

J

Jackson, John 41, 44, 77, 130, 160,
162, 188, 195, 260, 264, 266

Jackson, Rebecca 256

Jaw bands 101

Jesus Christ 22, 23, 24, 25, 26, 27,
104, 146, 160, 171, 203, 211,
223, 230, 231, 233, 235, 236,
237, 238, 244, 246, 248, 252, 270

Jewish burial customs 52, 56, 91,
93, 97, 99, 104, 105, 130, 158

Joseph of Arimathea 21, 103, 150,
240

Jude Thaddeus 34

Judica-Cordiglin, Giovanni 166

Jumper, Eric 44, 130, 266, 270, 277

K

King Umberto 49, 108

Knights Templar 37, 38, 39, 45

L

Libby, Dr. Wilfred 108

M

Mandylion 33, 34, 35, 36, 37, 38,
39, 40, 41, 42, 128

Marfan's Syndrome 180, 181

mass spectrometry 111

McCrone, Walter 57, 72, 108, 187

McDowell, Josh 72, 131, 229, 264,
266

medical studies 166, 169

medieval object 21, 30, 37, 39, 52,
56, 62, 76, 78, 80, 84, 91, 105,
107, 111, 117, 123, 126, 128,
132, 133, 135, 146, 156, 158,
186, 188, 208, 224, 248, 275

microscopic examination 22

Mills, Dr. Allan 258

miracles 28, 213, 236, 276

mites 91, 126, 129, 139

Moedder, Hermann 166

Morgan, Rex 134

Morris, Roger 196

Mueller, Marvin 229

N

natural hypotheses 190, 194

negative, photographic 22, 50, 56,
57, 59, 61, 78, 79, 83, 240, 258

New Testament 56, 68, 93, 94, 96,
97, 101, 102, 103, 104, 105, 146,
153, 154, 156, 162, 172, 205,
209, 210, 211, 238, 239, 241, 263

Nickell, Joe 59, 61, 79, 188, 272

O

othinia 99, 100

P

painting 21, 38, 47, 56, 57, 58, 59, 74, 75, 76, 77, 78, 91, 158, 189, 220, 244

Pellicori, Samuel 192

Pellicori-German model 90, 193

phosphorescent statues 79

photography 50, 61, 73, 194, 240

phylactery 130, 132

Pia, Secondo 50

pigment 22, 57, 59, 60, 73, 75, 76, 77, 85, 91

pigtail 261

Pilate 44, 83, 88, 94, 130, 131, 132, 147, 152, 260

Pilate lepton 132

polarized image overlay technique 81

Polarized Light Microscopy (PLM) 75

pollen 43, 44, 52, 70, 84, 85, 91, 126, 127, 128, 129, 139

Pope Sixtus IV 49

position of the nails 171

post-mortem 177, 178, 180

prayer box 130, 132, 256

preservation 23, 219, 220, 221, 222

Q

quasiphotograph 198, 207

R

Raes, Gilbert 43, 126, 260

reflectance 75, 85, 196, 246

relics 21, 24, 25, 28, 36, 37, 50

resurrection 26, 34, 85, 88, 99, 154, 160, 201, 202, 203, 204, 205, 206, 207, 208, 209, 210, 212, 213, 214, 230, 232, 238, 239, 240, 241, 244, 245, 246, 249, 275, 276

resurrection theories 26, 34, 85, 88, 99, 154, 160, 201, 202, 203, 204, 205, 206, 207, 208, 209, 210, 212, 213, 214, 230, 232, 238, 239, 240, 241, 244, 245, 246, 249, 275, 276

Ricci, Guilio 147

rigor mortis 101, 167, 173, 175, 178, 182, 204, 205, 206, 207, 240, 270

Rinaldi, Father 233

Roman Catholics 25

Romans 93, 131, 147, 152, 170, 243

Royal Chapel, Turin Italy 255, 256, 258

S

Savoys 49

scalp 68, 147, 152, 170, 267

scalp wounds 68, 94, 147, 152, 170, 267

Schafersman 194, 235, 237, 244, 272, 274, 276, 278

Schuermann, Oswald 80

Schwalbe, Larry A. 219, 277

Schwortz, Barrie 162, 229

scorch
theories 80, 275

scripture 2, 97, 100, 233

secret commission 126, 166

Shroud Owners 48

Simon of Cyrene 95, 148

sindonology 123, 134, 230, 233, 234, 240, 256

skepticism 26, 28, 105, 159, 230

spectrometry 111, 192

spices 97, 102, 103, 153, 190, 191

statistical probabilities 68

Stewart, T. Dale 152

stigmata 172

STURP 27, 41, 50, 56, 60, 63, 70, 162, 166, 268

sudarion 97, 100, 101, 102, 105

superficiality 90, 92, 191, 192, 193, 199, 207

T

Templecombe image 135

textile 91, 119, 125, 126, 133, 225

Textile Studies 133

thermogram 198

three-dimensionality 60, 78, 80, 83, 87, 90, 92, 130, 131, 132, 188, 189, 193, 207, 245

Thurston, Herbert 55

time lapse chemistry 84

V

vaporgraph theory 191

vertical mapping process 81

Vignon, Paul 31, 165, 190, 273

visible spectral reflectance 196

W

Whanger, Alan 80, 81

Wilcox, Robert 159, 190, 268

Willis, David 166, 267

Wilson, Ian 31, 37, 48, 82, 83, 120, 122, 125, 128, 130, 133, 135

wounds 22, 75, 147, 148, 160, 170, 194

wounds, scourge 22, 75, 94, 95, 147, 148, 160, 170, 194

wrapping the body 98, 104, 179

Wuenschel, Edward 40

X

X-ray 75, 186

X-ray fluorescence 186

Y

Yohanan 149, 152, 153, 173, 175

Z

Zeuli, Tino 151

Zugibe, Frederick 168, 182